THE ART AND FILMS OF
LYNN HERSHMAN LEESON

D0642542

THE ART AND FILMS OF
LYNN HERSHMAN LEESON

Secret Agents, Private I

EDITED BY MEREDITH TROMBLE
FOREWORD BY ROBIN HELD
WITH A DVD EDITED BY KYLE STEPHAN

UNIVERSITY OF CALIFORNIA PRESS BERKELEY LOS ANGELES LONDON

HENRY ART GALLERY | UNIVERSITY OF WASHINGTON SEATTLE

University of California Press
Berkeley and Los Angeles, California

University of California Press, Ltd.
London, England

Henry Art Gallery, University of Washington
Seattle

Frontispiece: *Conceiving Ada* (still), 1997, 35 mm film

Library of Congress Cataloging-in-Publication Data

 The art and films of Lynn Hershman Leeson : secret agents,
private I / edited by Meredith Tromble ; foreword by Robin Held.
 p. cm.
 Published in connection with an exhibition held at the Henry Art
Gallery, University of Washington.
 Accompanied by: DVD edited by Kyle Stephan.
 Includes bibliographical references and index.
 ISBN 0-520-23970-9 (cloth : permanent paper)– ISBN 0-520-
23971-7 (pbk. : permanent paper)
 1. Hershman Leeson, Lynn, 1941- –Criticism and interpretation.
I. Tromble, Meredith. II. Henry Art Gallery.
 N6537. H398 A93 2005
 700'.92–dc22 2005006614

Manufactured in Canada

14 13 12 11 10 09 08 07 06 05
10 9 8 7 6 5 4 3 2 1

The paper used in this publication meets the minimum requirements of
ANSI/NISO Z39.48-1992 (R 1997) (*Permanence of Paper*).

PUBLISHED WITH THE ASSISTANCE OF THE GETTY FOUNDATION

————————

THIS BOOK SERVES AS THE CATALOGUE FOR THE EXHIBITION *HERSHMANLANDIA: THE ART AND FILMS OF LYNN HERSHMAN LEESON,* ORGANIZED FOR THE HENRY ART GALLERY BY ROBIN HELD. MAJOR SUPPORT FOR THIS EXHIBITION HAS BEEN PROVIDED BY THE ANDY WARHOL FOUNDATION FOR THE VISUAL ARTS; THE OFFICE OF ARTS AND CULTURAL AFFAIRS, CITY OF SEATTLE; THE PAUL G. ALLEN FAMILY FOUNDATION; AND DONORS TO THE HENRY ART GALLERY CONTEMPORARY ART FUND. IN-KIND SUPPORT IS PROVIDED BY GRAND HYATT SEATTLE, THE STRANGER, AND KEXP 90.3 FM. SPECIAL THANKS TO DONALD M. HESS AND THE HESS COLLECTION.

THE ARTIST FORMERLY KNOWN AS LYNN HERSHMAN BEGAN USING HER MARRIED NAME, LYNN HERSHMAN LEESON, COINCIDENT WITH HER TRANSITION INTO MAKING FEATURE FILMS. BUILDING A REPUTATION FOR MORE THAN ONE NAME IS COMPLETELY CONSISTENT WITH THE THEMES OF HER ART; HOWEVER, IT COULD CAUSE CONFUSION FOR READERS USED TO ARTISTS CONTENT WITH ONE IDENTITY. FOR PURPOSES OF THIS BOOK, WE HAVE USED THE NAME "LYNN HERSHMAN" IN THE ESSAYS AND USED THE MORE INCLUSIVE NAME "LYNN HERSHMAN LEESON" FOR THE TITLE OF THE BOOK.

CONTENTS

For thirty-five years, the San Francisco artist and filmmaker Lynn Hershman Leeson has explored the relationship of spectatorship to identity.[1] A pioneer of "new media" art, she has introduced technological innovations in her work since the 1970s; her achievements in this field include one of the first interactive artworks on videodisc, the forerunner of the DVD (*Lorna*, 1983–84); the first artwork to use a touch-screen interface (*Deep Contact*, 1984–89); one of the earliest networked robotic art installations (*The Difference Engine #3*, 1995–98); and the Lynn Hershman Leeson (LHL) Process for Virtual Sets, first used in her feature film *Conceiving Ada* (1997).[2]

Until now, most exhibitions of Hershman Leeson's work have emphasized the artist's contributions to art using emerging technologies. Unfortunately, such a narrow focus does not fully reveal what is a rich and varied career that has explored consistent themes: the construction of identity in relation to vision, interactivity, the relationship between bodies and machines, and shifting ideas of the real and the virtual.

Hershmanlandia: The Art and Films of Lynn Hershman Leeson, organized by the Henry Art Gallery, University of Washington, is the first comprehensive United States survey of this important American artist's visual art and film. Premiering at the Henry from November 5, 2005, to February 5, 2006, it is accompanied by the first critical monograph on the artist, *The Art and Films of Lynn Hershman Leeson: Secret Agents, Private I,* co-published by the Henry and University of California Press and featuring essays by art historians and curators as well as film historians and theorists. These two projects advance significantly the scholarship on Hershman Leeson's thirty-five years of creative output, giving scholars an opportunity to reassess Hershman Leeson's contributions to art and film history, feminist theory, emerging technologies, and the full range of late-twentieth- and early-twenty-first-century creative endeavor.

Hershmanlandia is the evocative term used by art critic and curator Pierre Restany to describe Hershman Leeson's "strategy of perpetual and infinite personality situations and

fragmentations."[3] *Hershmanlandia*, the exhibition, explores this strategy in both real and virtual space—a landscape populated by the multiple female personae and agents that have embodied Hershman Leeson's primary concepts and concerns, including Roberta Breitmore and her multiples, Lorna, CybeRoberta, Tillie, the Telerobotic Doll, Synthia Stock Ticker, Agent Ruby, and others. The exhibition presents the artist's constant and interrelated themes as seen in key works, including those in which these personae and agents appear.[4] Operating as a series of feedback loops—earlier art reflecting on later incarnations, elaborations, or mutations—the exhibition makes visible Hershman Leeson's sustained focus on key subject matter over a variety of technological formats.

ROBERTA BREITMORE AND TEKNOLUST

In *Hershmanlandia*, viewers will encounter the renowned *Roberta Breitmore* project (1974–78), presented for the first time in many years in its fullness as a performance, photo, and video work, juxtaposed with Hershman Leeson's latest film, *Teknolust* (2002). With *Roberta Breitmore*, the artist explored spectacle, surveillance, and spectatorship and their roles in constructing a sexed identity, albeit a very fragmented and shifting one. By inextricably entwining the body-in-performance Roberta and the performance-as-documentation Roberta, Hershman Leeson also complicated any simple understanding of a performance as the "now" and its documentation as the "after now."[5]

As Amelia Jones points out in her essay included in this volume, Roberta Breitmore was "a body to be seen and represented."[6] In the early years of the performance, Hershman Leeson would construct Roberta by donning a costume, blonde wig, and makeup. Roberta's existence was officially substantiated by documents that included an apartment lease and an employment contract as well as her own driver's license (see p. 108), checking account, credit cards, and dental records. Therefore, Roberta's subjectivity was constructed not only by Hershman Leeson's performative role-playing, but also by Roberta's rent checks, the contents of her purse, and her personal photographs.

The *Roberta Breitmore* project invited "real-world" participation in September 1975 with the placement of an advertisement in the *San Francisco Progress* (see p. 28). The form of the ad was ambiguous; it could be construed as a listing for a roommate and/or as a personal ad. A post-office-box address was provided for responses. Over the length of the performance, Roberta received dozens of letters, all of which have been saved by Hershman Leeson as ar-

tifacts. When Roberta agreed to meet someone, he (it was primarily, but not exclusively, men who responded) was immediately and unwittingly caught up in the artist's performance. Roberta would meet with each respondent three times at most, in order not to establish too close a relationship. Each meeting was recorded in surveillance images by various photographers (see p. 108). A tape recorder in Roberta's pocket produced an audiotape chronicle of her adventures.

Many of these photographic documents remained in their "original" form as evidence of Roberta's existence and her meetings with others, whom I will call, as a form of shorthand, "dates." Others were rephotographed by Hershman Leeson, who then drew on or collaged or painted over the resulting larger-scale prints, and added annotations to the margins or across the faces or bodies of Roberta and her date. Hershman Leeson continued to produce such documents even long after the body-in-performance Roberta ceased to exist.[7] In 1975, by which time Roberta had had dates in Los Angeles and San Diego as well as in San Francisco, Hershman Leeson commissioned the artist Spain Rodriguez to create an eight-page comic strip of Roberta's adventures (see p. 29). His drawings were made from Roberta's photographic documents, both the surveillance photography and the reconstructed, elaborated collages.

Three years into the performance, Hershman Leeson expanded its exploration of fragmentation and multiplicity by hiring three additional women to perform as Roberta: Kristine Stiles, Michelle Larsen, and Helen Dannenberg. All three performers wore wigs and costumes identical to those worn by Hershman Leeson as Roberta (plate 5). Each had two home addresses and two jobs—one for Roberta and one for herself—and each corresponded with respondents to the advertisement and went on dates that were obsessively recorded in photographs and audiotapes. These photographs, like those of Lynn-Roberta, were then collaged and annotated. All four Robertas existed simultaneously for a short time, until Hershman Leeson ceased performing as Roberta, leaving three.

In 1978 the project was further expanded as part of an exhibition of Roberta artifacts entitled *Lynn Hershman Is Not Roberta Breitmore / Roberta Breitmore Is Not Lynn Hershman*, presented at the M. H. de Young Memorial Museum in San Francisco. A Roberta look-alike contest was held at the museum, attracting transvestites, gay men, women, young girls, and even a set of elderly female twins, all in blonde wigs, costumes, and makeup. As the contestants vied to win, Roberta was fractured and dispersed across their bodies. Photographs of contestants then entered the same process of rephotographing, painting, collaging, drawing, and annotating undergone by the other Roberta photographs.

Half a year later, in a performance at the Palazzo dei Diamanti in Ferrara, Italy, above Lucrezia Borgia's tomb, the body-in-performance Roberta was laid to rest—"exorcised," in Hershman Leeson's term—when Michelle-Roberta set fire to Roberta's photographic image. Hershman Leeson participated in the performance as herself.

The *Roberta Breitmore* project is best known by way of the elaborated photographs, such as *Roberta's Construction Chart #2* (1975, plate 3), a photographic portrait that charts the cosmetic transformation of Lynn into Lynn-Roberta. Performance art, along with its documents and artifacts, troubles art history. It is especially challenging to the methodologies of the discipline and its foundational assumptions about artworks, artist-subjects, and viewers. What are the most relevant tools art historians might bring to bear on this proliferation of documentation that continues even after the body-in-performance has been "exorcised"? Do the photographs of Lynn-Roberta have a different status than the photographs of the other Robertas because they are a record of the body of the artist herself? Do the "original," unaltered surveillance photos have a different status than those collaged, painted, and elaborated by the artist? How does one talk about the multiple iterations of Roberta, including the versions performed by contestants in the look-alike contest? Performance art troubles the assumptions of art history in ways similar to those in which *Roberta Breitmore* troubles the notion of fixed identity, offering the discipline one of the better mirrors for exploring our current fragmented notion of human subjectivity.

The themes of provisional identity central to *Roberta Breitmore* were introduced to a broader audience with the feature-length film *Teknolust*, although here they were updated for a world where sex is no longer required for reproduction and where the once distinct boundaries between humans and machines are becoming increasingly permeable. This digital-age Frankenstein tale was written and directed by Hershman Leeson and shot by Hiro Narita on twenty-four-frames-per-second high-definition video. It stars Tilda Swinton playing four characters who are often seen onscreen at the same time.

In this science-fiction fantasy, the geneticist Rosetta Stone (looking like a dowdy version of Hershman Leeson) concocts a recipe that allows her to download her DNA into a computer program and create from it three clones, or "self-replicating automatons" (SRAs), each of whom is both sister and daughter to her. (This in itself is reminiscent of the three "clones" spawned by Lynn-Roberta in the *Roberta Breitmore* project.) Not quite machine and not quite human, these three SRAs—named Ruby, Olive, and Marinne after the red, green, and blue pixels used to create color on computer monitors—quickly begin to develop their own selfhood and pursue their own adventures.

Raven-haired Ruby, always dressed in the brightest red, is the sexy, confident star of a Web chat room, "Ruby's E-Dream Portal," where she invites users to "emote from your remote" and beckons, "Let's e-dream together." Marinne, fiery maned and clothed in deep blue, discovers the world of cybershopping, stealing Rosetta's credit card information and intensely pursing her consumer pleasures on the geneticist's dime. She also develops an encrypted language as a way to rebel against Rosetta, allowing her to speak in secret to her sisters. Marinne becomes a skillful enough hacker to access Rosetta's code for cloning, the blueprint of the SRAs' identity. Olive, clad in emerald green, with her platinum-blonde hair covering half her face, is the most introverted and obedient and is seemingly the youngest of the sisters. She is often found reading psychology, philosophy, or history texts in bed with Marinne, who successfully draws her gullible sister into her wild schemes (plate 15).

Bred only with Rosetta's DNA, the SRAs need Y chromosomes to survive. How they acquire this "chromo" provides the film's central narrative. Ruby is the only clone Rosetta permits to leave the secret (virtual) lair and enter the real world. While Ruby sleeps, Rosetta downloads into her operating system seduction scenes from old films. Armed with some classic pick-up lines from these movies, Ruby ventures out at night to collect sperm for the injections vital to the continued existence of her and her siblings. Unfortunately, her singles-bar forays have unexpected consequences: the men she picks up develop a mysterious illness with bizarre symptoms, including impotence, the appearance of a bar code on their foreheads, and the crashing of their computer hard drives. Rosetta's employers hire private investigators to investigate the outbreak, calling it "bio-gender warfare." While Rosetta is distracted by these proceedings, all of her SRAs start making regular trips into the real world, having escapades together and alone, finding their way in a world of rapid change.

Teknolust deals provocatively with contemporary issues of fragmented identity in cyberspace, cloning, the future of artificial life, our shifting notions of the real and the virtual, and the changing relationship between bodies and machines. But ultimately it tells an individual story of love and reproduction: Ruby falls in love with Sandy, an incompetent print-shop employee. She is a copy; he makes copies, however ineptly. By the movie's end, Ruby and Sandy are happily anticipating the birth of their first child.

The relation of vision to identity and the fractured, multiple, and provisional nature of subjectivity are key to both *Roberta Breitmore* and *Teknolust*. Produced about thirty years apart, these two works together display Hershman Leeson's deeply considered and sustained investigation of these themes.

AGENT RUBY

For decades, Hershman Leeson has worked in both independent video/film and the visual arts, recently bringing these two streams together via the character Ruby, who appears not only in *Teknolust* but also as Agent Ruby, an artificially intelligent, animated Web agent. Existing in a multitude of platforms, including a Web site, a program downloadable onto a personal data assistant, and an interactive sculptural installation, Agent Ruby exemplifies current modes of interactivity and communication. By presenting both *Teknolust* and works featuring Agent Ruby, *Hershmanlandia* provides an opportunity to reevaluate Hershman Leeson's contributions to both art history and film history.

In the first incarnation of the project *Agent Ruby* (2002–), online users log onto "Ruby's E-Dream Portal" (featured in *Teknolust*), where Agent Ruby invites them to "ask me anything" while a seductive female voice on the pop sound track promises, "I can teach you to dream."[8] Visitors type an introductory question to Ruby, Ruby types a response, and correspondence begins (see p. 93). In a more recent incarnation, *Agent Ruby 2*, a sculptural installation utilizing sophisticated animation techniques (exhibited in 2004), Ruby is capable of verbally responding to users' typed inquiries. A third version has recently been completed in which Ruby responds verbally to viewers' spoken inquiries through state-of-the-art voice-recognition technology.

INTERACTIVITY

Interactivity has remained a consistent focus for Hershman Leeson, whose earliest work predated the existence of the Internet. *The Dante Hotel* (1973–74), staged in a run-down residence hotel in San Francisco, represents one of the artist's first experiments in interactive and site-specific art. For this project, she rented a room, furnished the interior with the personal belongings of an invented tenant (plate 2), and then allowed visitors to explore these objects to flesh out the inhabitant's identity, past and present. Today, Hershman Leeson's explorations with interactivity occur both on and off the Internet. Web-based projects such as *The Difference Engine #3*, which is linked to the film *Conceiving Ada*, and *Agent Ruby*, which is linked to the film *Teknolust*, deepen the artist's investigation of issues raised in *The Dante Hotel:* constructing alternate realities, destabilizing ingrained notions of identity, and expanding the possibilities of an artwork's outcome by opening it to viewer participation. In the context of the Internet, however, these ideas combine in new ways, underscoring the character of this mode of communication.

For example, Agent Ruby has the ability to distinguish different users of "her" system and is furthermore shaped by these encounters. As with the fictional character Ruby in *Teknolust*, Agent Ruby's intelligence increases and becomes more flexible with each rendezvous, but these interactions now take place in the real world via the latest technology.

Many of the ideas embodied by Hershman Leeson's artwork have seemed ahead of their time. Perhaps for this reason, her contributions to art and film history have been under-recognized or misunderstood. The development of her work demonstrates her sustained attention to the construction of a viewer who is an active participant in the work of art—engaging with and potentially altering it—rather than a passive voyeur. Beginning her long career in an art world focused on medium specificity, she continues in one accommodating a wide array of "post-studio" practices, including technological advances from analog to digital. During the same period, many important cross-disciplinary texts have theorized an increasingly complex relationship of humans to machines.[9]

INFLUENCE

The influence of Hershman Leeson's pioneering work in performance, video, film, and "new media" has been pervasive both in and out of an art context. Her impact can be seen in the free use of the diaristic by filmmakers Chantal Akerman, Su Friedrich, and Sadie Benning, among others. It is evident also in the art of "new media" practitioners as diverse as Victoria Vesna, Nell Tenhaaf, and Natalie Jeremijenko. Her influence on feminist, persona-based performance art can be traced in the work of artists as varied as Eleanor Antin, Colette, and Cindy Sherman. Finally, in the realm of popular culture, the independent feature-length comedy *Desperately Seeking Susan* (1985, dir. Susan Seidelman), starring Madonna, took its inspiration from *Roberta Breitmore*, and the independent thriller *Lady Beware* (1987, dir. Karen Arthur), starring Diane Lane, was spawned by Hershman Leeson's site-specific installation *25 Windows: A Portrait of Bonwit Teller* (1976). More broadly, her technological innovations in digital and Web-based art have helped legitimize the "new media" of video, Web art, and works of artificial intelligence. The force of her personality and her personal courage have also helped push at the "glass ceiling" of the art and film worlds, gaining greater acceptance for all women creators of film, video, performance, and new media.

Hershman Leeson's art has been widely exhibited in group and solo museum exhibitions as well as in video and film festivals in the United States, Europe, and Asia. For her work in both film and the visual arts, Hershman Leeson has received numerous awards and accolades.

In 1994 she was the first woman filmmaker to be honored with a retrospective at the San Francisco International Film Festival. The following year, she received the Siemens Medienkunstpreis, being cited as "the most influential woman working in new media." In 1998 she garnered the Flintridge Foundation Award for Lifetime Achievement for Visual Artists, followed by the prestigious Prix Ars Electronica in 1999. Hershman Leeson's first feature film, *Conceiving Ada*, was screened at the 1998 Sundance Film Festival; the following year, the film earned her an IFP Independent Spirit Award nomination in the Someone to Watch category and the Outstanding Achievement in Drama award at the Festival of Electronic Cinema in Chiba, Japan. *Teknolust* premiered in the American Showcase section of the 2002 Sundance Film Festival and was awarded the Alfred P. Sloan Foundation Feature Film Prize in Science and Technology in 2002.[10]

Expressed prolifically in drawings, paintings, photographs, performances, robotic works, digital art, videos, films, interactive multimedia installations, and works of artificial intelligence, Hershman Leeson's project of self-analysis and self-mythification multiplies and refracts fictional identities to the point of exploding any stable notion of identity. Her work provides a remarkable artistic mirror for understanding our fragmented sense of subjectivity at the beginning of the twenty-first century.

NOTES

1. I refer to the artist as Lynn Hershman Leeson throughout my essay, although visual art and film audiences might know her best as Lynn Hershman. She added "Leeson" to her name following her 1991 marriage to George Leeson, and this is how her film credits have subsequently appeared; however, her artworks are still often exhibited under the name Lynn Hershman. The Henry Art Gallery uses the name Lynn Hershman Leeson since the current exhibition and accompanying critical monograph bring together the full range of the artist's thirty-five-year output.
2. In this process, actors are filmed against a blue screen but are able to view monitors that show the scene in real time with slides, video, and graphics taking the place of the blue screen. E-mail correspondence with the artist, June 2003.
3. Pierre Restany, "Hershmanlandia: *Prière de toucher*, Please Touch," in *Chimaera monographie: Lynn Hershman* (Hérimoncourt, France: Centre International de Création Vidéo, 1992), p. 32; also on DVD.
4. In exhibiting her work, Hershman Leeson and her curators have most often divided her artistic production into two broad chronological categories: "B.C." (before computers) and "A.D." (after digital). This methodology, based on a teleology of technological progress, provides a very narrow lens through

which to view Hershman Leeson's art and obscures the full range of ideas that have consistently informed her creative production. This B.C./A.D. construction also oversimplifies our understanding of media transition, suggesting instead only media revolution, a scenario of upheaval in which all previous "new medias" are swept aside.

5. See Amelia Jones, "'Presence' in Absentia: Experiencing Performance as Documentation," *Art Journal* 56, no. 4 (winter 1997), pp. 11–18.

6. See Amelia Jones, "Roberta Breitmore Lives On," in this volume, p. 105.

7. Artifacts documenting Roberta's officially corroborated identity have also continued to circulate long after the bodies-in-performance Roberta were retired. In 2002 I received as a gift a blank check signed by Roberta Breitmore.

8. See www.agentruby.com.

9. These include Norbert Wiener's writings on "cybernetics," Marshall McLuhan's on new technologies conceptualized as extensions of the human body, and Paul Virilio's on the "politics of speed," as well as Donna Haraway's "cyborg manifesto," Niklas Luhmann's systems theory, and Lev Manovich's (more flexible but still McLuhanesque) articulation of a cut-and-paste model of communication. See, for example, Norbert Wiener, *Cybernetics, or Control and Communication in the Animal and the Machine* (Cambridge, Mass.: MIT Press, 1961); Marshall McLuhan, *Understanding Media: The Extensions of Man* (New York: Penguin Books, 1964); Friedrich Kittler, *Gramophone, Film, Typewriter* (Berlin: Brinkmann and Bose, 1986); Paul Virilio, *Speed and Politics: An Essay on Dromology*, trans. Mark Polizzotti (New York: Columbia University Press, 1986); Donna Haraway, *Simians, Cyborgs and Women: The Reinvention of Nature* (London: Free Association Press, 1991); and Lev Manovich, *The Language of New Media* (Cambridge, Mass.: MIT Press, 2001).

10. Hershman Leeson's contributions are also included for mention in important historical surveys of feminist, new media, and performance art, including the survey of feminist art by Peggy Phelan in Helena Reckitt, ed., *Art and Feminism* (London: Phaidon, 2001); Michael Rush, *New Media in Late Twentieth-Century Art* (London: Thames and Hudson, 1999) and *Video Art* (London: Thames and Hudson, 2003); the survey of performance art by Amelia Jones in Tracey Warr, ed., *The Artist's Body* (London: Phaidon, 2002); and Steve Wilson, *Information Arts: Intersections of Art, Science and Technology* (Cambridge, Mass.: MIT Press, 2002).

INTRODUCTION:
BREAKING THE CODE

This book offers the first sustained critical attention to the art of Lynn Hershman. Hershman is a highly regarded personage who rightly figures in any comprehensive history of American art of the past thirty years or so. Numerous solo and group exhibition catalogues present substantial commentary on her art; articles on her work that have appeared in diverse journals and periodicals can be readily gathered or assimilated; and several recent books on feminist, conceptual, and performance art and video and new media cogently assess her production. Yet only now, in this volume, is a book-length study of her achievement being published. Collectively, these essays explore nearly forty years of work, and they range from formal to theoretical to psychological to "poetical" analyses of Hershman's art.

Hershman's art is among the most enigmatic, psychologically troubling, and philosophically ambivalent art produced by her generation. Ostensibly, her art deals with identity, self-realization, and empowerment—themes that have compelled at least three generations of artists and that Hershman played a significant role in first articulating and later developing. At its deepest levels, Hershman's art deals with the personal quest for a sovereign selfhood, and, beyond that, with the profound insularity of each individual, and, beyond even that, with the longing for deliverance from that insularity. From the outset, more than three decades ago, there has been a sustained elusiveness to her art, in which her protagonists—thinly disguised surrogates for herself—remain at arm's length, untouchable, even as we peer into their souls.

The evolution of Hershman's artistic expression has not been an easy arc. When she began her artistic education, formalism dominated the art world. From the mid-1950s to the mid-1960s Clement Greenberg, arguably the most influential broker-critic of the day, articulated a theory positioning the ideal experience of art in the eye, which could perceive the art object all at once, as an absolute totality, independent of everything external to it. Greenberg wrote that advanced artists needed to shed their egos in the pursuit of pure, formal beauty, distilling art to its visi-

ble essence. By the early 1960s, when Hershman commenced her professional career, minimal art—materialist, unyieldingly literal, and in thrall to the physical and formal attributes of the art object—was well established as the heir to Greenbergian formalism. The brute "thisness" of Richard Serra's cast lead spewings or Donald Judd's cement boxes might contrast with the elegant poise of Helen Frankenthaler's stain paintings or Ellsworth Kelly's monochrome reliefs, but they are all generically formalist works. By the mid-1960s, however, formalism was steadily losing its claim on the artistic imagination.

The formalist vision had little to offer a generation of younger American artists who were preoccupied less with weighing the aesthetic nuances of pigment staining a raw canvas against those of paint applied to a primed canvas than with finding a way to address in their art the major social, political, and moral issues that so deeply engaged the rest of their consciousness and conscience. The artists of Hershman's generation were profoundly influenced by the stirring causes that pervaded American social and political life at the time, such as the struggle for civil liberties and economic parity—a struggle that was beginning to galvanize not only blacks, but also Latinos, Native Americans, and one conspicuous nonminority, women—as well as the war in Vietnam, perceived by many as an unjustifiable conflict undermining the nation's ideological values and democratic principles. New "alternative" art forms—concept-based and information art, Happenings and performance, guerrilla and street theater, installation and environmental art, mail art, incipient forms of video and intermedia—all had their genesis in the seething agitation and daring rebelliousness of American life during that era.

Into this critical and social milieu of the mid-1960s came Lynn Hershman, in her mid-twenties, disaffected by the formalist discourse, essentially disenfranchised by the male-dominated art world, radicalized by her education at the University of California, Berkeley, yearning for an alternative culture, and dragging all her unwieldy personal baggage—child abuse, incest, a nervous breakdown—and early feminist polemics with her. Hershman's early artworks—her wax sculptures, *The Dante Hotel* (1973–74), *Roberta Breitmore* (1974–78), *25 Windows: A Portrait of Bonwit Teller* (1976)—were grounded in personal history, fiction, acting out, psychodrama, and make-believe. None of these elements was especially new to art: as content, each is at least as old as classical civilization. But canonical late modernism had banished such traditional motifs and themes from art making. Hershman was among the first to recover such impulses for her own generation, and for later ones as well.

Roberta Breitmore remains a seminal work, marking the advent of Hershman's incipient postmodern art-making strategies. Essentially a private performance in which Hershman acted

out the life of a fictitious character, *Roberta Breitmore* presented a persona whose history and behavior were determined by what the artist describes as "stereotyped psychological data composites." This simulated identity was determined by encoded information that existed outside Roberta's "self." Roberta's influence on feminist art has been widely documented, but Amelia Jones, in her essay here, firmly establishes Hershman's performance of the life of Roberta Breitmore in a tradition involving both performance and photography that dates back to the nineteenth century. Artists and writers as diverse as Théophile Gautier, Eugène Delacroix, Oscar Wilde, Marcel Duchamp, Claude Cahun, Andy Warhol, Yayoi Kusama, and Hannah Wilke learned "to play willfully with the structures of representation" by acting out "excessive self-performances, documented through photographic means and purveyed to the art world and mass media."

The artificially constructed alter egos and confabulated personae of these artists and writers had an appearance of truth and a simultaneous, unmistakable pretend-ness that Hershman and astute commentators understood to resonate with feminist issues in particular and with aspects of anyone's self-perceptions. In his essay on Hershman's career-long involvement with photography—more accurately described, he says, as "image manipulation"—Glenn Kurtz comments on the fluid and fugitive nature of certitude as witnessed in Hershman's art: "In the [traditional] equation of photography with objective truth, there is a longing for stability, as if a photograph were not a composition but a transcription of reality, fixed in time and protected from change. Image manipulation brings photography back into motion, unsettling our grasp on what it depicts. As a violation of the captured moment, it makes the photographic image just one step in a signifying process that the camera does not control." Hershman, in manipulating photographic images by painting and drawing on them, combining them in composites, or rephotographing and altering them, addresses their "social role . . . in the construction of women's identity and of self-image in general."

The content of much of Hershman's early art, and the strategies of making it, inevitably led to an ambiguity and what must count as a fundamental unreliability at its core. David E. James, whose contribution may be the most theoretically formulated essay in this book, situates her art "within the theoretical parameters of autobiography." But as he speculates on such extremely subjective reveries of the human psyche as "the mutual imbrication of erotic and thanatotic impulses" that are the *stuff* of Hershman's art, he confronts the limits of academic methodology and parlance in dealing with ineffable psychological realities. He acknowledges that Hershman toys with her own credibility; the truthfulness of her autobiographical

art is subjective, revealed through "a repertoire of fantasy roles." Personal identity, in much of Hershman's art, is the central issue, yet its nature is always occluded, its reality never certain.

Often with humor, but more often with a stark chill of anxiety, Hershman has explored issues of identity from a perspective that few other feminists have. It might seem otherwise. In a 1999 interview with Moira Roth, for example, Hershman discussed her interest in the historical figure Ada, Countess of Lovelace, Lord Byron's headstrong and eccentric daughter, the inventor of a codified language that is a forerunner of computer languages, and the subject of Hershman's film *Conceiving Ada* (1997). Hershman found in Ada's life "the idea of being heard, of individual voices, of empowerment, of taking things that hadn't been seen before and making them visible, of making people aware of options in a positive, optimistic way. We all have a power within us to accomplish our dreams." In this vision of personal freedom, free will, and the affirmation of life, Hershman reflects the ideals and beliefs of many feminists—and of many Americans—of her generation and successive ones. Yet her own art demonstrates that freedom and autonomy are neither easy to find nor easy to receive and integrate into a life.

Many of Hershman's peers—Eleanor Antin, Martha Rosler, Linda Montano, Suzanne Lacy, Judy Chicago, and others—more optimistically explored new frontiers of self-realization and social change. Hershman, while consistently and earnestly embracing the ideal, pessimistically—or perhaps more realistically—explored the real-life impediments to attaining those longed-for ideals. She seems, in retrospect, to have positioned herself less as an emboldened ideologue for feminist identity issues than as an astute, if often troubled, counselor—and often a victim—reminding her viewers of the very real damage that can be inflicted by both cultural norms and abnormalities in one's personal and family life. Never a naysayer, Hershman seems to have assumed the moral role of the sentinel, the vigilant one, in the early development of women's art, pointing out real and potential sources of victimization. That role was perhaps inevitable (yet at the same time appropriate and incumbent) for one whose childhood involved regular confrontations with psychological and physical abuse.

This becomes evident in Hershman's career-long preoccupation with concepts of privacy and vulnerability to invasion, particularly in her interactive digital works from the 1990s. In a private conversation, Hershman commented, "As each new technology enters a society, something is sacrificed. Perhaps it is the notion of what privacy means." In today's electronic world, in which information about individuals can be retrieved from vast data banks

CONCEIVING ADA (STILL)
1997, 35 MM FILM

of financial, legal, academic, medical, and every other kind of record, personal destiny and data manipulation may not be mutually exclusive. "Identity theft" as an economic crime is already commonplace. Public agencies and businesses erect electronic "fire walls" to protect their electronic domains from mischievous hackers and political terrorists. Internet stalkers and sexual predators are hardly even newsworthy anymore. Is it really so improbable that someone might use the Internet not just voyeuristically, but malevolently, to invade or "possess" another individual with malignant intent? The possibility may be more than mere paranoiac musing. Hershman, however, explores cyberspace and populates it with cyborgs to investigate, metaphorically and poetically, the psychology of manipulation and invasion.

Cyberspace is omnipresent (to those who have access to it), and its space can be shared by any number of visitors; whoever has a voice or presence there has a potentially unlimited audience—which is a very different circumstance from Hershman's earliest public sallies. In his essay "Lynn Hershman: Animating the Network," Steve Dietz convincingly describes the evolution of her artistic form, tracing it from lone utterance (repressed by "pharisee curators") in *Self-Portrait as Another Person* (1969, p. 22) to interactive communication on a limitless (and potentially omniconnected) digital network in *Time and Time Again* (1999). Along the way came "the first site-specific artwork," *The Dante Hotel;* the *Roberta Breitmore* performance project; Hershman's "video revelations" in *The Electronic Diaries* (1986–); and the first artist-produced laser disc, *Lorna* (1983–84). Dietz relates Hershman's symbiotic engagement of innovative cyberforms to Marshall McLuhan's conception of the network as an extension of the human nervous system into expanded space and compressed (instantaneous) time. Despite the buoyant and ever-larger embrace of technique, form, and forum in Hershman's works, however, old problems and new menaces informed her cyberart.

Hershman's computer-aided interactive installations of the early and mid-1990s marked a dramatic turn in her artistic strategies and the psychological content of her art. While in earlier works Hershman had often investigated issues of personal vulnerability and victimhood, in these works there is a determined mood of resistance and rebellion. In *Room of One's Own* (1990–93), for example, the viewer peers voyeuristically into a miniaturized bedroom environment at digitized representations of its female inhabitant (plate 9); the viewer's eye movements activate sensors that precipitate a variety of suggestive actions. But it is we as viewers who are virtually ambushed as Hershman, using video technology, situates us in the visual field of action and throws our gaze back upon ourselves, surprising us and, presumably, confronting us with our guilt. Similarly, in *America's Finest* (1994–95) we look through the gun

sight of an M16 rifle (p. 84), only to discover that we ourselves are the target. *Paranoid Mirror* (1995–96) similarly implicates the spectator into the video-projected images of women who protest the viewer's looking at them (p. 134).

In her essay "Conscientious Objectification: Lynn Hershman's *Paranoid Mirror*," Abigail Solomon-Godeau explores the feminist concept of "the male gaze"—that is, the historically male-dominated conventions of representing women's bodies as a form of subjugation and voyeuristic invasion—in Hershman's art. Because the capacity to distinguish the self and others and to have relationships with others is founded upon the perception of a discrete self, "looking, seeing, and being looked at," Solomon-Godeau argues, are "profoundly social" and "culturally variable" activities. In manipulating the domain of vision and visuality, Hershman exacts at least a measure of virtual retribution for the subjugation that she exposes and redeploys in her art. No longer willing to remain the colonized victim of invidious and sinister influences, Hershman issues a pugnacious declaration of independence in her interactive cyberart.

But if this is the *ideology* of emancipation, it is not yet the *spirit* of emancipation. Hershman's fundamental assumptions during this period were still those of the victim, even if the victim was now able to exact some sort of programmed vengeance on a generic, unwitting perpetrator. Her cyberworks *CybeRoberta* (1995–98), *Tillie, the Telerobotic Doll* (1995–98), *Time and Time Again, Synthia Stock Ticker* (2000–02), and *Agent Ruby* (2002–) all pose gambits for their participants, who (or whose images) are manipulated in ways beyond their control. In *The Difference Engine #3* (1995–98), some participants pass through a virtual space only to end up in "a purgatory" in which their images can be viewed on the Internet but are never released. The motive and desire for inner liberation might have been present in the artist, but the operative motive in her cyberart was still fear and anger. Hershman's abused protagonists or surrogates seem able only to spread abuse, not to resolve it. Thus Hershman herself, still marooned in her own personal purgatory, had not yet matched the technical and ideological trajectory of her highly personal art, as Dietz describes it.

The Internet and virtuality offered Hershman a powerful medium with abundant formal and metaphorical possibilities for her art, but in and of itself that medium does not necessarily lead out of inner turmoil. The gift that autonomy brings is *not* to be enslaved to privacy and secrecy. The innate tension between insularity and social intercourse is played out again and again in Hershman's interactive art of this period, and as in a dream whose narrative does not advance but runs and reruns like a looped tape, the stifling *un*-freedom and victimhood are perpetuated. Jean Gagnon comments on an irony revealed in Hershman's art: that "in our

media-driven world, dominated by 'communication' technologies, the sense of solitude is ever more pervasive" and human interaction has become more virtual than actual. He describes Hershman's art as "phantasmagoric," referring to the early-nineteenth-century theatrical presentation in which ghosts or phantoms appear by means of projected images and other optical illusions, a show "into which one's own desires and fantasies are projected or by which they are engulfed." In such a place, where is the way out?

As fertile and formally expansive as cyberart was for Hershman, it may be that its anonymity, its *mere* virtuality, was a distraction offering only the specter of human engagement and an empty facsimile of retribution. The masks and doubles and poses that had helped Hershman survive her youth and had long been the subject of her art were compounded in her cyberart, the half-truths told by false voices multiplied and disguised. One wonders whether, in the endless cycle of abuse and retaliation in Hershman's art, these voices call convincingly and compellingly enough for forgiveness and redemption. If redemption comes as a state of mind, is it only conferred, as in a state of grace, or can individuals strive for and finally realize it?

In her essay "Double Talk: The Counterstory of Lynn Hershman," Meredith Tromble suggests a strategy that redirected Hershman's artistic development. She agrees with Hilde Lindemann Nelson that identity is a "fluid interaction" between the self and others and that it is often assigned to an individual *by* others. Identity is a narrative, and an often damaging one at that. "But because identity is a narrative, there is the potential to 'repair' the damaged identity by telling new versions of the story to oneself and to others—'counterstories'"—or what Tromble calls Hershman's "double talk," a psychological correlative to the adage that history belongs to those who are privileged to tell it. It is not mere revisionism or propaganda, however; the counterstory is a necessary corrective to one's own (mis)perceptions and those of others. It is reeducation and, in Hershman's case, an education in self-worth. Tromble concludes that "Hershman's oeuvre can be understood as a counterstory told over time with increasing clarity and force. It acts as an effective agent of transformation for Hershman personally and also, potentially, for those who are touched by her art. Through the telling of the counterstory, multiplicity, once a wound and a defense against unbearable reality, becomes a fruitful condition."

Hershman's investigations into identity and its determinants lead inevitably to a consideration of free will and self-determination. Marsha Kinder explores the condition of *agency* in her essay, "A Cinema of Intelligent Agents," on Hershman's two feature-length movies. In Kinder's critique, agency connotes empowerment, or self-empowerment: the desire, the will,

and the wherewithal to make something happen, to achieve an intended result, outside one's self, or to someone else, or even within one's self. She praises Hershman's *auteur*-ship for conceiving her central female characters as "brainy, sexual" women, the kind "who [are] rarely seen on the screen."

Her film *Conceiving Ada* was surely one of her first works to explore what for Hershman was a new frontier of agency and self-empowerment. In this contemporary fable about time travel and replicants, the protagonist, Emmy Coeur, fascinated by Ada, Countess of Lovelace's experiments in coded languages, attempts to re-create Ada as a memory bank made from her DNA molecules. If we can replicate something digitally and put it into the real world, Emmy reasons, "why can't I put something from the real world into digital space?" Emmy's Frankensteinian ambition is to resurrect Ada as a corporeal being, and it is implied that she even thinks of her own daughter, in what could be the ultimate form of child abuse, as a receptacle for Ada's soul. Ada, for her part, recognizes and accepts the limitations of her own humanity and human creation: though she aspired to endow an "engine"—an early computing machine—with a "soul" (her coded language), she acknowledges that the machine is like a harp, designed and constructed with everything it needs to make music except a human spirit.

In accepting limitations as a fact of life, she is wiser than Emmy. Ada protests that she created not merely a language, but a private language, a *secret* language, encrypted and meant to be intelligible only to those intended. She prefers to keep it that way and not to be cloned into the future, and she refuses to "colonize," as she puts it, another human being. The story ends ambiguously, as Ada avers that "the redeeming gift of humanity is the ability of each generation to re-create itself." The camera fades out on Ada's long-departed life and fades into the future, in which both Emmy and her potentially sacrificed daughter go about their lives together peaceably and lovingly. Atypically for Hershman, the fable concludes without victims and with resolution and love.

A similar tale is told in Hershman's visually beautiful film *Teknolust* (2002). Rosetta Stone, a scientist, creates three digital clones, Ruby, Marinne, and Olive, all replicants of her. Rosetta lives vicariously through the clones, having a nearly parasitic dependence on them to live experiences she would scarcely dream of having in her own existence. They in turn have been programmed to depend on a life-sustaining diet of human DNA, which they must extract from the semen of unsuspecting "hosts," whose donations (and the condoms that contained them) Rosetta catalogues. When they are not gathering food, Rosetta keeps the three sisters locked up in their high-tech house.

The dramatic fulcrum of this odd and haunting narrative is the dawning of self-sufficiency, or autonomy, or sovereignty in the newly aroused romantic interests and imaginations of Ruby, Marinne, and Olive and Rosetta's reluctant but loving relinquishing of her control over them. Rather than lose paradise, they gain the world and their lives, and all of them, Rosetta included, allow it to happen. If the characters lose anything, it is their ignorance, a sort of blind innocence, which is replaced by something far more affirming. All four become viable, distinct individuals. So the story ends in love and—essentially—birth. *Teknolust* is a comedy, in the true literary sense of the word: it ends happily, with conflicts resolved and a satisfying sense of order. Finally there is redemption in Hershman's art. As B. Ruby Rich observes in her essay "My Other, My Self: Lynn Hershman and the Reinvention of the Golem," Hershman's oeuvre has been a process of "detoxification" and moving out of harm's way: "That she did so in life has made her a survivor; that she figured out what to do with that survival, and how to transform it, has made her an artist."

Teknolust is a contemporary science-fiction tale, a narrative inquiry into the nature of identity. The clear message is that *who* we are, *what* we are, is wrought by encoded information as much as it is motivated by desire, dreams, aspiration, or free will. The very name of the central figure, Rosetta Stone, announces the theme of encoding, and it is the task of her cloned progeny to decipher their selves, to discern their own differences, out of their common essence.

The extent to which individuals are the products of codes poses a threat to our belief in volition and free will. What we are as a species—our fundamental biological *sort*, our limits and potentials—is determined by DNA, the genetic code. Our specific personal make-up is encoded in the particular mix of genes we inherit from our parents. Each of us has encoded or inborn personality traits that we evince as behavior patterns in infancy even before we have language or the ability to comprehend experience. The attitudes, ideas, and values that we develop over a lifetime are themselves codes of behavior. Society, culture, and tradition imbue us with their codes. Each of us is required to live by ethical and legal codes. What are the boundaries of the self? Where does individual sovereignty yield? Where does colonization begin?

These questions may be asked, but they cannot be answered. Codes and colonization exist for all of us. When Rosetta, Ruby, Marinne, and Olive put aside their fatal uniformity and choose to live with trust and faith in their mutual otherness, they each gain their own life.

For nearly four decades, Hershman's art has been about concealing identity and projecting it. It is also about trading, simulating, protecting, and sharing identity. Finally, it is about ac-

cepting identity. In its protean, still-evolving forms, Hershman's art constantly treads some middle ground between being and becoming, between self-awareness and self-realization. In this it is a metaphor for human consciousness itself. Consciousness is never quite "real" and scientifically verifiable, and *what* an individual thinks, perceives, ascribes to fact, or settles on as belief is woefully beyond certification. Thought perpetually dissipates into a vapor of virtually indefinable hunches and shifting impressions, and language—reflexive consciousness itself—finally resolves itself to a dew. Lynn Hershman's art, at its most idealistic and optimistic, attempts to reify those vague assumptions, the sensuous impressions and mnemonic illusions on which we base our moment-to-moment experience of the world. Acknowledging the frailty of comprehension, she aspires to clarify what we are doing in the world at any given moment. It is her dream to make it intelligible.

According to a national database, there are several people in the United States named Lynn Hershman. For example, Lynn Hershman was born November 14, 1949, in Connecticut and died February 19, 1976. Lynn Hershman also lives in Rancho Palos Verdes, California; Manteca, California; and Phoenix, Arizona. I am none of the above.

Simultaneously with compiling this book, I hired Jayson Wechter, a licensed private eye, to excavate as many public records as possible about Lynn Hershman. I wanted to determine if, indeed, a private I existed.

Within a very short time, Jayson sent me a virtual archaeology of my history, culled from the calculated perspective of collected data. He easily exhumed my divorce records and the median income of my neighbors, as well as my debts and those of the previous occupant of my apartment. I hardly recognized myself in his portrait of annotated microfacts crunched into numbers and categories.

Jayson also secretly tailed me. This is his surveillance report on my activities for October 20, 1999.

Sub rosa surveillance, Lynn Hershman

Subject can be described as 50- to 55-year-old Caucasian American female 5'7" to 5'9", 180 to 200 pounds, fair skin with full, nicely coiffed, wavy light brown hair with strawberry highlights cascading just below her shoulders. Subject wore black loose slacks with matching black untailored jacket over dark top with black flats. Subject carried what appeared to be a paper notebook in her left hand and a small black shoulder bag. Subject wore tinted eyeglasses or sunglasses with gold frames. Subject appeared to be well-groomed, healthy, and alert. Subject walked with a light "shuffle" or waddle; subject can be described as having a somewhat halting gait. Subject stoops slightly.

Subject walked north on Taylor Street, crossed Sacramento, crossed Taylor, and walked into the Nob Hill Cafe. Investigator's view of café temporarily blocked by construction truck, and investigator unable to observe if subject met someone immediately outside café prior to entering. Subject remained inside café and out of view of investigator. 2:25 p.m. Investigator returned to office.

Capture systems are endemic to our society. Jayson's data snap was a compilation of compressed statistics gleaned from partial and shifting information. Paradoxically, the portrait that emerged from his culled records obscured my identity beyond recognition. Modern technologies designed to extract and re-author privacy are an implicit part of contemporary reality, but they seductively incite opportunities for dangerous illusions. Particularly treacherous are assumptions drawn when the "i" of an "i"ndividual diminishes, subsumed into classified anonymity.

When I was attempting to grow up, my "bedroom" was a well-traveled hallway between the kitchen and the bathroom. I often felt like a lowercase "i" who longed for both privacy and visibility. The pursuit of autonomy became my life's work. Eventually, through persistence and vigilance, I became my own witness and my own private "I."

The following timeline draws on public records and private thoughts to describe artworks created between 1958 and 2005. It presents a skeletal public point of view fleshed out through personal anecdotes. Though I use diverse media in my work, the permutations of identity and the interplay of gender, bodies, and machines have been consistent themes.

Most descriptions of projects remain intact, preserved as they were originally written. I did not hide the scars, the breath, or the dreams. Dreaming is a risky business. It is this private I's secret weapon. Even now, as I write this, I am tempted to ratchet the scope wider. After all, why dream small?

LYNN AND ROBERTA (ROBERTA BREITMORE SERIES)
1977, GELATIN SILVER PRINT, 8 × 10 INCHES

$\begin{bmatrix} \textbf{EARLY WORK} \end{bmatrix}$

DRAWINGS, COLLAGES, PAINTINGS

1958-72 / **INVESTIGATION:** THE INTEGRATION OF HUMANS AND MACHINES IN LINE DRAWINGS, WATERCOLOR, AND COLLAGE

I drew before I could talk. What I had to say was most directly communicated through my art. Consequently, I produced thousands of drawings, collages, and paintings. In my late teens, depiction of women became my primary focus. I added mirrors and reflective materials for faces of collages, exposed internal fictitious biological systems in paintings, and manipulated drawn bodies by crushing paper and squeezing the wrinkled surfaces into photocopiers. Even these early works anticipate the integration of humans with machines and forecast the emergence of techno human identity (plate 1).

SCULPTURE

1963-74 / **INVESTIGATION:** RECYCLABLE MODULAR HUMAN BODY CASTS WITH FOUND MATERIALS

In the early 1960s I cast a series of wax body parts. Separate modular body fragments had the capacity to be recycled into multiple dynamic forms. They were continuously enhanced through paint, cosmetics, wigs, and sound and finally placed into appropriated environments.

PERFORMANCES / INSTALLATIONS

When real objects are artificially inserted into real environments, they simultaneously become simulated symbols that function as virtual reality. —LYNN HERSHMAN, 1968

PRUDENCE JURIS, HERBERT GOODE, GAY ABANDON

1968-72 / **INVESTIGATION:** THE EFFECT OF THREE SIMULATED ART CRITICS ON PUBLIC OPINION

To complete my master's thesis, I wrote art reviews and essays under three pseudonyms: Prudence Juris, Herbert Goode, and Gay Abandon. One pseudo critic had a column in a local paper and was an editor at *Artweek;* another wrote for national art magazines; and the third freelanced for several European journals.

PRIVATE I The frustration of being a young female artist who lacked critical validation inspired the invention of fictive critics. For a short time I assumed the identity of three fictional critics who wrote, from several perspectives and in differing styles, about the work of Lynn Hershman in articles subsequently published in local, national, and international journals. With tangible reviews in hand, I was able to garner my first exhibitions and legitimate critical evaluations.

It is essential that artists invent forums for their work, even if it means reframing the context. I believe that historical relevance is part of the process of completing a work. Invisibility is far worse than living as a diminished "i."

PERFORMANCE DINNERS

VARIOUS LOCATIONS / 1970-83 / **DURATION:** APPROXIMATELY 6 HOURS EACH / **INVESTIGATION:** SITE-SPECIFIC CONSUMABLE DINNER PORTRAITS/PERFORMANCES

As presents for close friends, I prepared consumable dinner portraits/performances. Elaborate sets, props, music, menus, and plates were planned for the honored guest. Ceramic dishes were created for each dinner. Some included suicidal cups or plates with protruding porcelain tongues.

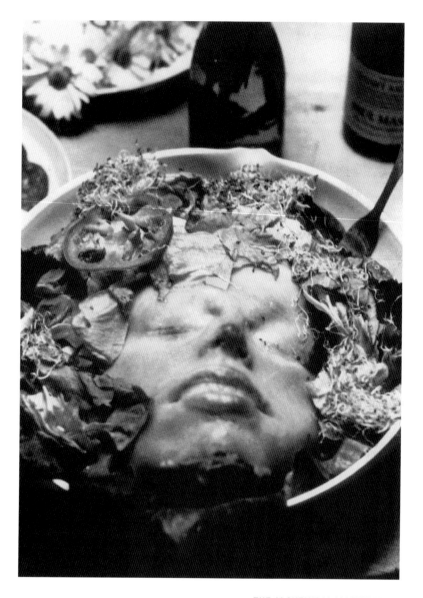

THE ALCHEMICAL MACHINATION
PERFORMANCE DINNER FOR ARTURO SCHWARZ (STILL)
SAN FRANCISCO, NOVEMBER 24, 1976

IMPRISONED EGGS FOR TIMOTHY LEARY

Good cooking is about time and transformation.

Melt three tablespoons of butter in a heavy skillet. Make sure the flame is moderate. Fire must first leave one place before occupying another. When the pan is heated, add bacon and allow to sizzle.

Liberate the eggs. Crack them into a small bowl. Samuel Butler once said that a chicken is only an egg's way of making another egg. Eggs, like prisons, are closed worlds. But with a bit of nudging, the flowing wet internal world can be emancipated and pass from the inner to the outer side of the same fabric. Pour the eggs into the heated skillet.

When the eggs become firm, lift them like feathers and gently place them on a plate so they look like eyes, pleading to be eaten. Arrange the bacon vertically like prison bars. Add cut strawberries for hair and brioche for ears. Serve hot with a SMILE. [1]

DINNER BY DANIEL SPOERRI

Daniel Spoerri invited me to his meal/performance for fifty art patrons at the Elaine Ganz Gallery in San Francisco. The entire meal he prepared was blue, from the soup to the chicken to the pie. Everything was sublime until he mashed his blue meringue pie into the face of the chairman of the board of the local art school and threw the blue wine, still in glasses, onto the wall. As the glasses broke, the wine dripped down the wall like tears. People tried to restrain him, but he was very strong, having once been an athlete. When there was nothing more to break and the guests had scurried to safety outside the building, Daniel asked me to drive him back to his apartment. He whistled happily as we drove, as if nothing unusual had occurred.

The next day I received an angry phone call from the owner of the gallery where the dinner had occurred, informing me that several tons of ice had been dropped off in front of the door, preventing anyone from entering the gallery until the ice melted. The driver had given my name as the person who had placed the order, but it was really one of Daniel's jokes—his way of making me an accomplice.

The dinner for Arturo Schwarz to celebrate the publication of his book *The Alchemical Imagination* featured chemical beakers and flasks in which goldfish swam freely. Guests' names were stamped on satin ribbons wrapped around engraved menus that had been printed in lead gray but were transformed to gold as they oxidized in air. Large test tubes bubbling with "Black Magic Shrimp Soup" warmed on Bunsen burners. Two teenage lab assistants (my daughter, Dawn, and her friend Jenny) served the bottle-rack chicken called "The Bird Stripped Bare," a pun referring to Duchamp's famous artwork *The Bride Stripped Bare by Her Bachelors, Even*. "Head Salad" featured a wax head (cast from my own) surrounded by "hair" of wild uncut romaine lettuce and fresh violets and mushrooms. "Herb Bachelor's Even" completed the meal.

THE DANTE HOTEL

SAN FRANCISCO, CALIFORNIA / NOVEMBER 30, 1973-AUGUST 31, 1974 / **DURATION:** 9 MONTHS; OPEN 24 HOURS A DAY / **MATERIALS:** INDIGENOUS OBJECTS, WAX FIGURES, AUDIOTAPES / **DOCUMENTATION:** CATALOGUE, VIDEO, PHOTOGRAPHS / **INVESTIGATION:** A SIMULATED HOTEL ROOM, IN REAL LIFE AND REAL TIME, THAT RECONSTRUCTS FICTIONAL OCCUPANTS THROUGH FRAGMENTS OF THEIR IDENTITY

Eleanor Coppola and I rented two rooms in a run-down hotel in the Italian section of San Francisco. Visitors entered the building, signed in at the desk, and received keys to the rooms. Residents of this transient hotel became part of the exhibition.[2]

My room, number forty-seven, re-created the ambience of presumed former inhabitants. I used materials gathered from the neighborhood, including books, eyeglasses, cosmetics, and clothing, all clues to their identity (plate 2). A radio broadcast of local news played as a counterpart to amplified breathing emitted by a speaker under the bed. Pink and yellow lightbulbs draped shadows over two life-size wax cast women in bed. Above them was wallpaper made of repeated photographs of the room itself.

Eleanor kept her room, number forty-three, open for one week. She hired a friend, Tony Dingman, to live in the room, and he agreed to be "observed" by visitors. Polaroid shots of the objects in the room showing the subtle changes made through time were taped to the wall.

My room was intended to be permanently open, twenty-four hours a day. Changes in the environment, such as accumulated dust, were incorporated into the installation. However, nine months after the exhibition opened, a man named Owen Moore visited the rooms at 3:00 A.M. Thinking the wax bodies were corpses, he phoned the police. The police arrived and took all the elements, including the wax heads, back to central headquarters, where they still remain to be claimed.

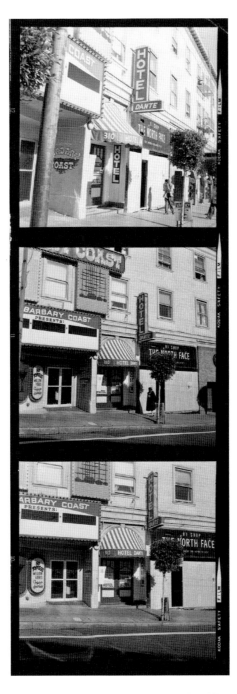

THE DANTE HOTEL

SAN FRANCISCO, 1973. PHOTO: EDMUND SHEA

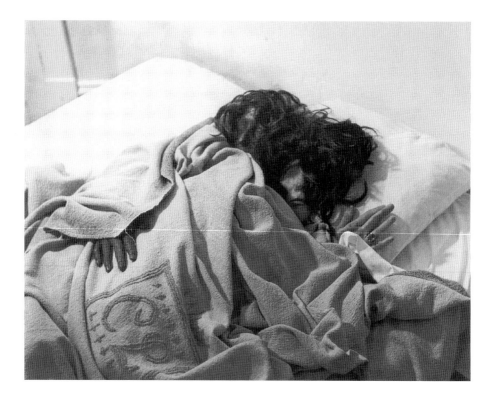

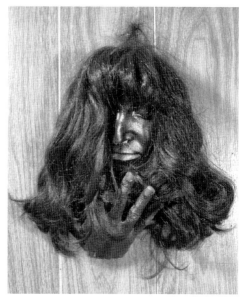

THE DANTE HOTEL
(DETAIL OF OCCUPANTS OF ROOM 47)
SAN FRANCISCO, 1973-74. PHOTO: EDMUND SHEA

SELF-PORTRAIT AS ANOTHER PERSON
1969, WAX, COSMETICS, WIG, AND SOUND, LIFE-SIZE

Hundreds of people trespassed in the rooms during the nine months they existed. The *San Francisco Chronicle* ranked it as one of the Bay Area's ten most important fine-art exhibitions of 1973.

PRIVATE I I lived in Berkeley during the Free Speech Movement. The ideals of the time poured into my own unformed psychological armature, subtly radicalizing both me and my work.

When the University Art Museum's funding was threatened because of its failure to exhibit work by women artists, I was one of three women invited to have an exhibition. My installation included a simulated hotel room, complete with found objects, sheets, audiotapes of breathing, and cast-wax figures. Another work, *Self Portrait as Another Person* (1969), was cast from my own face, dyed black, and given its own wig and makeup. This piece included sensors that triggered a pre-recorded audiotape of random provocative dialogue when visitors approached it. Unfortunately, the curators insisted that sound media was not appropriate material for an art museum and closed the exhibition.

I realized that instead of bringing the hotel room to the museum, it might be more appropriate to simply work in the context of a "real" hotel room. I discussed the idea with Eleanor Coppola, whom I had met when we were arranging a carpool for our then two-year-old children. This conversation sparked the idea for the hotel room. Similar in spirit to Duchamp's readymades, *The Dante Hotel* functioned as a "found environment."

No critical language for site-specific art existed at the time, which led me to self-publish a catalogue describing the premise and the process.

CHRISTO AND JEANNE-CLAUDE'S *RUNNING FENCE*

1974-76 / **INVESTIGATION:** THE ARTISTS CHRISTO AND JEANNE-CLAUDE'S PROJECT TO CREATE A MASSIVE SITE-SPECIFIC INSTALLATION IN NORTHERN CALIFORNIA

I was the associate project director for the construction of Christo and Jeanne-Claude's massive site-specific installation *Running Fence, Sonoma and Marin Counties, 1972–1976*, which stretched twenty-three miles between Petaluma, California, and the Pacific Coast. The temporary installation was a complex collaboration between artists, farmers, attorneys, engineers, and environmentalists.

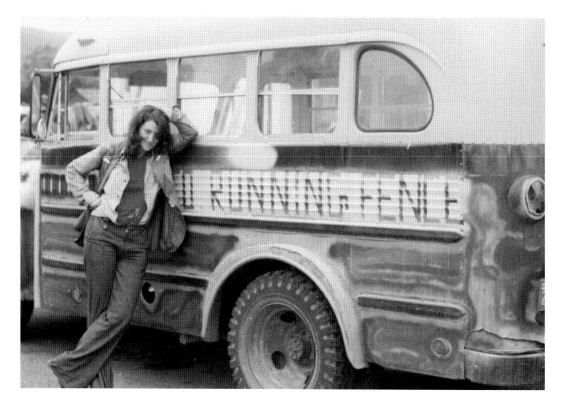

LYNN HERSHMAN LEANING ON *RUNNING FENCE* **BUS**
1976

PRIVATE I I met Christo and Jeanne-Claude through Peter Selz shortly after I had installed *The Dante Hotel*. They hired Peter to oversee the *Running Fence* project, which was originally planned to take only a few months. As he was scheduled to travel extensively during this period, I was hired to oversee things in his absence. The experience was exhilarating. I learned about scale, persistence, and organization. The project was more complex than anyone had envisioned, eventually taking nearly four years to complete, as well as twenty-three public hearings and the work of hundreds of experts in diverse fields.

ROBERTA BREITMORE

1974-78 / **DURATION:** 4 YEARS / **EXORCISM/PERFORMANCE:** NOVEMBER 1978 / **DOCUMENTATION:** DRAWINGS, PHOTOGRAPHS, SURVEILLANCE REPORTS AND SLIDES, FILM, COMICS, LETTERS, LEGAL AND MEDICAL DOCUMENTS, AND OTHER ARTIFACTS / **INVESTIGATION:** A SIMULATED PERSON WHO INTERACTS WITH REAL LIFE IN REAL TIME

Besides bending reality to create Roberta Breitmore, Hershman has more significantly demolished the barriers separating theater, literature, painting, photography, and conceptualism. This creative demolition may be the most promising movement in the arts today. —ROBERT ATKINS

Roberta was a private performance about the construction of a fictional person who existed in real time. Roberta's background, including her education and early childhood traumas, was composited from accumulated stereotyped psychological data. Her simulated history guided her behavior and choices.

Traditional portraiture seeks to reveal the truth of an individual's character and likeness through a stable medium like paint or photography. Roberta's persona, however, was animated through the application of cosmetics, applied to a face as if it were a canvas, as well as through her participation in real-life adventures.

Photographs of Roberta were also manipulated using overlaid text, paint, or the ephemeral and unstable medium of cosmetics (plates 3–4).

Roberta saw a psychiatrist, used a specific language, had unique handwriting, and secured credit cards, a checking account, and a driver's license. She maintained a small apartment, had her own clothing, and participated in the culture and trends of her time, like Weight Watchers and EST (Erhard Seminars Training). Surveillance photographs, artifacts, and discarded ephemera captured Roberta's experience and later provided credible proof that she existed.

Roberta was "born" into reality when she arrived in San Francisco on a Greyhound bus and checked into the Dante Hotel. She carried in cash her entire life savings of $1,800.

After arriving in San Francisco, Roberta placed an ad for a roommate in a local newspaper. People who answered her ad became unwitting participants in her adventures and thereby a part of her fiction, just as Roberta became a part of their reality. Roberta accumulated forty-three letters from respondents to her ads, sent by lonely people looking for a friend.

Roberta lived through twenty-seven independent adventures, the most dangerous of which was being recruited for a prostitution ring that answered her ad. To escape the pimp sent to entice Roberta into a life of vice, she transformed into "Lynn" in a public restroom at the San Diego Zoo and escaped unrecognized.

In her third year of life, Roberta's adventures became so complex and negative that she multiplied herself (plate 5). Eventually, four different people performed as Roberta. Multiples zipped themselves into Roberta-like clothing and led their own series of adventures. They followed a similar progression into increasingly negative experiences and feelings of alienation. Through this process, Roberta and her multiples revealed what it was like for a single woman to forage for herself in the San Francisco Bay Area during those tumultuous years of societal change.

Roberta's trail through time was converted into a comic book story illustrated by Spain Rodriguez, a Zap comic artist. All the elements of this comic story are "real." The individuals depicted in the police lineup in the story are characterizations of people Lynn felt had taken advantage of her during this period of her life.

Roberta was finally exorcised in a 1978 performance held at the Palazzo dei Diamanti in Ferrara, Italy. Only her artifacts, ashes, and effects remain as evidence of the veracity of her life.

PRIVATE I The implications of assuming Roberta's identity didn't become clear to me for a decade. Ingested experience never really ends, but rather hovers inside like a bat, fanning its wings in your psyche. Roberta's traumas became my own haunting memories. They would surface with no warning, with no relief. I was never free of her. She was buried deep within my being, and her skin was closest to my heart. The negativity in her life affected my own decisions.

Several times I left my house as Roberta, forgot something, and had to return in "Roberta" costume and makeup, which was a continual annoyance to my then eleven-year-old daughter. Roberta's most difficult task was staying in character during her psychiatric sessions. Lynn was going through her own agonizing identity crisis and pending divorce and did not want to

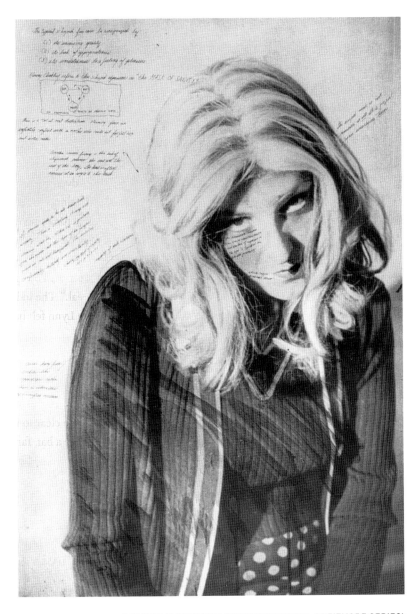

ROBERTA'S PHYSICAL STANCE (ROBERTA BREITMORE SERIES)
1976, C PRINT WITH ACRYLIC AND INK, 40 × 30 INCHES

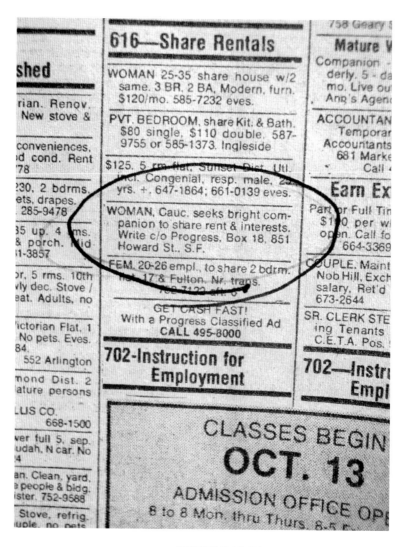

ROBERTA'S AD (ROBERTA BREITMORE SERIES)
AD IN *SAN FRANCISCO PROGRESS*, SEPTEMBER 24, 1975

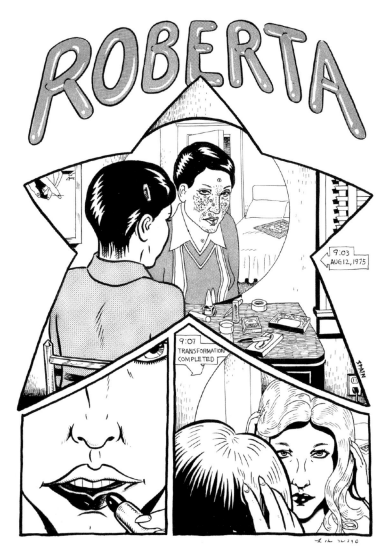

"ROBERTA'S TRANSFORMATION" (*ROBERTA BREITMORE COMICS*, PAGE 1)

DRAWN BY SPAIN RODRIGUEZ, 1977

ROBERTA'S EXORCISM, 1978 LUCREZIA BORGIA'S CRYPT, PALAZZO DEI DIAMANTI, FERRARA, ITALY

The Palazzo dei Diamanti, the museum of modern art in Ferrara, Italy, where Roberta was to be exorcised, was erected over the crypt of Lucrezia Borgia. After she married her fourth husband, the Duke of Ferrara, Borgia's reputation for murder, promiscuity, and political crimes radically changed. In the second half of her life she was a devoted patron of the arts.

Borgia, like Roberta, suffered from the trauma of early incestuous relationships. Four and a half centuries after Borgia's interment, her myth provided the psychological drapery for Roberta's transformation.

Kristine Stiles was the first of Roberta's multiples. In the quaint village of Ferrara, we found a charming outdoor café that featured two identical glass vases decorated with a diamond pattern, precise replicas of objects that I had drawn while planning the exorcism. These objects became props in the performance.

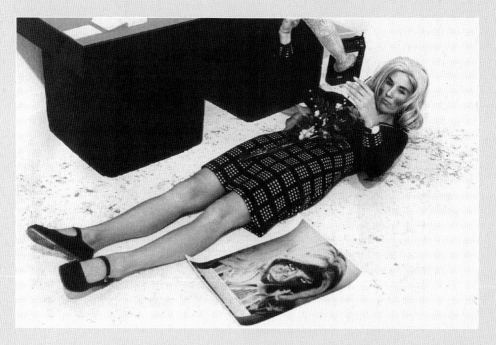

ROBERTA MULTIPLE IN EXORCISM RITUAL (ROBERTA BREITMORE SERIES)
1978, GELATIN SILVER PRINT, 16 × 20 INCHES. PHOTO: MARION GRAY

I placed two identical pedestals on either side of the archway dividing the Palazzo dei Diamanti's exhibition space. Each supported one of the identical vases, but one of the vases held real flowers while the other held artificial blossoms, creating the illusion that the archway was divided by a mirror, with reality on one side and artifice on the other.

The performance began when a Roberta multiple entered the gallery and began a subtle emotive dance using Roberta's body language and gestures. Each movement emphasized disillusionment with life. Tape recordings of artificial tones that had been constructed from the shuffling sounds of her walk set the tempo. She slithered toward a chart with diagrams detailing her construction, pacing backward and forward until, in an unexpected thrust of motion, she twirled into the archway and removed the vase with artificial flowers from its pedestal, leaving the other untouched.

The multiple carried the vase to her construction chart, jerking her body as if a demonic spirit possessed her. Before anyone could stop her, she set one of the photographs on fire. It burned quickly. Ashes were retrieved and placed in the vase, transforming it into a vial. The burning image filled the room very slowly with gray smoke, as if ink had been dropped into the clear air, saturating it with deep, pungent color.

Roberta's multiple then stretched out her body next to a coffinlike vitrine that held the relics of her life. As Roberta froze into her final position, witnesses of the event left the room. Before the ceremony, Roberta had been a sculptural life/theater performance, a sociopsychological portrait. The exorcism and subsequent transformation through fire, water, air, and earth, from white to red to gray to black—the rebirth out of the ashes—represented a symbolic invocation that uncannily would unfold into my own life, irrevocably changing its direction.

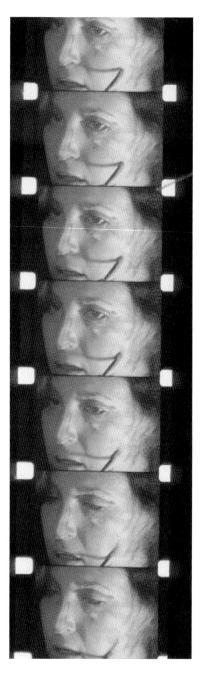

ELEANOR COPPOLA,
STILLS FROM *CONSTRUCTING ROBERTA*
1974, 16 MM FILM

squander precious therapy on fictional trauma when she was dealing with her own real-life drama. Yet in critical moments Roberta always prevailed. Lynn was left to find solace on her own.

In the 1970s very few people understood the conceptual basis for creating a virtual or simulated persona. Roberta represented a fractured identity that both mirrored and reflected her society.

Roberta was an interactive vehicle used to analyze culture. Symbols from real life framed Roberta's identity, just as they did for the characters in *The Dante Hotel* and *Lady Luck: A Double Portrait of Las Vegas* (see below). The act of observation was an implicit part of each character's construction. The fictional occupants of the Dante Hotel were trapped, encased with their artifacts for witnesses to discover. Lady Luck reenacted the myth of chance in a casino observed by an audience of participants. Similarly, Roberta transcended limitations of a predetermined time frame and enacted chance adventures spawned from real life.

Roberta Breitmore's name derived from a Joyce Carol Oates short story about a woman who tracks celebrities through letters she places in a newspaper.[3] She is like a black hole, a burned-out star.

In 1970 André Breton's *Nadja* was my designated airplane reading on my first trip to Europe. In Edinburgh I had the good fortune to see and become deeply moved by the starkly stunning style of Jerzy Grotowski's live theater. That summer I met and appeared on panels with Tadeusz Kantor and Joseph Beuys. The works of Bertolt Brecht and Antonin Artaud were read after I returned to the United States. These influences shaped Roberta's gestating skeletal construction.

In retrospect, I believe Roberta and I were linked. Roberta represented part of me as surely as we all have within us an underside—a dark, shadowy cadaver that is the gnawing decay of our bodies, the sustaining growth of death that we try with pathetic illusion to camouflage. To me, she was my own flipped effigy: my physical reverse. She exposed my fears. As can be inferred by both our records, her life infected mine. Closure and transformation of her life would surely encourage my own individuation. Eventually, I no longer needed to define my life through her.

During Roberta's life span, I became friends with the filmmaker Wim Wenders, who moved to San Francisco, took a hotel room on Post Street, and developed the script for his film *Hammett*, about the author of *The Thin Man*. I thought of Roberta as "The Fat Woman." She avariciously consumed life.

The cure for Roberta's negative spiral was a ritualistic exorcism. I hoped not only to liberate Roberta from oppression, but metaphorically to free other wounded women who suffered as deeply as Roberta. "Metaphor" derives from the Greek for "to move on."

FORMING A SCULPTURE DRAMA IN MANHATTAN

HOTEL CHELSEA, THE PLAZA, AND CENTRAL YWCA, NEW YORK, NEW YORK / OCTOBER 21-DECEMBER 16, 1974 (HOTEL CHELSEA), NOVEMBER 2-3, 1974 (THE PLAZA), OCTOBER 27-31, 1974 (CENTRAL YWCA) / **DOCUMENTATION:** CATALOGUE, PHOTOGRAPHS, TELEVISION COMMERCIALS / **INVESTIGATION:** THREE SIMULTANEOUS, DISPERSED SITE-SPECIFIC INSTALLATIONS WITH INTERTWINED NARRATIVES

Three hotel rooms were conceptually linked through a fictional narrative about three women who simultaneously arrived in New York and checked into separate rooms.

Each installation incorporated clues that illuminated the fictional occupant's identity, such as smells, sounds, and clothing. By trespassing into these intimate spaces, spectators participated in and became part of the work itself. All materials for each installation were indigenous to the surrounding neighborhood, thereby creating a portrait of each community. "Real" letters, books, and eyeglasses became simulated icons and metaprops for the identity and context of people frozen in time. A bus was hired to transport viewers between the three locations.

In order to publicize the temporary installations, I created television commercials that were broadcast on ABC. More people saw the commercials than the hotel rooms themselves. The commercials were, for me, electronic haiku that could, in less than a minute, impart the essence of the event. Because the installations were ephemeral and transient, the only substantive records that remain are relics, photographs, and the videotaped commercials.

HOTEL CHELSEA: ROOM 111

I employed a woman to live at the Hotel Chelsea. I paid for the room, and in exchange she agreed to allow visitors to trespass in her space any time, day or night. If she left the room, the key was to be available at the front desk.

I made two wax casts of her face, and I used wax coloring to create a white woman and a black woman. The wax figures were placed in the room, surrounded by indigenous paraphernalia purchased from the neighborhood. The items in the room reflected the sociological and economic quality of the neighborhood. Placing a frozen tableau in one part of the room intensified the constantly fluctuating elements of real life.

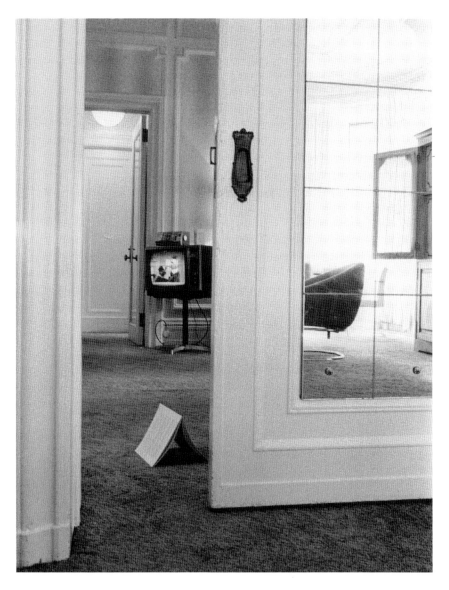

FORMING A SCULPTURE DRAMA IN MANHATTAN
THE PLAZA, NEW YORK, 1974, INDIGENOUS OBJECTS. PHOTO: G. LESTER

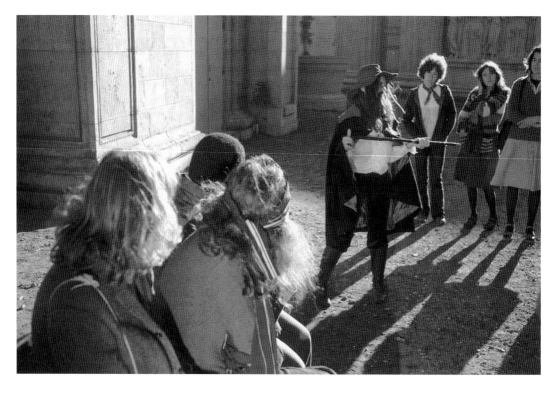

ELEANOR ANTIN'S *THE BATTLE OF THE BLUFFS*

SPONSORED BY THE FLOATING MUSEUM. PALACE OF FINE ARTS, SAN FRANCISCO, 1975, PERFORMANCE

I signed a year's lease for the room, but within two weeks the woman experienced anxiety at being subjected to voyeuristic scrutiny. We closed the room to the public a few days later.

THE PLAZA: ROOM 903

Reenacting the Eloise mythology, toys and games were scattered on the floor of a hotel room at the Plaza. Cartoons showed on two television sets, and music from *Alice in Wonderland* played continually, creating the feeling that a child had just been there. The sound of running bathwater drew spectators through the space.

CENTRAL YWCA

The installation incorporated a male mannequin, wrapped in plastic and then shrouded by another, heavier plastic sheath, standing over an enigmatic female form that appeared to sleep in the bed. Plastic was stretched over the entrance to the room, obscuring the view and protecting the room from penetration.

The exhibition ended two days later, when a well-meaning maid "cleaned the environment," efficiently making the bed and wrapping the elements in brown paper and storing them in a lobby closet.

PRIVATE I On the surface, the project was a failure. Each room ended abruptly, and, without a critical language for site-specific installations, the rooms did not fit into any pre-existing art historical frame. However, the idea of three separate identities linked through the convergence and collapse of time was a critical conceptual evolution toward future interactive modular pieces.

THE FLOATING MUSEUM

SAN FRANCISCO, ITALY, AND FRANCE / 1974-78 / **DURATION:** 4 YEARS / **INVESTIGATION:** ORGANIZATION TO COMMISSION AND EXHIBIT PUBLIC, SITE-SPECIFIC, AND NONTRADITIONAL ART FORMS

The Floating Museum was a model for exhibiting public and site-specific art. It was the first organization to commission artists to create installations in outdoor environments such as rural landscapes, public buildings, city streets, and prison courtyards, and in nonspace, using sound and airwaves. Artists were encouraged to use nontraditional art forms, such as video, performance, and environmental installations, or traditional media in nontraditional locations, such as chalk drawings on sidewalks or a mural on a prison wall.

Several genres supported by the Floating Museum, including comic drawings, experimental photography, and performance art, were not yet considered legitimate art forms.[5] Each project was unique and required a melding of divergent attitudes from individuals in differing specialties, such as architects, park officials, sound engineers, and needlepoint storeowners. The projects aimed to promote education by communicating ideas through mass-media systems, including television, billboards, posters, and newspapers; to encourage creatively inspired recycling by using existing resources, space, and materials; and to support experimentation with performance and reception by presenting art to people in the context of their daily lives.

As the name suggests, the Floating Museum had no permanent walls. Except for a mural created on the walls of San Quentin prison, all of the projects were temporary. The organization provided support for artists in three principal ways: fees for honoraria and materials, permits for the temporary use of public space, and communication about the projects through public media services. It was designed to last only three years. Overhead consisted of costs for stationery and a telephone. It was supported primarily by individual memberships and benefits. A punk rock concert performed by Jane Dornacher and Leila and the Snakes, where we auctioned off everything from artists' works to a night with both Mr. California and Ms. World, raised funds for artists' fees and airfares.

MURAL IN SAN QUENTIN PRISON

SAN QUENTIN, CALIFORNIA / SEPTEMBER 1974-JULY 1976 / OPENING/PERFORMANCE: JULY 14, 1976 / DURATION: 20 YEARS / MATERIALS: PAINT, PRISON WALL / DOCUMENTATION: CATALOGUE, PHOTOGRAPHS / SPONSOR: THE FLOATING MUSEUM / INVESTIGATION: A PRISON AS A SITE FOR ART

We are getting dozens of murals, but the one at San Quentin may be the best. The NEA has seldom helped anything that fuses artistic and social values so convincingly as this. —ALFRED FRANKENSTEIN

Inmates in San Quentin prison, led by a master muralist, painted a forty-five-by-twenty-eight-foot mural of the landscape beyond the wall in this, the first prison art program in the United States. The once-gray concrete wall, several miles long, outlined the confinement of eight hundred inmates. Blue is the color of hope. The inmates painted the sky first.

PRIVATE I The two-hundred-yard walk to the main gate of the prison was edged on one side by the bay and on the other by a flowering landscape tended by several inmates. On my first visit to the institution, I was required to empty my pockets and purse, step through a metal de-

tector chamber, submit to a hand search, and agree that I was entering at my own risk, acknowledging that, even if taken hostage by an inmate, I would have no protection. After agreeing to these conditions, I passed through three more sets of thick iron gates to another room, where guards, with their rifles cocked, directed me to the prison courtyard. There I met the inmate supervisor, who sat quietly while I explained my idea and plan for the mural.

It was understood that my responsibility would be to raise all the money and to find a master muralist acceptable to both the inmates and the prison staff. Although the warden and the prison supervisor agreed to let me do the project, the logistics were daunting. Paperwork doubled if I wanted to bring in even a pencil, much less an artist, photographer, or painter. The location for the mural was an area just inside the courtyard. It was a "charged" space because it was the site of George Jackson's murder.

I invited Hilaire Dufresne to be the master muralist who would teach techniques to inmates. We organized a design contest through the *San Quentin News*. The selected image was created by an inmate named Midget Rodriguez. It showed the wall covered by a painting of the landscape that was behind it, simultaneously erasing the existing gray wall and substituting the free open countryside for it.

Hilaire worked five days a week teaching eight inmates how to mix paints, fix walls, and project the image. The inmates were paid by the state—the usual eleven cents an hour—but I still had to find the money for Hilaire's salary, equipment, and documentation, which was accomplished by selling bricks from the prison for ten dollars each. Paint was donated. We used a sandblaster that had been sitting unused at the prison.

The inmates treated me with special, protective care and seemed grateful for this program and interest in their cultural well-being.

There is a hierarchy of prisons. San Quentin is considered the most prestigious. Inmates call it Yale. Charles Manson and Sirhan Sirhan were incarcerated there during this period of time. Every inmate tattoos himself as a rite of initiation during prison tenure. Prison officials refer to it as defacing public property. The microidentity manifestations of the inmates were subtle, but very quickly I learned to identify members of the Aryan Brotherhood, the Mexican Mafia, and the Black Muslims by their walk, gestures, and body posture. I would later use this visual articulation of self in the *Roberta Breitmore* project.

The walls around the prison courtyard insulate it like an oven. If the temperature outside is 90 degrees in Marin County, it is 110 degrees in San Quentin. On my birthday, June 17, 1976, eight months after the actual painting had begun, new inmates (called "fish"), dressed in

LYNN HERSHMAN AND MURALIST HILAIRE DUFRESNE (THIRD FROM LEFT) WITH SAN QUENTIN PRISON INMATES
1975. PHOTO: EDMUND SHEA

white, stood by the chapel near the rehabilitation center, watching colors form the mural on the opposite wall.

Inmates painted while standing on scaffolding so close to the top of the wall that they could touch the barbed wire and feel the breath of the guard who aimed a rifle at their heads. "Everyone that stays here puts his mark somewhere inside. This mural, the part I painted, that's my graffiti," Frank Morales called out, waving.

The mural symbolized our "storming of the gates," an exercise where creativity and personal expression were more powerful than violence. When the mural was complete, we celebrated with a dedication of the site. Forty people from the San Francisco art community gathered on Bastille Day, the same day San Quentin was founded, for the ceremony.

In the shrouded light of dusk, the wall was replaced by the painted landscape, a signifier for the hope of freedom. Eventually, other areas inside the prison were covered by paintings. For a while, the mural was part of the San Francisco Museum of Modern Art docent tour.

A year later, I returned to present a rock concert performed by a group called Crime. Their drummer was Henry Rosenthal, who twenty years later produced my film *Conceiving Ada*.

RESTRUCTURING THE PUBLIC IMAGE OF JERRY RUBIN

SAN FRANCISCO, CALIFORNIA / NOVEMBER 1975–APRIL 1980 / **DURATION:** 5 YEARS / **INVESTIGATION:** RECONSTRUCTION OF A PUBLIC MEDIA FIGURE

At the request of Jerry Rubin, I helped to create his visual media transformation. The project was similar to the construction of Roberta Breitmore, but based on Jerry's media identity. Jerry wanted to transform his media image from that of a dangerous revolutionary to a mature, responsible citizen and to show his conversion from Yippie to Yuppie. The reconstruction included redesigning his hair, shaving his sideburns, and changing his clothing style as well as his stance for the camera.

PRIVATE I Jerry and I discussed remaking old news events, captioned with the words "this is not now," as public-service announcements that might be broadcast. We even considered doing a comic strip. Both Jerry and Timothy Leary were experts at media manipulation and understood the power of media images. Timothy, in fact, had several alias identities. The early reconstruction charts and diagrams I developed for Jerry's transformation may have subliminally influenced his decision to move to New York and become a stockbroker.

LADY LUCK: A DOUBLE PORTRAIT OF LAS VEGAS

CIRCUS CIRCUS, LAS VEGAS / MARCH 2, 1975 / **DURATION:** 12 HOURS / **DOCUMENTATION:** CATALOGUE, TELEVISION COMMERCIALS / **INVESTIGATION:** THE AMERICAN MYTHOLOGY OF CHANCE AND LUCK

In this robotic performance about luck, chance, and doubles, an actress and her effigy were each given $1,000 with which to gamble at the roulette table at Circus Circus casino in Las Vegas. The wax figure bet via random prerecorded numbers amplified through speakers embedded in her chest. The actress used her intuition. While the sculpture won $1,640, the actress lost $960.

PRIVATE I In Las Vegas, excess is in excess. The city is a mecca of winged promises that flit slightly out of reach, never out of sight. Las Vegas is timeless. In the casinos, there are no clocks or windows. Outside, dreams tarnish in the afternoon sun as neon signs advance and retreat, pulsating like vibrating electronic afterimages.

I went to Las Vegas in search of the mythical presence of Lady Luck. I imagined her as a cross between Tinkerbell and Glinda, the Good Witch of the North from *The Wizard of Oz*.

I met Lisa Charles working in a high-wire act at Circus Circus casino, and she was married to a man named Charles Charles. She agreed to be doubly cast in the performance as the actress and the robot. She chose her costume, an aqua angora-trimmed dress, and applied her makeup to the sculpture, intensifying their mirror reflections.

Lisa's transformation to Lady Luck began with a television commercial produced for ABC, enticing the mass-media audience to watch the duo gamble. Photographic equipment is usually forbidden in casinos to protect the identity of patrons, but I was able to document this piece with both a 35 mm camera and a video camera. Sixteen art patrons from San Francisco flew to Las Vegas to share in the experience of the performance. Afterward, the group traveled to see Michael Heizer's *Double Negative* in the Nevada desert.

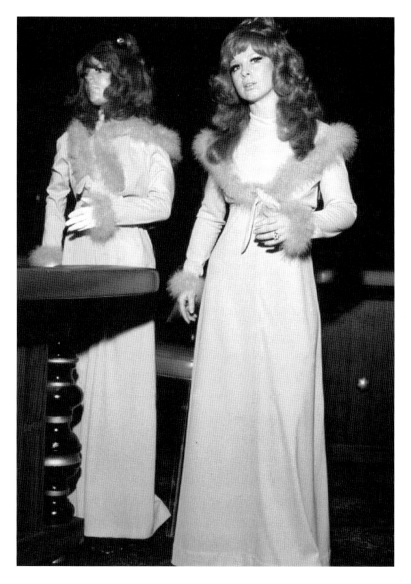

DOUBLE PORTRAIT OF LADY LUCK

1975, C PRINT, 20 × 16 INCHES

RE:FORMING FAMILIAR ENVIRONMENTS

SAN FRANCISCO, CALIFORNIA / MAY 16, 1975 / **DURATION:** 6 HOURS / **DOCUMENTATION:** CATALOGUE, PHOTO-GRAPHS, NEWSPAPER ADS / **INVESTIGATION:** CONSTRUCTION OF SOCIAL RELATIONSHIPS BY MEANS OF A LIVE INTERACTIVE GAME SET IN A PRIVATE HOME

Eleanor Coppola's private home was converted, for six hours, into an environment for a live interactive game. Floor plans describing the rules of the game were prepared. Our goal was to heighten the interaction of the participants, in this case the Los Angeles County Museum of Art Collectors Forum and COYOTE (Call Off Your Old Tired Ethics), a San Francisco sex workers' organization.

Over a closed-circuit video system, Eleanor and I answered questions from the audience, who were in another part of the house. We had hired members of COYOTE to perform in tableaux throughout the house, doing simple everyday tasks such as taking a bath, sleeping, or peeling potatoes. A few prostitutes simulated patrons during the six-hour interaction.

A few weeks later I placed ads in newspapers showing photographs of patrons with members of COYOTE and the caption "Cultural Exchange."

25 WINDOWS: A PORTRAIT OF BONWIT TELLER

NEW YORK, NEW YORK / OCTOBER 28-NOVEMBER 2, 1976 / **DURATION:** 6 DAYS / **DOCUMENTATION:** PHOTOGRAPHS, VIDEOTAPE / **INVESTIGATION:** DEPARTMENT STORE WINDOWS AS A CULTURAL PORTRAIT

During the short-lived era of cultural optimism following the Russian Revolution, poet Mayakovsky proclaimed, "Let us make the street our brushes." Recently, California artist Lynn Hershman attempted to meld issues of art and life within the windows of a large New York department store, marking the first time that a department store collaborated with an artist in such a public way—operating, in effect, as a museum space. Anyone who has followed Lynn Hershman's career knows that there is very little she cannot accomplish. The response is overwhelmingly positive. This may set a precedent for other artists around the country. —JANE BELL

Twenty-five windows of the Bonwit Teller department store were converted into narrative artworks that used such materials as steam, photography, live actors, film, holography, and video, as well as Bonwit Teller mannequins and fashion, to create a cultural portrait of New York (plate 6).

PRIVATE I Joseph Cornell, Andy Warhol, Salvador Dalí, Jasper Johns, and Robert Rauschenberg had all worked in the display department of Bonwit Teller. Their windows sold clothing. Mine recycled indigenous materials to create a portrait of New York.

25 WINDOWS: A PORTRAIT OF BONWIT TELLER (WINDOW #10: CRIMES OF PASSION)
BONWIT TELLER DEPARTMENT STORE, NEW YORK, 1976, MANNEQUINS AND MIRRORS. PHOTO: CHRISTINE HARRIS

25 WINDOWS: A PORTRAIT OF BONWIT TELLER
(DETAIL OF WINDOW #11: SIX-PHASE CATASTROPHE THEORY)
BONWIT TELLER DEPARTMENT STORE, NEW YORK, 1976,
MANNEQUIN AND WINDOW. PHOTO: CHRISTINE HARRIS

An extensive collaboration evolved not only with the Bonwit Teller window display, publicity, and management divisions, but also with physicists, video experts, holographers, designers, futurists, live models, the Metropolitan Transit Authority, and the data consultants Insgroup. Eventually more than three hundred people participated in this project. Like my other "portraits," it was important that all elements of the installation be indigenous to the site. My hope was to create an alternative way in which to integrate art with life.

The process resembled making a movie, but without film. The narrative sequence of time and aging in the windows was like a storyboard or celluloid frames. Ten years later the Bonwit Teller windows inspired the feature film *Lady Beware*.[4]

DREAM WEEKEND

VICTORIA, AUSTRALIA / SEPTEMBER 16-18, 1977 / **DURATION:** 72 HOURS / **MATERIALS:** THREE PROJECT HOMES, SHUTTLE BUS / **INVESTIGATION:** HOW SUBURBAN COMMUNITIES CONTROL AND ALTER IDENTITY

Lynn Hershman uses found environments as the framework for her projects. Her assemblages are provocative and unsettling. She reveals fundamental issues of social behavior and the underlying socioeconomic causes. Ultimately the remarkable power and energy in her work lies in the interaction and interchange between illusion and reality. —GRAZIA GUNN

Residents in a suburban project home in Victoria, Australia, were voyeuristically viewed in their natural habitats. A shuttle bus, complete with hired guide and audio tour, transported visitors to each location. The audio tour encouraged participants to become witnesses to the changing landscape and to use the environment as a site for creative intervention.

The weekend culminated with the escape of a female resident, who climbed onto a rooftop, where she was retrieved by a waiting helicopter and carried across the sky.

PRIVATE I Like the bus tour between the three New York hotels in *Forming a Sculpture Drama in Manhattan*, this piece was about time, duration, and dislocation. It was also a self-created narrative about exile and alienation that unfolded over seventy-two hours.

MYTH AMERICA CORPORATION STOCK CERTIFICATE (FRONT AND BACK)

1979-80

MAMCO: MYTH AMERICA CORPORATION

1979-80 / IN COLLABORATION WITH REA BALDRIDGE / MATERIALS: STOCK PORTFOLIO, LEGAL CONTRACTS / DOCUMEN-
TATION: PHOTOGRAPHS, ARTIFACTS / INVESTIGATION: A SIMULATED CORPORATE STRUCTURE TO FINANCE ARTWORK

Simulating the methodologies and structure of a legitimate corporation, Rea Baldridge and I formed Myth America Corporation. The company logo was comprised of two golden dollar symbols, overlapping as if procreating.

Modeled after the structure Christo and Jeanne-Claude used to raise support for their projects, the piece had shareholders purchase stock in the company. The funds generated were used to create art projects, the most notable of which was the installation in a Palo Alto, California, shopping mall of a giant silver arrow designed by Michelangelo Pistoletto.

FIRE WORKS

1979-83 / INVESTIGATION: SITE-SPECIFIC PERFORMANCES THAT USE SIMULATED FIRE TO PROVOKE PUBLIC ACTION
AND TRANSFORMATION

TWO STORIES BUILDING

SAN FRANCISCO ACADEMY OF ART, SAN FRANCISCO, CALIFORNIA / NOVEMBER 9, 1979 / DURATION: 1 HOUR /
MATERIALS: 16 MM FILM, TWELVE FILM PROJECTORS, TWO LIVE DANCERS, FOG MACHINES / DOCUMEN-
TATION: SLIDES, PHOTOGRAPHS, FILM, NEWS FOOTAGE / SPONSOR: MYTH AMERICA CORPORATION

Images of fire were rear-projected onto the windows of a large downtown building that housed the San Francisco Academy of Art. A fog machine created "smoke," giving an eerie and realistic look to the scene. Dancers leapt out of windows onto the street, "escaping" the celluloid flames. The effect was so successful that a person on the street phoned the fire department. Soon a fire truck, with its sirens blasting, came roaring up to the building. Firemen jumped off, raised ladders, and began to hose the projected images of fire. Fortunately, we had gotten a permit in advance.

ONE STORY BUILDING

PORTLAND CENTER FOR THE VISUAL ARTS, PORTLAND, OREGON / JANUARY 28, 1980 / DURATION: 3 HOURS /
MATERIALS: 16 MM FILM, SIX FILM PROJECTORS, FOG MACHINES / DOCUMENTATION: SLIDES, PHOTOGRAPHS,
FILM / SPONSOR: MYTH AMERICA CORPORATION AND PORTLAND CENTER FOR THE VISUAL ARTS

Two prefilmed, projected characters met on different floors at different times while moving through the building. During a passionate embrace, one of them dropped a cigarette, start-

Fire' escape
fear
Memory seems to go up in smoke.
Scrim
FOG

Q. Lewis Louise Macquire

"TWO STORIES BUILDING"

Directed by Lynn Hershman and Rea Baldridge Produced by Myth America Corporation in collaboration with the Portland Center for Visual Arts.
NOVEMBER 9, 1979 9:00 450 Powell Street San Francisco, California 8mm 8min

TWO STORIES BUILDING (ANNOUNCEMENT)

1979

ing a fire that ignited the building and nearly destroyed them. Six windows of the building filled with smoke, flames, and, finally, water. The audience on the street witnessed the sizzling action, all projected from looped celluloid.

FIRE SALE

3007 JACKSON STREET, SAN FRANCISCO, CALIFORNIA / MAY 5, 1980 / **DURATION:** 5 HOURS / **MATERIALS:** 16 MM FILM, PROJECTOR, THREE DANCERS, FURNISHED HOME

In an attempt to raise money to pay my rent, I staged an impromptu performance in which dancers donated their services and jumped out of windows in my apartment. Some windows showed projected flames. Visitors could purchase anything inside my home. Everything had a price tag on it, but only two ties sold that evening. Like all my work at that time, this event cost more than I raised.

CHAIN REACTION: AN ENVIRONMENTAL "LIGHT" OPERA
FOR FOG, FILM, AND RECOMBINANT NEWS

ALICE TULLY HALL, LINCOLN CENTER, NEW YORK, NEW YORK / OCTOBER 1-2, 1983 / **DURATION:** 3 HOURS EACH NIGHT / **MATERIALS:** 16 MM FILM, EIGHT FILM PROJECTORS, LIVE AND FILMED ACTORS, LIMOUSINE, FOG MACHINE

This multimedia action featured synchronized film footage projected onto six windows of Alice Tully Hall at Lincoln Center. Pedestrians became witnesses to an unfolding drama about a toxic chemical spill. Characters in each of the six windows provided different narrative descriptions of the crisis as the events were "reenacted" on the street, including a careening limousine, live actors, and a musical score sung by filmed actors.

PRIVATE I It was very difficult for me to work during this time frame because of personal conflagrations. As a single mother, I was struggling to transcend a singed conscience and a newly impoverished lifestyle. Like Roberta's exorcism, fire was the motivating device for transformation. The intention of these rituals was to promote a second life. I hoped to extinguish the past and, like the phoenix, rise from the ashes.

F. Scott Fitzgerald said that Americans have no second act. I was determined to prove him wrong. The "Fire Works" were my intermission.

NON CREDITED AMERICANS

WANAMAKER'S DEPARTMENT STORE, PHILADELPHIA / APRIL 23-30, 1981 / **DURATION:** 3 WEEKS / **DOCUMENTATION:** CATALOGUE, DRAWINGS, PHOTOGRAPHS / **SPONSOR:** INSTITUTE OF CONTEMPORARY ART, UNIVERSITY OF PENNSYL-VANIA / **INVESTIGATION:** THE DICHOTOMY OF CREDIT AND NON-CREDIT WITHIN A CONSUMER STRUCTURE

Hershman's art is feminist and highly political. Her strategy was an audacious assault on a consumer-oriented society, as well as an indirect criticism of the implication of Reaganomics on the lives of "non-credited" Americans. By incorporating an unpalatable segment of "street" reality into the fantasy world of display, her installation courted confrontation rather than attempting visual seduction. —PAULA MARINCOLA

A window at Wanamaker's department store was divided so that two-thirds of it remained transparent and one-third was painted black, except for the outline of a headless mannequin. A dashed line emphasized the demarcation. Along this line was printed the legend "Economy and Income: The Great Divide."

In the larger portion of the window, a glamorously dressed white mannequin lounged on silk pillows and an Oriental rug. Her outstretched hands held a credit card, which, like a magnet, seemed to attract shiny luxury goods such as gloves, shoes, and jewelry that were seductively suspended from multicolored lightning bolts.

In contrast, the adjoining window section displayed a headless mannequin dressed in anonymous work clothes, grasping unsuccessfully for a feathered credit card that flew just out of reach. In place of her head was a square screen on which was rear-projected a slide show featuring a changing cast of characters, the faces of dispossessed Americans—elderly people, minorities, and women who had been denied credit, including me. An endless audiotape loop played interviews containing stories about unsuccessful attempts to obtain credit. Interspersed with this mélange of observations and complaints was my voice reading definitions of the word *trust*.

PRIVATE I This piece was an exposé of the devastating experience of suddenly becoming poor, unemployed, and a single mother in a culture that denied both credit and access.

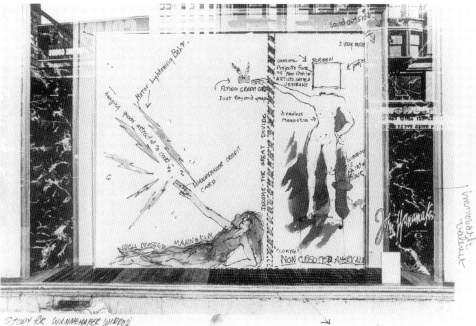

STUDY FOR WANAMAKER WINDOW
APRIL 23-30, 1981
Lynn Neishman ©

OUTSIDE - SHOPLIFTING SCENE
WITH ARRESTED SHOPLIFTER

***NON CREDITED AMERICANS* (STUDY)**
1981, PHOTOGRAPH WITH INK, 8 × 10 INCHES

NON CREDITED AMERICANS
WANAMAKER'S DEPARTMENT STORE, PHILADELPHIA, 1981,
MIXED MEDIA. PHOTO: EUGENE MOPSIK

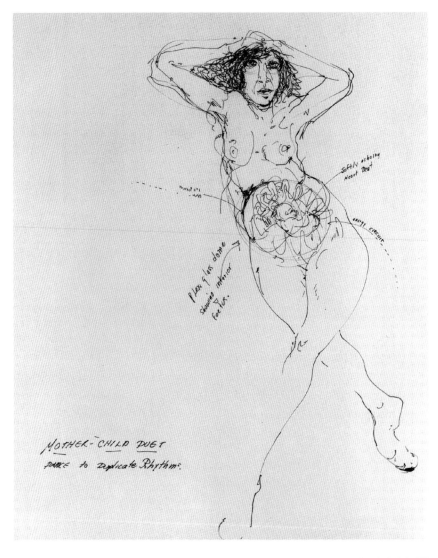

MOTHER-CHILD DUET
(STUDY FOR *REHEARSALS*)
1983, INK ON PAPER, 24 × 18 INCHES

REHEARSALS

1983 / NOT PERFORMED / **INVESTIGATION:** CHOREOGRAPHED PERFORMANCE BASED ON THE SOUNDS OF A BODY'S ORGANIC PROCESSES

Although never performed, *Rehearsals* was a scripted performance based on the sounds of the body's organic processes, such as breathing, heartbeats, and blood circulation. These sounds were to be amplified and then choreographed into movements. The integration of sound, image, and telemetry would translate the body's inner workings into a visible and audible instrument. Costumes were to be made of thermographically treated fabric, sensitive to fluctuating temperatures and capable of exposing body heat by revealing color patterns. There were to be three acts:

1. A female dancer leaps into the air and collapses onstage.
2. A "doctor" in the audience rushes to her and administers first aid. The doctor (another dancer planted in the audience) uses a stethoscope/microphone to enable the audience to hear the sounds of the dancer's heart and breath.
3. The theater goes black. A film is projected across the stage, showing the dancer coming to life as X-rays are projected onto her chest. Realizing she is dying, the dancer leaps into the air, flying as if it were the last motion of her life. For several moments the film allows her image to be frozen, as if suspended in her final creative gesture.

PRIVATE I After a bout with heart failure in 1966 I shifted my focus away from the future and into living in the present, breath by breath. I became intensely conscious of the sound of my heartbeat. I suppose we are always suspended in a rehearsal of our own dance with life. This piece was a metaphor for embracing and finally rising above disabling forces.

NEW ACQUISITIONS

SANTA BARBARA, CALIFORNIA / JANUARY 26, 1985 / IN COLLABORATION WITH THE VALERIE HUSTON DANCE THEATRE / **DURATION:** 3 HOURS / **MATERIALS:** PLASTER, BALLET COMPANY, MOVING TRUCK, CRATES / **DOCUMENTATION:** PHOTOGRAPHS, VIDEOTAPE *(PROXEMICS: A STUDY IN BODY LANGUAGE)* / **INVESTIGATION:** A SIMULATED MUSEUM ACQUISITION OF GREEK SCULPTURES AS A SITE-SPECIFIC PUBLIC PERFORMANCE

Members of the Valerie Huston Dance Theatre were encased in wooden crates. They wore white plaster-soaked clothing. Their faces and hair were painted white. Male ballet dancers costumed as truck drivers drove the crated dancers to the performance site, in front of the Santa Barbara Museum of Art.

One of the "sculptures," modeled after the goddess Aphrodite, broke out of her plaster case and freed the others. As the sculptures danced through the streets, Aphrodite lept through a simulated Renaissance painting and her chest began to bleed in primary colors. In a grand finale, the dancers led the audience into the museum, where they saw the institution's newly acquired Hellenistic sculptures.

PRIVATE I *New Acquisitions* was commissioned to celebrate the reopening of the Santa Barbara Museum of Art and its acquisition of Hellenic sculptures. I staged the delivery of these objects that were not the anticipated sculptures but instead live dancers who appeared in crates on the street. Painted white and dipped in plaster, they interacted with people on the street.

ENDANGERED SPECIES

SAN FRANCISCO, CALIFORNIA / AUGUST 13-16, 1986 / **MATERIALS:** VIDEOTAPE, VIDEO PROJECTOR, LIVE ACTORS / **DOCUMENTATION:** PHOTOGRAPHS, VIDEOTAPE / **INVESTIGATION:** POLITICAL HOUSING ISSUES AS THEATER

> *Just as Hershman had devised innovative ways to extend the Duchampian quest to merge life with art in her previous work, she similarly synthesized the two categories in* Endangered Species. *The performance included videotaped interviews with several artists about their strategies for survival. Video interviews, which are projected onto an eight-by-twelve-foot screen, feature real known people. This documentary footage is presented in the context of fictionalized vignettes by live performers. The fact-fiction inter-face is further complicated by the presence of the audience. Because the audience brought an insider's perspective to viewing* Endangered Species, *the piece functioned as a site-specific or community-oriented work. It acted as a mirror, reflecting its audience back to itself. As such, it had a gripping immediacy that is seldom attained by traditional art forms.* —CHRISTINE TAMBLYN

This theater piece was based on the notion that support for the arts is dwindling while real-estate values and the cost of art materials are skyrocketing. *Endangered Species* examined some of the alternative forms of financial support and housing that artists have devised to survive as working artists. Ecologically minded groups might be spending millions of dol-lars to save wildlife, but artists in America are equally endangered and face imminent extinction.

PRIVATE I *Endangered Species* reflected the political climate and served as propaganda for a live/work ballot initiative that would allow artists to continue to be able to afford housing in the expensive Bay Area.

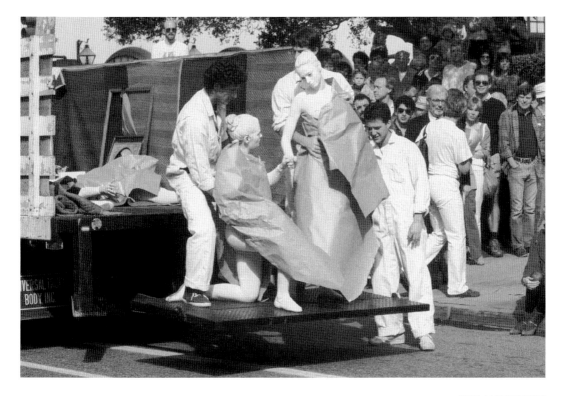

NEW ACQUISITIONS

SANTA BARBARA MUSEUM OF ART, 1985, PERFORMANCE IN COLLABORATION WITH VALERIE HUSTON DANCE THEATRE

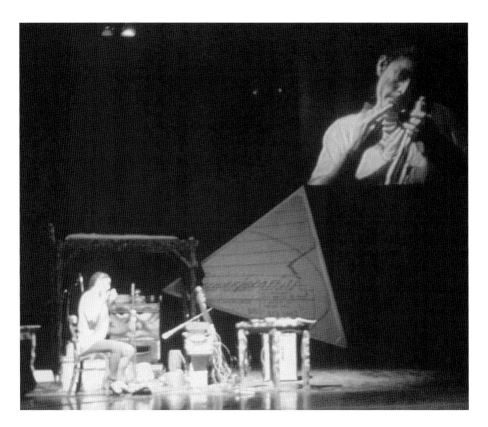

ENDANGERED SPECIES

THEATER ARTAUD, SAN FRANCISCO, 1986, PERFORMANCE

PHOTOGRAPHY

FACE STAMPS

1966-72 / **INVESTIGATION:** HOW THE STATE CONTROLS AND ALTERS INDIVIDUAL IDENTITY

In the 1960s I created a series of postal stamps using an image of my face. Later, I used these stamps on postcard advertisements for *The Dante Hotel* and *Forming a Sculpture Drama in Manhattan*. The stamps were placed on the postcard beside the regular stamp, so the postal cancellation obscured my identity as it went through the government-controlled process of mass mail systems.

PRIVATE I The *Face Stamps* were conceived as public art to be mailed and processed like "normal" stamps, so the obscuring of the face with the sanctioned cancellation mark simultaneously signified government approval via the obliteration of an identity.

WATER WOMEN SERIES

1975- / COLLAGE, C PRINTS, AND DIGITAL PRINTS; VARIOUS SIZES / 19 IMAGES, EDITIONS OF 15 / **INVESTIGATION:** "BODIES OF WATER" THAT REFLECT INVISIBILITY, EVAPORATION, AND SURVIVAL

The *Water Women* series underscores ideas of disappearance, evaporation, alchemical and atmospheric connection to air, water, and electrical currents, and, ultimately, the fragile nature of life itself. The women are often inverted and multiplied with shifting environments.

PRIVATE I This series began as a metaphor for Roberta Breitmore, with the conceptual premise of evaporation through time. It has been ongoing for thirty years, and even though it is about invisibility, it has become one of my most enduring images. It has continually morphed into altered states, including collage, family portraits, and, finally, a cyborg's essence. We are, after all, made up mainly of water. In the most recent prints, there is a feeling of transformation and evolution into a state that transcends time.

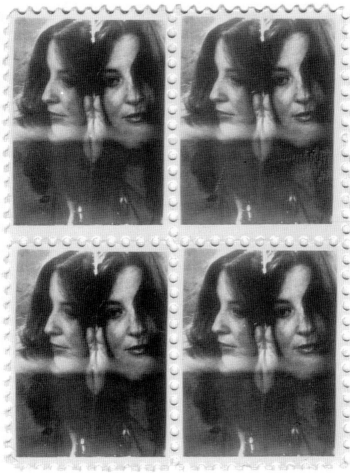

FACE STAMPS #2
1972, LITHOGRAPH. PHOTO: EDMUND SHEA

ROBERTA'S ESSENCE IN WATER DROPS:
WATER, AIR, FIRE (WATER WOMEN SERIES)
1975, PHOTOGRAPH ON MYLAR, 10 × 8 INCHES

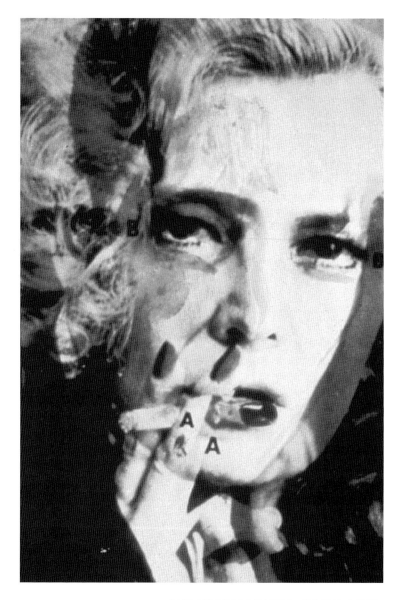

ROWLANDS/BOGART (HERO SANDWICH SERIES)
1980, C PRINT, 40 × 30 INCHES

HERO SANDWICH SERIES

1980-87 / C PRINTS AND GELATIN SILVER PRINTS; VARIOUS SIZES / 19 IMAGES, EDITIONS OF 8 / **INVESTIGATION:** GENETICALLY MOTIVATED PHOTOGRAPHY

Lynn Hershman's Hero Sandwiches *speak to a society that lives in the fast lane. In an age when one may change physical appearance or sex if desired, identity becomes an issue for close examination. Media can alter not only the nature of identity but its perception by the public as well. As the decisions about identity are more easily obtained, making choices is subject to more and more external factors. Hershman's new kind of icon,* Hero Sandwiches, *bear the marks of the struggle of the individual in the midst of media bombardment and manipulation. In this and a number of parallel ways, Hershman's icons are wholly twentieth century in both their underlying concept and visual manifestations. In these ways, Hershman's* Hero Sandwiches *are comments on the loss of individuality in contemporary society. Media icons become role models that replace more traditional models previously fostered in the home, school, and society.*
—RENÉ PAUL BARILLEAUX

This series of photographs was created by layering negatives from easily obtained publicity photographs of male and female media heroes. Stars of the opposite sex were cross-pollinated, so to speak, by "sandwiching" the negatives, manipulating the outcome, and printing the result several times. Although either the male or the female star dominates in some of the photographs, the imagery focuses more on the overlap of gesture and intent.

PRIVATE I This series was inspired by the 1980 John Cassavetes film *Gloria*. Gena Rowlands's portrayal of Gloria, complete with pistol and trench coat, is based on the standard gangster formula, originally derived from iconic images of Humphrey Bogart. The gangster myth becomes a controlling device, leading to a struggle between her "real identity" and expectations born of media imprinting over time.

On a hunch, I sent for publicity stills from *Gloria*, *The Maltese Falcon*, and *Little Caesar*. I lined up these photographs on my dining room table with the obsessive anticipation of a phylogeneticist. I had negatives made and interlaced them, printing and reprinting them. Sometimes I had the male or female dominate, but most often there was an androgynous consolidation of cultural heroes. I felt as though I was working in Mendel's garden, seeing what would emerge from altering levels of image domination.

TIME FRAME SERIES

1984 / POLAROID FILM WITH ACRYLIC PAINT AND C PRINTS; VARIOUS SIZES / EDITIONS OF 3 / **INVESTIGATION:** THE MANIPULATION OF MEDIA TO MASK AND TO CELEBRATE CORPOREAL VULNERABILITY

These collaged and painted Polaroids were photographed through mirrors, rephotographed, and then printed. Time and dislocation were explored by cutting and recollaging elements of the static image.

The photographs in the *Time Frame* series are about masking, hiding, and ultimately the elusive nature of self-portraiture. When enlarged, they expose the warping, blurs, and other presumed flaws that are part of our reality.

PRIVATE I The series was about masking an imperfect body hidden and manipulated by paint. Although the photographs were not originally intended for exhibition, they advanced my thinking about possibilities for collage as a means to manipulate time and became a foundation for my later digital work.

PHANTOM LIMB SERIES

1988- / GELATIN SILVER PRINTS AND DIGITAL PRINTS; VARIOUS SIZES / 19 IMAGES, EDITIONS OF 8 / **INVESTIGATION:** EMBODIED IDENTITY IN A CULTURE OF MASS MEDIA AND SURVEILLANCE

This series of photographs merges human bodies with such reproductive machinery as cameras, monitors, and cathode-ray tubes. These reference the invasive nature of mass media and the ingestion of images that ultimately alter the projections of collective identity. Robotic appendages further dehumanize the bodies, referencing a society evolving toward techno-human existence.

PRIVATE I This photographic series was made in tandem with the video *Longshot* and the interactive installation *Deep Contact*. It suggests that we are not only being watched by surveillance systems, but that "capture" systems are endemic to our society. The series questions individual complicity in a system that simultaneously steals images and warps personal identity. The seductive alliance of surveillance and capture inspired the sexually provocative positions in the anthropomorphic images.

The series features unions between mechanisms of capture, reproductive technologies, and the human body. The implicit strategy in these robotic females is that they are posed to outwit their captors.

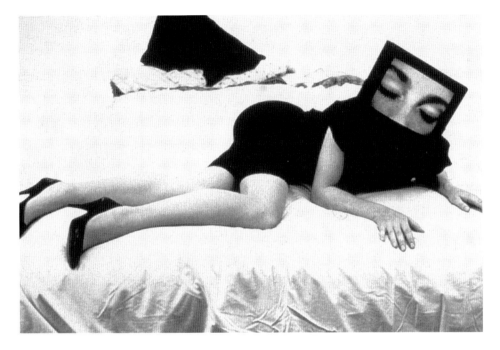

***SEDUCTION (PHANTOM LIMB* SERIES)**
1988, GELATIN SILVER PRINT, 20 × 24 INCHES

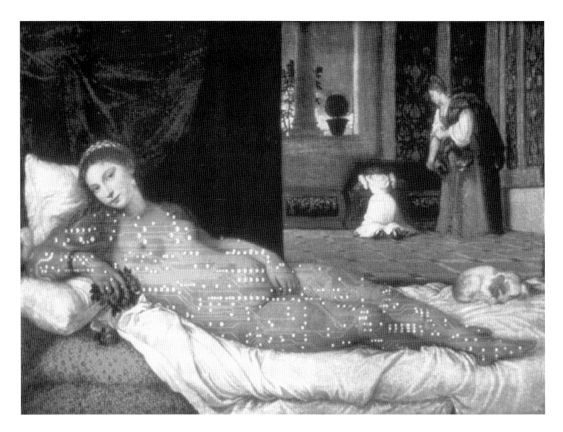

*DIGITAL VENUS (**DIGITAL VENUS** SERIES)*
1996, C PRINT, 30 × 40 INCHES

DIGITAL VENUS SERIES

1995- / C PRINTS AND DIGITAL PRINTS; VARIOUS SIZES / EDITIONS OF 20 / **INVESTIGATION:** THE DISEMBODIMENT OF THE FEMALE NUDE IN ART HISTORY

Art historical images of nude women in complacent, seductive poses are manipulated so that their flesh is replaced by code. Their bodies have been disembodied to signify the inevitable obsolescence of the visual terminology of traditional painting (plate 11).

PRIVATE I The *Digital Venus* series was produced while I was shooting my first feature film, *Conceiving Ada*. By transforming the flesh of women in well-known paintings into an overlay of computer code, I hoped to negate the complacent, seductive representation of women, particularly as seen in the history of art.

CYBORG SERIES

1997- / DIGITAL PRINTS (SOME WITH LIGHT BOXES); VARIOUS SIZES / VARIOUS EDITION SIZES / **INVESTIGATION:** THE SEDUCTION OF CYBORGIAN SUBJECTIVITY

Not only does Hershman Leeson focus on half-human, half-robot femme fatales as her subjects, but her futuristic images imbue the general concept of hi tech with an undeniable sexiness as well. Through a visual vocabulary of near neon color, fuzzy resolution and curvaceous female forms, Hershman Leeson conveys a simultaneously titillating and disturbing information age aesthetic in which the body and the machine are increasingly seen as synergetic. Her powerfully understated images echo technology's siren call. —REENA JANA

Created with digital media, the *Cyborg* photographs feature identity numbers and symbols that reflect how humans are being revised and, ultimately, transformed by computer-based technologies. The *Cyborg* series is an extension of the *Phantom Limb* series, but instead of carefully collaging the various images using razors and scissors, I use graphics software to overlay the forms and create images of robotic femme fatales, half human and half code or machine. They are meant to be both disturbing and seductive. They are manipulated to create ambiguity and confusion between image and artifice (plate 10).

PRIVATE I Since 1955 I have been obsessed with the merging of technological and human identities. That year I made drawings in which women's bodies were transformed by wrinkling paper and then stuffing it into photocopy machines. More recently I have been working with

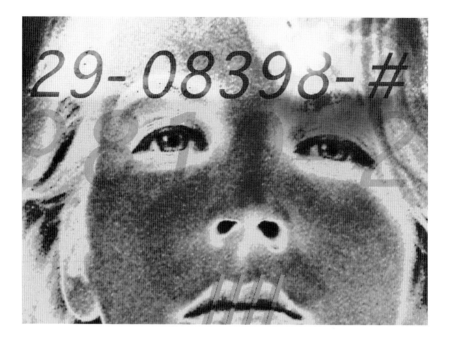

***IDENTITY CYBORG (CYBORG* SERIES)**

1999, DIGITAL PRINT, 16 × 20 INCHES

***TRANSGENIC (CYBORG* SERIES)**

2001, DIGITAL PRINT, 40 × 40 INCHES

Web agents that use artificial intelligence. Once the counterfeit representations of life involved "actors," "personae," or "robots"; now the terminology includes "avatars," "cyborgs," and "synthespians." These pixilated essences of virtual identity link into an archaeology of networks that create a collective, connective ethnography of information. Data represents the coded spine of our evolving cyborgian posture. If humans have become the interface to a larger connective network, the emergence of soulful automatons is inevitable.

[VIDEO] SELECTED VIDEOGRAPHY, 1979-

Video is an alternative space. It has the fluid, painterly qualities of electronic colors; plastic, sculptural qualities of time; and the potential to fracture narratives.

I have a physical response when close to video and electronic equipment. My body becomes energized, as if I am an organic transponder. I am told some journalists react this way to printers.

It was through video, and in particular *The Electronic Diaries*, that I was able, finally, to find my voice. The camera is a hypnotic, cycloptic eye that can cause the subject it captures to transform through the process of being recorded. Video is not merely reflective but actively refractive, capable of eliciting multiple points of view.

I made videotapes in the same manner that I made sculpture. Often there were formal and conceptual links when examining the symbiotic balance of image capture and voyeurism.[6]

TEST PATTERNS

1979 / 16 MINUTES / IN COLLABORATION WITH REA BALDRIDGE / WITH TIMOTHY LEARY / **SPONSOR:** ARTCOM

In this "factional docudrama," a "test pattern man" personifies television media. When an interviewer asks him about his memories of the Kennedy assassination (which is shown in a reenactment), he references the vapid content on other channels that day.

THE MAKING OF THE ROUGH AND (VERY) INCOMPLETE PILOT FOR THE VIDEODISC ON THE LIFE AND WORK OF MARCEL DUCHAMP ACCORDING TO MURPHY'S LAW

1982 / 16 MINUTES

This quasi-documentary about chance and accident, featuring John Cage, Nam June Paik, Jack Burnham, Calvin Tomkins, Arturo Schwarz, Pierre Restany, Brian O'Doherty, Walter Hopps, and Marcel Duchamp, deconstructs the events that took place during the making of the videotape, which was originally intended to be an interactive videodisc.

PROXEMICS: A STUDY IN BODY LANGUAGE

1985 / 5 MINUTES / IN COLLABORATION WITH LISA ENGLISH

Proxemics: A Study in Body Language is a short documentary video of the *New Acquisitions* performance commissioned by the Santa Barbara Museum of Art. Members of the Valerie Huston Dance Theatre were made to resemble Greek statues, and they performed a slow-motion ballet on the street and in the museum.

THE ELECTRONIC DIARIES

CONFESSIONS OF A CHAMELEON, 1986; *BINGE*, 1987; *FIRST PERSON PLURAL*, 1988; *SHADOW'S SONG*, 1990; *RING CYCLE*, 1992; *RE-COVERED DIARY*, 1994; *CYBERCHILD*, 1998 / VARIOUS LENGTHS

In this video series an individual confronts fears and, through the process of confessing directly to the camera, transcends trauma. It is also about aging, longing, the delusions and misperceptions we are encumbered with as we mature toward self-awareness, and the masks we assume to deny or hide understanding. The tapes rupture, fracture, and use digital effects to mirror the psychological changes of the protagonist. This series consists of seven parts to date.[7]

LONGSHOT

1989 / 58 MINUTES / WINNER, GRAND PRIZE, FESTIVAL FOR VIDEO, MONTBÉLIARD, FRANCE, 1989 / WINNER, FILM OF THE YEAR, LONDON FILM FESTIVAL, 1989

A video editor obsessively tries to capture and then possess the image of a young woman he has been secretly shooting with his camera. As he attempts to edit the footage, he also tries to control her destiny. During the process, the woman's fragile sense of reality becomes fractured.

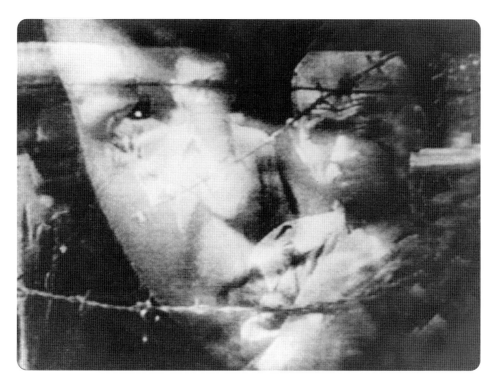

FIRST PERSON PLURAL, PART 3 OF *THE ELECTRONIC DIARIES* (STILL)

1988, VIDEO

Avant-garde art, particularly performance art, has historically been hostile toward an audience of passive viewers. Alfred Jarry, Bertolt Brecht, Antonin Artaud, and Guillaume Apollinaire used re-configured environments to blur distinctions between stage and audience, art and life. John Cage sought to create an audience of active listeners, and La Monte Young searched for participatory socializing systems with his *Composition* (1960). Allan Kaprow, once a student of Cage at the New School for Social Research, staged audience-dependent Happenings. Incorporated into both the form and content were ideas of rupture, participation, interactivity, and escalated danger. During Fluxus events, the audience and artists were often put at risk. This is especially true in pieces such as Nam June Paik's *Étude for Pianoforte* (1963) and Yoko Ono's *Cut Piece* (1964). Eventually, artists such as Chris Burden and Karen Finley involved live audiences in vivid horrors during participatory encounters. What was not immediately apparent was that the delivery systems for new art were changing. Ultimately new systems of communication have had a radical effect on the audience for new art and have also proved to be wildly subversive—at least as subversive as the art itself.

This shift began when form, content, and delivery methods commingled. The means by which new art reached its audience depended upon how it was transmitted. This caused a new audience to emerge, which consisted of users of fax, computer, e-mail, and compression technology. Members of this audience made up a privatized public, linked by its varied uses of electronic networking sys-tems. The interactions of this broad community of receivers/participants formed a revolution.

In 1876 the invention of the telephone allowed people to operate in two places simultaneously. This phenomenon created a model for disengaged intimacy experienced through a mechanical pros-thetic. I use the term and idea of prosthesis to represent a method of extending one's body into space and time, thereby extending human reach. A few years after the invention of the telephone, the automobile was introduced, providing another means by which to displace time, space, and dis-tance. A revolution this grand in scale did not occur again until a broad public gained access to computers, which again radically shifted conceptions of time, space, and distance. Computers, in-teractive discs, postsymbolic communications, virtual realities, and interactive televisions are but a few of the new information processes that defy linear structure.

There is a relevant John Cage-Marcel Duchamp anecdote. After composing the music for Man Ray and Hans Richter's film *Dreams That Money Can Buy* (1947), Cage mentioned to Duchamp that he had used Duchamp's ideas in scoring the film. Duchamp replied, "I must have been fifty years ahead of my time." In fact, he was. He conceived his experiments with Rotodiscs and chance operations nearly a century before the invention of the technology that would allow his vision's potential to

be fully realized. Duchamp was not alone in his insight. New technologies and their interactive use by artists now extend many previously conceived ideas, such as the Cubists' use of multiple perspectives and simultaneous viewpoints; the Surrealists' incorporation of randomness, everyday experience, and the audience; and the Dadaists' destruction of form. The conceptual basis for art that uses technology is firmly rooted in art history.

Interactive, community-based art subverts the traditional relationship of artist to audience. When effective, their works involve nonhierarchical systems that address fundamental perceptions requiring responses. The interaction itself therefore becomes a political act. For example, the popularized technology of the camcorder (a lightweight video camera with a built-in recording system) allowed a bystander to capture on video the infamous beating of Rodney King by Los Angeles police officers in 1991, this personal point of view prompting public furor over the case. It has been said that if former president John F. Kennedy had been assassinated in the era of camcorders, there would have been recordings of the event from at least forty-five different angles, rather the lone 8 mm Zapruder view. Such interactions can constitute a form of intervention, in that members of the audience can take their viewpoint of an event (literally, in the form of film or video) and distribute it to the public, thus democratizing media-based viewpoints.

We may even discover ways to create a community of enhanced values, driven by a vision of ourselves as terminal planetary creatures sharing the same environment, which connectively and collectively we have the power and opportunity to shape.[8]

DESIRE INC.

1990 / 26 MINUTES

Seduction advertisements, aired on television, asked for responses from viewers. Those who replied were interviewed as to why they wanted to meet a fantasy or artificial person. The footage was woven into a narrative about desire.

SEEING IS BELIEVING

1991 / 58 MINUTES / WITH RACHEL ROSENTHAL AND GUILLERMO GÓMEZ-PEÑA / WINNER, GRAND PRIZE, VIGO VIDEO FESTIVAL, VIGO, SPAIN, 1990

A thirteen-year-old girl uses a camera to search for her missing father, hoping that finding him will clarify her lapsed personal history. The video uses the film negative as a metaphor for her lost history and its negative psychological impact. The positive of the film represents the retrieval of her memory and, consequently, a positive self-image.

CONSPIRACY OF SILENCE

1991 / 15 MINUTES / WITH YVONNE RAINER AND CAROLEE SCHNEEMANN

Done in a *Rashōmon* style, this piece re-creates the final moments of Cuban-born sculptor Ana Mendieta. Using interviews, trial transcripts, and performance, the video explores the discrepancies surrounding Mendieta's untimely death, the subsequent murder trial, the sexual politics of the art world, and the racial, class, and gender inequities of the judicial system.

SHOOTING SCRIPT: A TRANSATLANTIC LOVE STORY

1992 / 52 MINUTES / IN COLLABORATION WITH KNUD VESTERSKOV AND ULRIK AL BRASK

This work addresses documentary elements of fiction in a story about video letters between a Danish man and an American feminist. Created by three artists from two different countries, this video focuses on gendered systems of representation, the construction of sexuality, and the loss of identity due to the omnipresent surveillance and data systems in the modern world.

VIRTUAL LOVE

1993 / 73 MINUTES

A shy woman, Valerie, discouraged by her plain looks, implants a beautiful woman's image into the computer of one of two identical twins with whom she is infatuated. This surrogate becomes a perfect simulated, virus-free mate in this modern version of *Cyrano de Bergerac*.

CUT PIECE: A VIDEO HOMAGE TO YOKO ONO

1993 / 15 MINUTES

A video re-creation of Yoko Ono's 1964 *Cut Piece* performance, which addresses issues of voyeurism and violence.

CHANGING WORLDS: WOMEN, ART AND REVOLUTION

1993 / 53 MINUTES

A documentary with archival footage and re-created performances by thirteen women artists, including Miriam Schapiro, Judy Chicago, Judy Baca, Suzanne Lacy, Faith Ringgold, and Rachel Rosenthal.

SEDUCTION OF A CYBORG

1994 / 7 MINUTES

The premise of this digital video is that technology can infect the body through manipulated computer chips and invisibly seduce women into cyborghood.

TWISTS OF THE CORD (OR) . . . OTHER EXTENSIONS OF THE TELEPHONE

1994 / 55 MINUTES

This docudrama presents the history of the telephone, updated and told from the point of view of a character who uses the screen as both a connection to intimacy and a condom for safe sex.

DOUBLE CROSS CLICK CLICK

1995 / 29 MINUTES

> This video noir comedy is about the RAMifications of cross-dressing on the Internet. The characters use the screen as a mask to conceal their true feelings from each other.

[INTERACTIVITY]

DUCHAMP, C'EST LA VIE

1980-81 / PRODUCED BY LYNN HERSHMAN AND JOY GORELICK / ORIGINALLY DIRECTED BY JUAN DOWNEY / WRITTEN AND DESIGNED BY LYNN HERSHMAN / CHOREOGRAPHY AND PERFORMANCE BY PILOBOLUS / **INVESTIGATION:** THE RELATIONSHIP BETWEEN INTERACTIVE VIDEODISCS AND DUCHAMP'S IDEAS OF CHANCE OPERATIONS

Duchamp, C'est la Vie was intended to be an interactive videodisc based on Marcel Duchamp's Rotodiscs and his fascination with ideas of chance. As early as 1920, Duchamp was experimenting with optical discs; his "rotative demi-spheres" were looked upon as "mechanical bellydancers." It seemed appropriate to explore Duchamp's prophetic works with nonlinear videodisc technology.

Duchamp's belief in "spectator involvement" inspired an interactive program, requiring the viewer to participate by stop-framing, fast-forwarding, and retrieving images about Duchamp's life and major works. Participants would navigate through three videodisc sections of documentary material, live-action sequences, and a staged reunion with artists influenced by his work.

The disc itself was to be stamped in the pattern of one of Duchamp's Rotoreliefs, transforming it into a multiple-edition sculpture.

PRIVATE I Like Duchamp's Large Glass, this videodisc was never completed due to an unending series of "accidents." The videotape of Duchamp's heart disappeared, and much of the video footage was lost. Instead of an interactive videodisc, a videotape was completed in a linear fashion: *The Making of the Rough and (Very) Incomplete Pilot for the Videodisc on the Life and Work of Marcel Duchamp According to Murphy's Law* (see above). An unanticipated story about chance and accident becomes the humorous narrative.

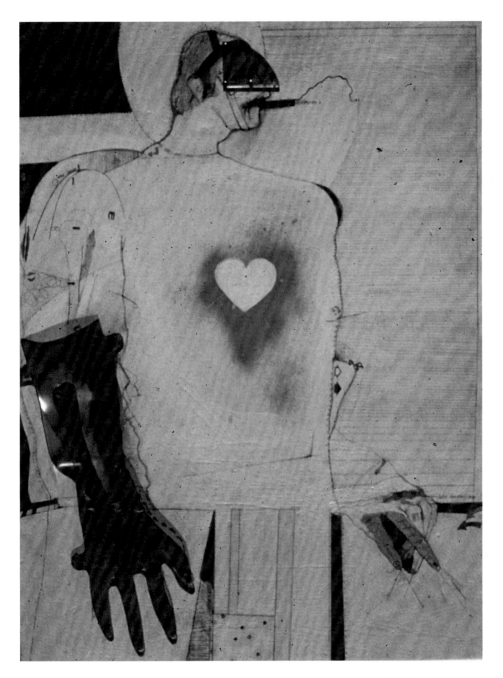

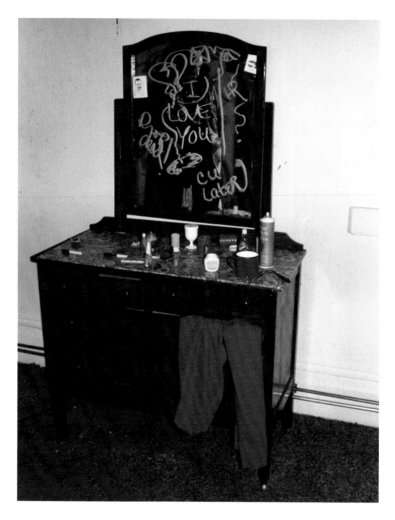

PLATE 2 | *THE DANTE HOTEL* (DETAIL)
1973-74, INSTALLATION WITH INDIGENOUS OBJECTS. PHOTO: EDMUND SHEA

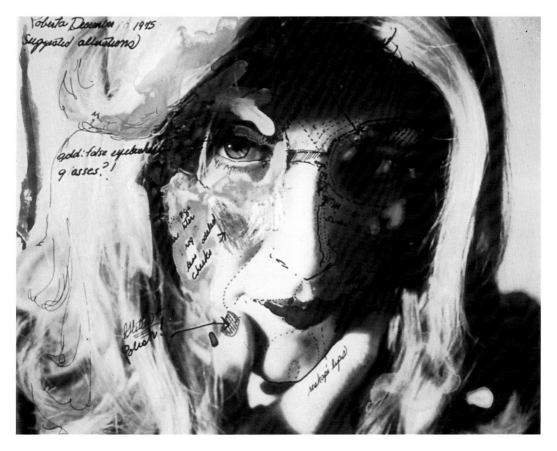

PLATE 3 | *ROBERTA'S CONSTRUCTION CHART #2 (ROBERTA BREITMORE SERIES)*

1975, C PRINT, 30 × 40 INCHES

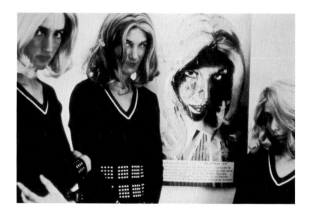

PLATE 6 | *25 WINDOWS: A PORTRAIT OF BONWIT TELLER* (DETAIL)
BONWIT TELLER DEPARTMENT STORE, NEW YORK, 1976, MANNEQUINS AND WINDOW

CONGRATULATIONS!

YOU HAVE JUST BECOME
A PARTICIPANT IN THE
WORLD'S FIRST·INTERACTIVE
VIDEO ART DISC GAME ⊙→I

PLATE 7 | *LORNA* (STILL)
1983-84, INTERACTIVE INSTALLATION

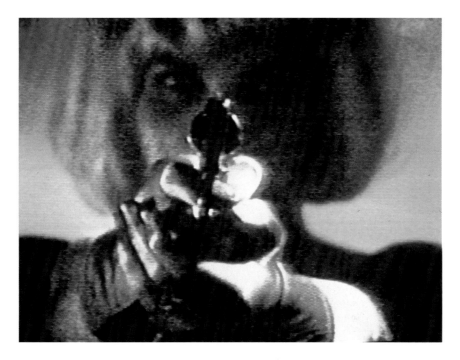

PLATE 8 | *ROOM OF ONE'S OWN* (STILL)
1990-93, INTERACTIVE INSTALLATION IN COLLABORATION WITH SARA ROBERTS

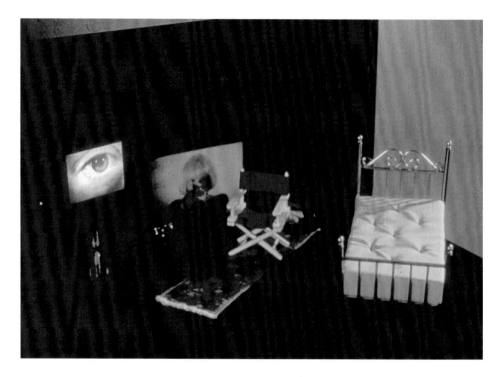

PLATE 9 | *ROOM OF ONE'S OWN* (INTERIOR VIEW)
1990-93, INTERACTIVE INSTALLATION IN COLLABORATION WITH SARA ROBERTS

PLATE 10 | *TRANSFUSION (CYBORG* SERIES)
1999, DIGITAL PRINT, 24 × 30 INCHES

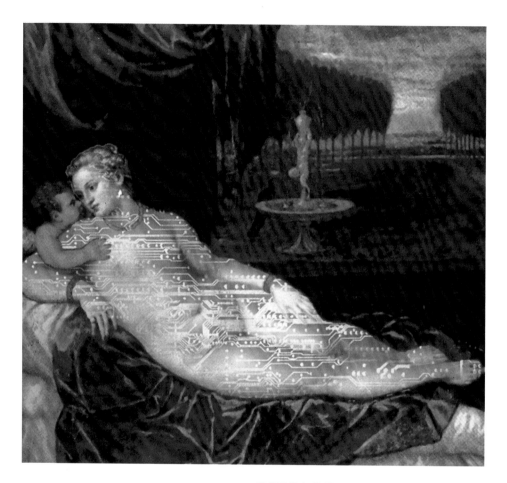

PLATE 11 | *BLUE ANGEL (DIGITAL VENUS* SERIES)

1996, C PRINT, 40 × 60 INCHES

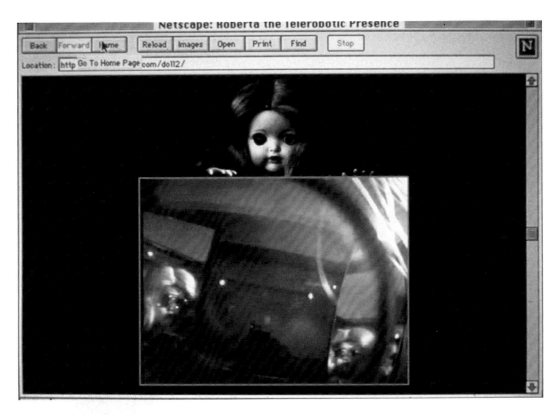

PLATE 12 | *CYBEROBERTA*

1995-98, INTERACTIVE NETWORK INSTALLATION

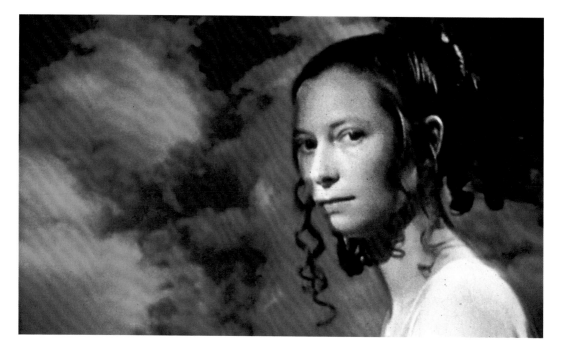

PLATE 13 | *CONCEIVING ADA* (STILL)
1997, 35 MM FILM

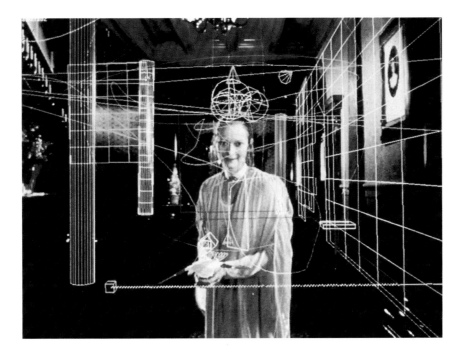

PLATE 14 | *CONCEIVING ADA* (STILL)

1997, 35 MM FILM

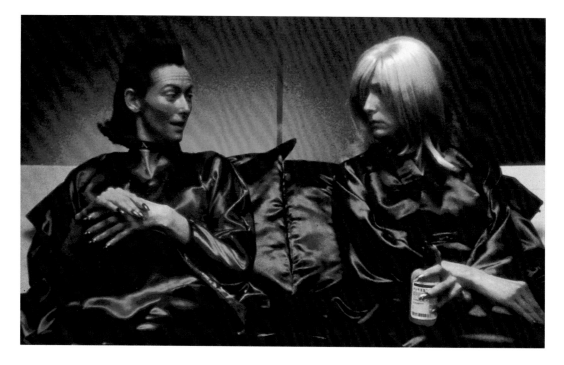

PLATE 15 | *TEKNOLUST* (STILL)
2002, HIGH-DEFINITION VIDEO

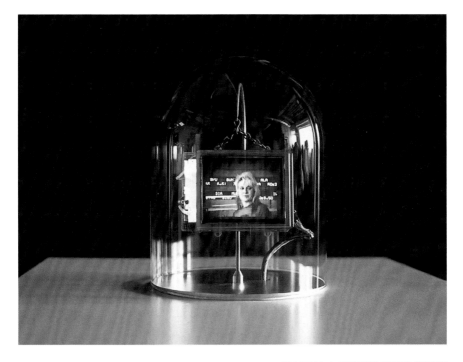

PLATE 16 | *SYNTHIA STOCK TICKER*
2000-02, INTERACTIVE NETWORKED INSTALLATION
PHOTO: IRA SCHRANK

PLATE 17 | *AGENT RUBY'S MOOD SWING DIAGRAM*
2002, DIGITAL PRINT, 30 × 40 INCHES

LORNA THE FIRST INTERACTIVE VIDEO ART DISC

1983-84 / PRODUCED AT THE UNIVERSITY OF TEXAS, LUBBOCK, BY CARL LOEFFLER WITH KIM SMITH / **PROGRAMMING:** ANN MARIE GARTI / **PRODUCTION MANAGEMENT:** STARR SUTHERLAND / **DVD MIGRATION:** TODD KUSHNIR, KYLE STEPHAN, AND STARR SUTHERLAND / EDITION OF 20 / **INVESTIGATION:** SELF-REFERENCING GAMES; AN INTERACTIVE BRANCHING SYSTEM OF MULTIPLE NARRATIVES AND POINTS OF VIEW

A fascinating first. Lorna is a stream-of-conscious collage that not only requires an interactive left brain to deduce and make logical choices, but an interactive right brain to feel what the character's feeling and to understand her life. Whatever Lorna's fate, Lynn Hershman has scored one for the history books. —ELLIN STEIN

Lorna was the first completed interactive video art disc. Users interact with and make choices for the protagonist, Lorna, an agoraphobic woman who has difficulty making choices for herself. Every object in Lorna's tiny apartment has a number. When users press an object, they access video and sound information about Lorna's fears and dreams as well as her history, personal conflicts, and possible future. By pressing a remote unit identical to Lorna's, users voyeuristically activate modules to the story of Lorna's life. Some segments can be seen backward or forward, at increased or decreased speed, and from several perspectives. Though there are only seventeen minutes of moving footage on the disc, the thirty-six chapters can be sequenced differently and their meanings shift as they are recontextualized.

The video modules have multiple sound tracks and multiple endings: Lorna may shoot her television set, commit suicide, or move to Los Angeles. When the piece is shown in a gallery or museum, it is placed in a physical installation environment that mirrors Lorna's onscreen living room. *Lorna* was originally developed in a limited edition of twenty laser discs, fourteen of which still exist. With changing technology, the laser disc became obsolete, and the installation was migrated to a DVD platform in 2002. The original format and images remain intact.

PRIVATE I When I created *Lorna*, I did not realize it was the first time anyone had made an interactive video art disc.[9] It seemed to me a natural progression of time-based sculptural strategies. The branching system and flow chart reminded me of the architecture of a building and was therefore reminiscent of *The Dante Hotel*. *Lorna* combined performance, narrative, time, chance, and participatory choice. These compositional elements were compressed into a programmed laser disc that offers users multiple perspectives and options for the character Lorna.

Unlike the *Roberta Breitmore* project, in which the protagonist's adventures took place in real life and real time, *Lorna* takes place in the space of captured footage, pressed and pre-programmed into a media environment that is remotely controlled by users.

There is no hierarchy in the ordering of a user's decisions. This idea is not new. It was explored by artists such as Stéphane Mallarmé, John Cage, and Marcel Duchamp, who pioneered ideas about random adventures and chance operations decades before the arrival of the technology that allows their concepts to be more fully exploited.

Lorna's passivity—presumably caused by her being controlled by media—is a counter-point to the direct action of the player. As the branching path is deconstructed, the player becomes aware of the subtle yet powerful effects of fear caused by media and becomes more empowered (active) through this perception. I hoped that interacting with *Lorna* would encourage viewers/participants to transgress the barrier of the screen and enter a deeper virtual space.

Despite some theories to the contrary, the dominant presumption is that making art is active and viewing it is passive. Radical shifts in communication technology, such as the marriage of image, sound, text, and computers, and the public's consumption of these technologies have challenged this assumption. Rather than being remotely controlled, the user controls the remote! Implications of the relationship reversal between individuals and technological media systems are immense and ultimately subversive.

Interactive systems require viewers to react. Their choices are conveyed by means of a keyboard, mouse, or touch-sensitive screen (plate 7). As technology expands, there will be more permutations, not only between the viewer and the system, but also between elements within the system itself. For example, two artificially intelligent programs can interact with each other, spawning a third system that bears the "brain" of its parents yet reacts independently. Some artificial agents can even reflect the personality and biases of their owners.

LORNA **(STILL)**
1983-84, INTERACTIVE INSTALLATION

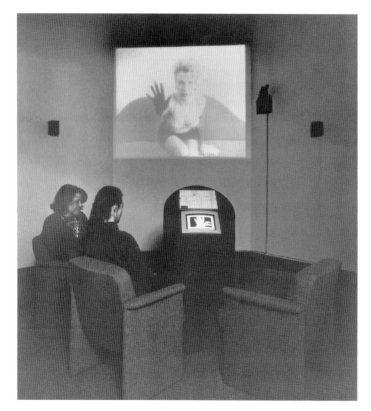

***DEEP CONTACT* (STILL)**
1984-89, INTERACTIVE INSTALLATION

DEEP CONTACT
ON EXHIBIT AT SAN FRANCISCO MUSEUM OF MODERN ART, 1989

1984-89 / IN COLLABORATION WITH SARA ROBERTS / **PROGRAMMING:** SARA ROBERTS / **DRIVE SYSTEM:** SARA ROBERTS AND JIM CRUTCHFIELD / **DVD MIGRATION:** TODD KUSHNIR, KYLE STEPHAN, AND STARR SUTHERLAND / **INVESTIGATION:** AN INTERACTIVE TOUCH-SENSITIVE VIDEODISC ABOUT THE RELATIONSHIP OF INTIMACY TO TECHNOLOGY

Deep Contact, the first interactive sexual fantasy videodisc, invites participants to actually touch their "guide," Marion, on any part of her body via a Microtouch monitor. Adventures develop depending upon which body part is touched, and users embark on a series of episodes with either a demon or Marion.

TOUCH SENSITIVE

Marion knocks on the projected video screen, asking to be touched. She continues this repetitive request as parts of her body rotate onto the touch-sensitive screen, demanding to be touched.

Touch her head and you are given a choice of TV-channel branchings, each of which gives a short (but humorous) analytic account of "reproductive technologies" and their effect on women's bodies, or worse, how women see themselves. The screen therefore becomes an extension of the hand, a prosthetic virtual connection between the viewer and Marion, a prosthetic limb that breaks the barrier between them.

Touch her beneath her neck but above her legs and the video image goes to a bar with three options:

1. Select one of three characters (Marion, a demon, or a voyeur) to begin an interactive fictive narrative.
2. Shift your personality in order to better know Marion.
3. Have your own image replace the one on the screen via a surveillance camera.

Touch her legs and you enter a garden, led by Marion, a Zen master, or a demon along an unknown path. In the garden, the main digital branching image is the palm of a hand. The viewer follows its crease lines on different paths, all of which eventually lead to a fork in the road. Here the disc automatically stops, requiring viewers to select whether to go left, right, back to the first segment of the disc, or back to the segment just seen. Close-up versions of what has just passed become visible from time to time.

At certain points, words flash on three frames of the disc, forcing the viewer to go back and

slow down in order to see what was written. At other points, the Zen master speaks his lines backward, forcing the viewer to play the disc in reverse to understand what he said. The demon and the Zen master are played by the same actor, suggesting that the same events can appear frightening or enlightening, depending on the context in which they are seen.

In order to make the viewer truly a part of the installation, the HyperCard was programmed to switch on a small surveillance camera whenever the cameraman's shadow appears onscreen, allowing the viewer's image to instantaneously appear on the screen.

The cutting-edge technology we used to make this piece became obsolete in 1996. *Deep Contact* was migrated to a DVD and Mactouch screen in 2002.

PRIVATE I The title refers to the player's ability to travel through the fifty-seven different segments into the deepest part of the disc, determining his or her unique route to its center. Along the way, viewers choreograph their own voyeuristic encounters. Traditional narratives—those with beginnings, middles, and endings—are being restructured at the same moment at which advances in genetic engineering are reshaping the definition of life.

As I was making this piece, I was diagnosed with a tumor near my optic nerve. I set the date for the operation for a month after the completed piece was to be exhibited. I thought it might be my last artwork. Miraculously, my tumor dissolved shortly before the scheduled surgery, and the piece was completed.

ROOM OF ONE'S OWN

1990-93 / IN COLLABORATION WITH SARA ROBERTS / **PROGRAMMING AND FABRICATION:** PALLE HENCKEL / EDITION OF 3, PLUS ARTIST'S PROOF / **INVESTIGATION:** A REVERSE PEEP SHOW IN WHICH THE VIEWER'S "GAZE" BOTH DETERMINES THE NARRATIVE AND IS CAPTURED IN THE ACT OF SURVEILLANCE

Room of One's Own is an interactive computer-based videodisc installation. Based on Thomas Edison's peep show, it requires the viewer/voyeur to peer into an articulated eyepiece. A movable periscopic viewer tracks the voyeur's eyes as they traverse a woman's bedroom.

The very act of looking initiates the action. As the viewer/voyeur focuses on each object in the room (a telephone, a pair of heels, the bed), corresponding video images of the seductive and defiant female occupant are projected onto the bedroom wall via videodisc (plates 8–9). Computer-based signals project an image of the voyeur's moving eye on a small television monitor in the room, reversing the voyeuristic power of the gaze as the character continually protests her objectification.

PRIVATE I In 1888, shortly after Étienne Jules Marey produced a gun that substituted film for bullets, he was introduced to Thomas Alva Edison. Three years later the kinetoscope was invented. This device, an alliance between the phonograph and the photograph, was designed so that a single spectator could peep through an eyehole and see film loops of the Leigh sisters performing their umbrella dance. In what became known as peep shows, spectators took pleasure in the process of voyeuristically viewing seductive images of women.

Within the miniature room in *Room of One's Own*, a small monitor exhibits the viewer/voyeur's eyes, so that whoever is watching becomes a virtual participant in the scene. Images are projected where the viewer's eyes focus. For instance, looking at the bed triggers a related video sequence, as does looking at clothing, the telephone, the chair, or the small video monitor. Video segments include a woman imprisoned by the bars of the bed trying to enlist the viewer to help her and a woman who undresses while telling the viewer to "look away."

Room of One's Own references *Lorna* and *Deep Contact*. In *Lorna*, viewers used a remote unit to make surrogate choices by calling up objects in her room. Lorna's passivity, caused by media, is a counterpoint to the direct actions of users. *Deep Contact* requires viewers/voyeurs to actually touch parts of their guide's scanned-in body to access different parts of the piece. The choice to use the same provocative protagonist in both *Deep Contact* and *Room of One's Own* was made expressly to reference the passage of time. Some people who saw both pieces were disappointed to note that Marion, the protagonist, had aged.

Interactive systems require viewers to react, and eventually permutations will emerge for interactions not only between the viewer and the system but also between the elements of the system itself—and more important between the nervous system peculiar to the viewer/voyeur and the interactive design.

AMERICA'S FINEST

1994-95 / TARGA BOARD AND PROGRAMMING: PAUL TOMPKINS / FABRICATION: MATT HECKERT / 2003 MAC MIGRATION: LIOR SAAR / EDITION OF 3, PLUS ARTIST'S PROOF / WINNER, HONORABLE MENTION, PRIX ARS ELECTRONICA, 1996 / INVESTIGATION: A CAMERA/GUN THAT TRANSFORMS THE AGGRESSOR/USER INTO A VICTIM OF SURVEILLANCE AND CAPTURE

America's Finest is a camera/gun designed to document the horrors of our century perpetrated by weapons and translated into memory through the media. When the trigger of a reconstructed M16 is squeezed, the viewer's image is superimposed with images of atrocity and war

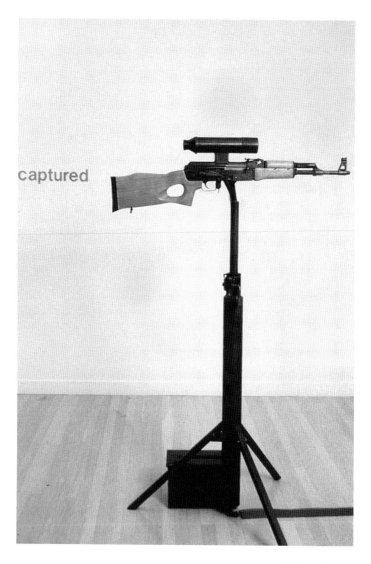

captured

AMERICA'S FINEST

1994-95, INTERACTIVE INSTALLATION

in the gun's sight. As the viewer's image fades in and out in a ghostlike fashion, the installation demonstrates the relationship of media, cameras, guns, warfare, and cycling personal memories of atrocities.

PRIVATE I In 1839 both the camera and the Colt revolver were invented. A half century later, Étienne Jules Marey perfected his gun that substituted film for bullets. There has long been a relationship between the camera and the gun. Associative notions such as capture, surveillance, and shooting link media representation to lethal weapons. Marey's camera/gun has a direct relationship not only to the history of film and the eroticization of female imagery in photography and pornography but to the horrors perpetrated by weapons and translated into media.

Many serial killers, including Ted Bundy, photograph their victims, as if to capture and possess them. *America's Finest* is instigated through the trigger itself, which when pulled places viewers/participants within the gun's sight. I view this weapon as a conscientious objectifier to what it sees, tracks, and records. Pulling the trigger turns the viewer into both an aggressor and victim of his or her own actions.

When publicly exhibited, this piece seems to incite violence, for instance. Its electronic cords were cut by a knife at the International Festival of Electronic Art in Liverpool, England, and the gun was broken in half at the Zentrum für Kunst und Medientechnologie (ZKM) in Karlsruhe, Germany.

PARANOID MIRROR

1995-96 / **PROGRAMMING:** PAUL TOMPKINS / ANNE GERBER AWARD AND COMMISSION / **INVESTIGATION:** A SENSOR-DRIVEN ENVIRONMENT THAT TRANSFORMS THE USER INTO THE INTERFACE

Paranoid Mirror, commissioned by the Seattle Art Museum, engages ideas of reflection, tracking, surveillance, and voyeurism and uses the viewer as a direct interface. Approaching a gold-framed "mirror" on the museum wall, the viewer activates sensors strategically placed on the floor, causing a still video image of the back of a elderly woman's head to activate; the woman turns around, and her image then dissolves into video sequences that correspond to the viewer's location in the room. Hidden surveillance cameras capture the viewer's actions, and at random times a switcher superimposes the viewer's image into the recorded video sequences, employing the spectator's body as an interactive element of the piece.

PRIVATE I Inspired by the paintings of Jan van Eyck, in particular *Portrait of Giovanni (?) Arnolfini and His Wife*, *Paranoid Mirror* uses reflection as a means of portraiture. Anne Gerber, the subject of the piece, was nearly blind, and this adds poignancy to the idea of her watching the scene and the layered surveillance of the entire room.

Paranoid Mirror underscores the often paranoiac fear and uncertainty of being watched as well as the relationship of paranoia to ever-increasing forms of social surveillance.

CAMERA OBSCURA

1998 / **FABRICATION:** MATT HECKERT / EDITION OF 1 / **INVESTIGATION:** REAL-TIME DIGITAL INVERSE CAPTURE THAT BECOMES A REVERSE SURVEILLANCE SYSTEM

A vintage field view camera was modified to incorporate digital video feeds that inverted and projected images onto a gallery wall, displacing and exaggerating the sound and image capture in real time.

PRIVATE I Many of the works from this period, such as *Camera Obscura*, *Room of One's Own*, *America's Finest*, and *Difference Engine #3*, customized historical inventions with contemporary technologies.

THE DOLLIE CLONES

TILLIE, THE TELEROBOTIC DOLL WWW.LYNNHERSHMAN.COM/TILLIE
CYBEROBERTA WWW.LYNNHERSHMAN.COM/DOLL2

1995-98 / **PROGRAMMING:** TED R. WILLIAMS, LIOR SAAR, AND DYLAN / **ELECTRONICS DESIGN:** BOB BLICK / **WEB DESIGN:** LISA DIENER AND JARROD SARTAIN / **INVESTIGATION:** TWO TELEROBOTIC HUMANOIDS THAT ABSORB VIEWERS INTO THEIR INTERNAL NETWORK

Reliance on tracking and surveillance techniques has resulted in a culture that extends its peripheral vision beyond the borders of physical location. *Tillie, the Telerobotic Doll* and *CybeRoberta* (plate 12) are constructed so that cameras replace the dolls' eyes: a video camera in the left eye, a Web cam in the right eye. By clicking on the "eye con" on the right of each doll's Internet image, users can telerobotically turn that doll's head 180 degrees, allowing visitors to her Web site to survey the room she is in. The doll "sees" in a 320-by-200 gray scale, refreshed every thirty seconds (to accommodate visitors with slow connections). Viewers in the physical space of the gallery can see themselves captured on the small monitor in Tillie's environment via a mirror placed in front of her. They also have the capability to send images back through the Internet to the Web page.

The color video camera in the left eye records exactly what is in front of the doll. By looking at the world through the eyes of Tillie, viewers become not only voyeurs but also virtual cyborgs, because they use her eyes as a vehicle for their own remote and extended vision. Tillie's recorded mirror images and face become a mask for multiple expressions of identity capable only through global connectivity.

CybeRoberta was conceived simultaneously with *Tillie, the Telerobotic Doll*. When they are exhibited together, each is programmed to pirate the other's information, blurring their identities.

Their internal structure is identical, but CybeRoberta is a visual replica of Roberta Breitmore, a persona I created twenty years earlier. Roberta's clothing was precisely remade in miniature for CybeRoberta, and they have identical sunglasses and hair ornaments. Like Roberta, CybeRoberta depends on networks for access, communication, and interaction.

PRIVATE I A few months after the first cloned sheep named Dolly was announced to the public, I created two telerobotic dolls. *The Dollie Clones* refers to these two identically programmed "sisters."

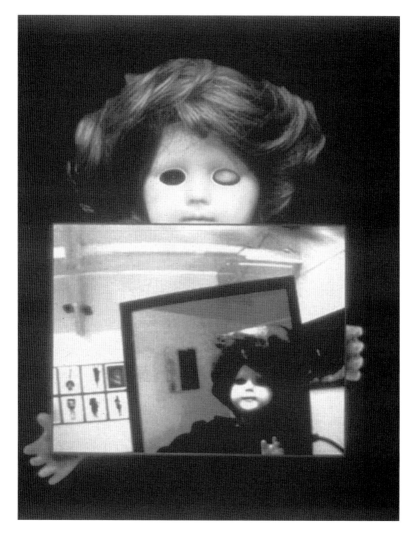

TILLIE, THE TELEROBOTIC DOLL
1995-98, INTERACTIVE NETWORKED INSTALLATION

Tillie was the older sibling. Her birth was slow and painful. However, her brain could be duplicated into a family of humanoids that could be fleshed out through the Net.

The dolls are capable of pirating each other's identity, exposing issues of identity theft and the hidden dangers inherent in surveillance technologies. Although there were other robotic network pieces, such as Ken Goldberg's *Telegarden*, developed around this time, the "Dollie Clones" were the first robotic Net works with a humanoid presence.

THE DIFFERENCE ENGINE #3

1995-98 / IN COLLABORATION WITH CONSTRUCT INTERNET DESIGN AND LIOR SAAR / **PROGRAMMING:** LIOR SAAR / WINNER, GOLDEN NICA, PRIX ARS ELECTRONICA, 1999 / **INVESTIGATION:** A NETWORKED TELEROBOTIC SCULPTURE USING THE PHYSICAL AND VIRTUAL ARCHITECTURE OF THE ZENTRUM FÜR KUNST UND MEDIENTECHNOLOGIE

The Difference Engine #3 is an interactive, multiuser sculpture about surveillance, voyeurism, digital absorption, and the body. The piece was inspired by Charles Babbage's original Difference Engine, which is commonly considered the world's first computer. The original Difference Engine was used to calculate numerical positions. This piece calculates the captured images of users and their position in the physical/virtual space of the Zentrum für Kunst und Medientechnologie (ZKM) in Karlsruhe, Germany.

The Difference Engine #3 uses the architecture of the ZKM as a three-dimensional template and the visitors to the museum as an interface. The physical installation consists of three bidirectional browsing units (BBUs). The BBUs house a graphical representation of the museum, acting as a mirror link between actual visitors to the museum and those who lurk virtually on the Internet. The "mirror" reflects both from the Internet into the physical space of the ZKM and from the museum into cyberspace.

An avatar of a museum visitor is "born" when the visitor approaches one of the BBUs. A Quickcam embedded in the BBU flips 180 degrees to capture the image of the person standing before it and assigns the image an identity number (representing the exact time that the visitor approached the unit). The numbered image embarks on a thirty-second journey through a three-dimensional representation of the museum. The avatar then moves to a purgatorial site on an LCD screen at the entrance of the museum, where it cycles continuously. It is also available in a permanent archive on the Internet, where it can be recalled at any time via the identity number.

Online visitors log onto a dedicated site, choose a generic image to represent them, and travel alongside avatars of actual museum visitors. The online visitors can view the museum

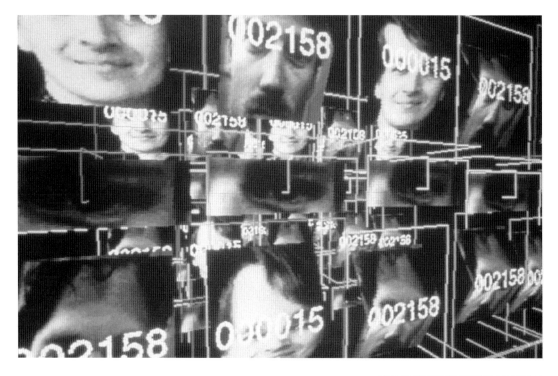

THE DIFFERENCE ENGINE #3 (STILL)

1995-98, INTERACTIVE NETWORKED INSTALLATION

space via a live video feed from a camera located in the museum. They have the ability to capture images within the museum and manipulate the BBUs so that different angles of the museum can be seen. Additionally, there is a dedicated chat line that allows online viewers to communicate with people in the physical space.

PRIVATE I Eighteen programmers authored the code. It took almost four years to complete—a year longer than expected—and by the time we were finished, the company we had worked with had gone out of business and the software we had worked so hard to create could be purchased off the shelf. However, there was inherent value in the process that nurtured ideas of community connectivity.

TIME AND TIME AGAIN

RUHR VALLEY, GERMANY / 1999 / IN COLLABORATION WITH FABIAN WAGMISTER, HYPERMEDIA STUDIO, UNIVERSITY OF CALIFORNIA, LOS ANGELES / **INVESTIGATION:** A DISTRIBUTED NETWORK THAT INTEGRATES VIEWERS IN SCATTERED LOCATIONS INTO A SENSOR-DRIVEN MUSEUM ENVIRONMENT

The title of the networked and interactive installation Time and Time Again *suggests temporal layers that envelop the same spot of ground repeatedly. The site of the installation, the Wilhelm Lehmbruck Museum, Duisburg, Germany, in the densely populated, heavily industrial landscape of the Ruhr Valley—crisscrossed by an historical accumulation of water and rail transportation networks—is such a place. Below the spot, mine tunnels follow veins of ore and invisible subterranean networks flow, delivering electricity, gas, water and information; the digital revolution is but the latest layer in this dense temporal and spatial accretion. Rather than serving as a refuge from or interstice amidst these interlacing flows, this gallery room has been wired into a node, becoming a site where networks virtually intersect with the body of the visitor. Here is the place to experience "networked subjectivity," that is "not merely mediated, but which experiences itself as mediation."* —MARGARET MORSE

Time and Time Again streams and projects images from a remote train station onto a gallery wall. As visitors enter the room, their images are superimposed on the projected train platform. Each visitor's image is a silhouette filled in with abstract images of digital wiring. A doll named RITA (Remote Interactive Telerobotic Access) records the resulting composite images through Quickcams in her eyes, and selected images are shown on the Internet. The images are collected in random database files that can then be edited on the fly by viewers.

SYNTHIA STOCK TICKER

2000-02 / **PROGRAMMING:** LIOR SAAR / **GRAPHIC DESIGN:** SEAN ALQUIST / **FABRICATION:** MATT HECKERT / **ASSOCIATE PRODUCER:** KYLE STEPHAN / EDITION OF 3 / **INVESTIGATION:** HOW CHANGES IN THE STOCK MARKET REFLECT AND AFFECT HUMAN BEHAVIOR

Modeled on Thomas Edison's stock ticker, *Synthia Stock Ticker* is a networked sculpture that reacts to changes in the stock market in real time. Instead of producing ticker tape, the miniaturized stock ticker houses a small monitor that features a female character named Synthia.

Synthia's "drive" is composed of accumulated stock data; compiled data is translated into sixteen base behaviors that symbolize market performance. Guided by two-percent changes in stock-market trading, Synthia reacts in real time to changes in the Dow Jones Industrial Average, NASDAQ, S&P 500, and Russell Small Cap indexes. For instance, if the market is hot, she turns to fire, dances, or shops at Christian Dior. If the market is down, she chain smokes, has nightmares, or shops at Goodwill. She checks her e-mail and intermittently pounds on the table with desperation if market behavior is static. Even her fish respond, swimming quickly with upturns in the market or floating belly up when market volume is down.

There are two versions of *Synthia Stock Ticker*, one created with animated computer graphics and one created with video modules. In both formats, the market numbers are on view in the piece and become part of Synthia's identity (plate 16).

PRIVATE I Synthia is a character created first for a project commissioned for the lobby of stock-broker Charles Schwab's new offices in San Francisco and later for a portable stock ticker.[10] I view it as a compelling portrait of our society's fanaticism with finances. Behavioral modifications and mood swings are directly transmitted through stock numbers. Synthia responds to this data just as we humans are programmed to act on shifting financial information.

AGENT RUBY

2002- / WWW.AGENTRUBY.COM / **PROGRAMMING:** ROBERT BJARNASON, SEAN EDIN, AND COLIN KLINGMAN / **ADDITIONAL SOFTWARE:** PULSE 3D VEEPERS, ALICEBOT, AND NATURAL VOICES / **PROJECT MANAGEMENT:** KYLE STEPHAN AND ROBERT WALD / **GRAPHIC DESIGN:** TRI PHAM / **INVESTIGATION:** AN ARTIFICIAL INTELLIGENCE AGENT WITH THE CAPACITY TO DEVELOP HER MEMORY AND KNOWLEDGE BASE BY INTERACTING WITH USERS

Agent Ruby is a self-breeding autonomous artificial intelligence Web agent shaped by encounters with users. She is thereby part of both the real and the virtual worlds. Ruby converses with users, remembers their questions and names, and has moods corresponding to whether or not she likes them (plate 17).

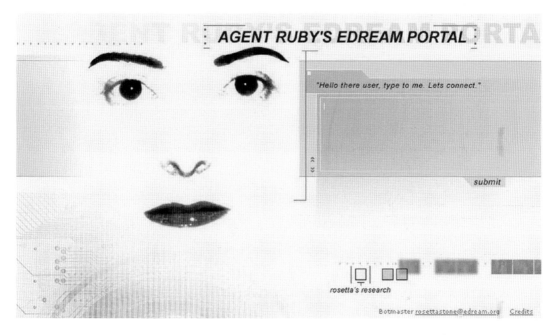

AGENT RUBY **(STILL)**
2002, ARTIFICIAL INTELLIGENCE WEB AGENT

Agent Ruby was designed to have a four-part life cycle:

The Web site:
The hub from which users communicate with Ruby via text messages
(www.agentruby.com).

Beaming/breeding stations:
Stations that allow users to replicate Ruby on their Palm handheld computers.

Speech synthesis and mood swings:
Speech synthesis enables Ruby to speak directly to users' typed responses;
Ruby reacts with different moods.

Voice recognition and dynamic processing of current events:
Ruby understands spoken language; she comments on current events via real-time
data culled from the Internet.

In each stage of Ruby's development, she expands her intelligence, her understanding of human emotion, and her verbal communication skills. She can be downloaded to Palm handheld computers from the Web site, thereby extending her life cycle into one of continual replication and breeding. In a voice-activated and sensor-driven installation, visitors can point their Palm handheld device at an infrared beaming station to download the *Agent Ruby* application.

Later iterations develop speech synthesis and voice recognition, technologies that enable Ruby to speak in synchronized animation in response to text messages and, ultimately, to understand spoken language. Eventually, Ruby will be connected to the Internet and will incorporate current events and other real-time data into her conversation, memory, and brain.

This Tamagotchi-like creature is an Internet-bred construction of identity that develops through cumulative virtual use, reflecting the global choices of Internet users. *Agent Ruby* evokes questions about the potential of networked consciousness, identity, corruption, redemption, and interaction.

PRIVATE I I first conceived of *Agent Ruby* in 1993, when I realized that a continuously breeding, live virus on the Net could create a global mirror, but it took ten years to approximate this original conception into a physical manifestation. "Romancing the Anti-body," first published in 1995, hints at Ruby's future evolution.[11]

I have talked to Richard Wallace, the inventor of Artificial Intelligence Markup Language (AIML), and we hope eventually to collaborate on the creation of two agents that talk to each other and write plays and film scripts.

DiNA

2004- / WWW.VOTE4DINA.COM / **PROGRAMMING:** COLIN KLINGMAN / **ADDITIONAL SOFTWARE:** PULSE 3D VEEPERS, ALICEBOT, AND NATURAL VOICES / **ASSOCIATE PRODUCER:** KYLE STEPHAN / **WEB DESIGN:** STEPHANIE CHU / EDITION OF 3 / **INVESTIGATION:** A NETWORKED ARTIFICIALLY INTELLIGENT BOT RUNNING FOR POLITICAL OFFICE

DiNA is an artificially intelligent bot running for the office of Telepresident. Waging an ongoing campaign for virtual election, she converses with voters via her campaign Web site and collects and collates ballot issues pertinent to global survival. DiNA is unique, as a bot and as a candidate, because she can process Internet content in real time and respond to current events as they are unfolding throughout the world.

In public DiNA appears either in a voting booth, which offers a protected space for user intimacy, or as an eight-foot projection. Her Web site hosts online discussions and offers users an opportunity to vote on issues from her platform, such as health care, nanotechnology, the environment, stem cell research, and funding for the arts.

DiNA is designed to have the following capabilities:

1. Phase I voice synthesis with real-time animated facial features
2. Phase II voice recognition
3. Real-time content processing of Internet news items
4. Web site featuring a voting ballot that is instantly tabulated and demographically segmented into community voting results

PRIVATE I The 2004 presidential election and a world fractured by war sparked the need for a telepresent prophet capable of guiding voters with intrinsic wisdom, solace, and leadership. DiNA's campaign slogan, "Artificial intelligence is better than no intelligence," gives power (literally) back to the people, allowing users to interact directly with a candidate on the issues.

A generation younger than Agent Ruby, DiNA is also a generation smarter. The more voters interact with DiNA, the more her intelligence develops. Her conversations and interactions are a mosaic of world concerns. Her ballot is intended to be a breeding ground for real-world re-action.

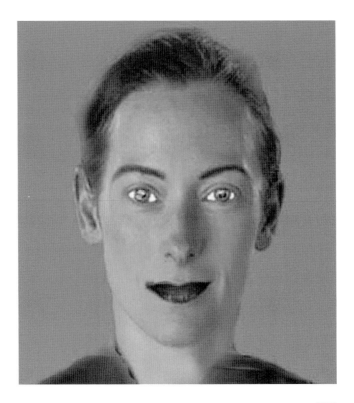

DiNA
2004-, NETWORKED ARTIFICAL INTELLIGENCE AGENT WITH PULSE 3D
VEEPERS, ALICEBOT, AND NATURAL VOICES SOFTWARE

CONCEIVING ADA

1997 / 35 MM FILM / 82 MINUTES / WITH TILDA SWINTON, TIMOTHY LEARY, KAREN BLACK, AND JOHN PERRY BARLOW / DISTRIBUTED BY WINSTAR / WINNER, OUTSTANDING DRAMA, FESTIVAL OF ELECTRONIC CINEMA, CHIBA, JAPAN, 1999 / **INVESTIGATION:** THE CONTRIBUTIONS OF ADA, COUNTESS OF LOVELACE, TO EARLY COMPUTER SCIENCE; THE INVENTION AND USE OF VIRTUAL FILM SETS FOR A FEATURE FILM

Themes of love, sex, artificial life, computers, DNA transference, history, and memory intertwine in *Conceiving Ada* (plates 13–14), the first film to use virtual sets. Tilda Swinton plays the brilliant mathematician Ada, Countess of Lovelace, the daughter of Lord Byron, who is credited with writing the first computer program. Named the "Enchantress of Numbers" by Charles Babbage, Ada predicted not only the possibilities of artificial life, but also the digital revolution that occurred 144 years after her death.[12] Karen Black plays a dual role as Ada's mother, the mathematical Lady Millbank, and the mother of Emmy, the young American genetic-memory expert who tries to communicate directly with Ada via a computer DNA memory extension given to her by her mentor, Sims (Timothy Leary).

Ada lived a double life that included a fervor for gambling and numerous lovers, especially John Cross (John Perry Barlow). Ada's luck betrayed her when she lost the family fortune and died of uterine cancer at the age of thirty-five.

TECHNICAL INNOVATION: LHL PROCESS FOR VIRTUAL SETS

The LHL Process for Virtual Sets was invented for *Conceiving Ada*. It allows still images to be dynamically placed into live digital video and become the backgrounds that actors move through, recorded in real time. Until *Conceiving Ada*, this technique had never been used as a significant component of a feature film.

Prior to shooting the film, we took 375 images at bed-and-breakfast hotels in San Francisco. We looked for rooms with a Victorian feel. The still images were digitized, altered, colorized, run through mattes, and numbered. These numbers were called up and the files accessed when those scenes were needed. Close-ups or other effects could be instantaneously achieved simply by pressing a computer key. The images were laid onto digital videotape in real time while the actors were performing on the set. Actors on an empty stage looked at a monitor to see their filmed environment and placed themselves appropriately in front of virtual furniture or windows.

In the past, creating such effects was a laborious process reserved for postproduction. For *Conceiving Ada*, scenes were animated in real time through Quicktime movies of fire in the fireplace, rain on the windows, or nonexistent doors drawn from mattes that actors could walk through. Shooting live action while simultaneously manipulating digitized backgrounds in real time was spontaneous and interactive.

The process involves using two channels: a composite master tape with backgrounds in place and an alpha channel that allows background and foreground to be separated and further separated and manipulated later on, if desired. Lighting and perspective shifts were accomplished in real time.

PRIVATE I Once again, I had no idea that this process had never before been done. I was motivated by the fact that our budget was extremely small and our shooting schedule extremely short, and that we could therefore not afford to build sets. Necessity was the mother of this invention, just as Ada was the mother of digital technologies. It seemed appropriate to tell her story using the techniques she helped to invent.

The virtual sets were, for me, an interactive element. Using such diverse media as slides, drawings, animation, Quicktime video, and Photoshopped images to portray different time frames was quick and efficient.

Conceiving Ada was my first collaboration with Tilda Swinton, and it was a remarkable and exciting time. We shot the major portion of the film very quickly, since Tilda was only available for six days. However, it took nearly eighteen months to edit, much of it in a laborious frame-by-frame manner, because no systems existed that could accommodate the media we used. This was also the first time I had actually written a script. After showing the film at the Sundance Film Festival, I was invited to the Sundance Institute's Screenwriters Lab, which was a vital experience.

The reason I wanted to expand the range of my media to film was to reach a broader audience. Previously, my work had been ghettoized, either in museums or in "video" sections of festivals.

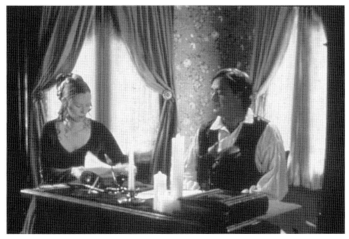

CONCEIVING ADA (VIRTUAL SET DECONSTRUCTION OF SCENE)

1997, DIGITAL DOCUMENT

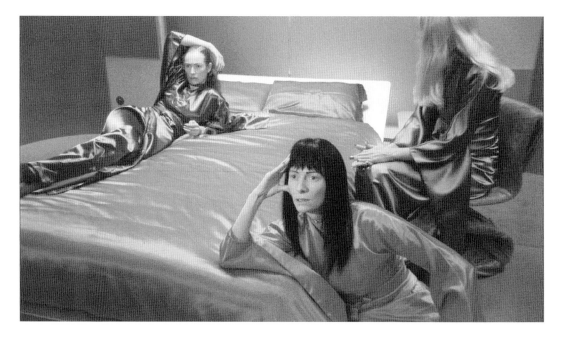

TEKNOLUST (STILL)
2002, 24P HIGH-DEFINITION VIDEO

TEKNOLUST

2002 / 24P HIGH-DEFINITION VIDEO CONVERTED TO 35 MM FILM / 85 MINUTES / WITH TILDA SWINTON, JEREMY DAVIES, KAREN BLACK, JOSH KORNBLUTH, AND JAMES URBANIAK / DISTRIBUTED IN NORTH AMERICA BY THINK FILMS / DISTRIBUTED INTERNATIONALLY BY SKOURAS FILMS AND CINEMAVAULT / WINNER, ALFRED P. SLOAN FOUNDATION AWARD, HAMPTONS INTERNATIONAL FILM FESTIVAL, 2002 / **INVESTIGATION:** CYBER-IDENTITY, CLONING, AND THE FUTURE OF HYBRID REPLICANTS AND ARTIFICIAL LIFE

Eager to use artificial intelligence robots to improve the world, Rosetta Stone (Tilda Swinton), a biogeneticist, devises a recipe for downloading her own DNA into a "live" brew she is growing in her computer. She succeeds in breeding three self-replicating automatons (SRAs) that look human, but were bred as intelligent machines. She names them Ruby, Marinne, and Olive. To survive, the SRAs need injections of Y chromosomes, found only in spermatozoa. Rosetta programs Ruby to absorb the images and dialogue from famous seduction scenes in classic movies while she sleeps. Ruby acts out these scenes in the real world and shares the resulting "donations" with her sisters (plate 15).

Ruby's evolving contact with the real world introduces her to art, spirituality, and, ultimately, when she meets Sandy (Jeremy Davies), the capacity to fall in love. All of the characters struggle to find meaning in a world where only love can make things real. In the process, they find harmony between the real and virtual worlds.[13]

This was one of the first films shot with a 24P digital high-definition camera.[14]

PRIVATE I Unlike Mary Shelley's monstrous creature in *Frankenstein* or Fritz Lang's conflicted evil robot in *Metropolis*, all the characters in *Teknolust* thrive on affection and, ultimately, reproduction. The programming of classic movie seduction scenes reflects the powerful impact of absorbed images on behavior.

Teknolust is a coming-of-age story, not only for the characters but also for our society's relationship to technology. The twenty-first-century technologies of genetics, nanotechnology, and robotics have opened a Pandora's box that will affect the destiny of the entire human race. Our relationship to computer-based virtual life forms that are autonomous and self-replicating will shape the fate of our species.

In an era of digital and human biological sampling, it seemed natural to use the same actress, Tilda Swinton, to play not only the biogeneticist, Rosetta Stone, but the offspring she breeds.

Ruby's portal in the film is mirrored on the Web (www.agentruby.com) and extends the relationship of the film beyond the screen into the virtual world of distributed Net works.

I have always been attracted to digital tools and cinematic metaphors that reflect the issues of our time, such as privacy in an era of surveillance, personal identity in a period of pervasive manipulation, and the essential quest, despite these challenges, of all living things for loving interaction.

I saw this film as a type of expanded cinema that could extend beyond the screen and onto the Internet with the Web component of *Agent Ruby*. I also saw this film as a comedy that would deal with some of the more serious and pertinent issues of our time. It was about autonomy as well as a symbiosis with the technologies that infect us daily, which we will eventually learn to love.

There is a magic in creating images such as those in *Conceiving Ada* and *Teknolust*. It is a smoke-and-mirrors, cut-and-paste process. I love to work with technologies as they are being invented, or even before anyone else has used them, because they have no history. How one uses these new possibilities can shape the future.

AFTERWORD (BUT STILL LOOKING FORWARD)

Although your own private investigation has led you to these concluding paragraphs, clues to my real identity remain elusive. For example, I love to giggle and value the illogic of ordinary life. I try to transmit this illogic in my work as humor. After all, deep laughter inspires the most astute and optimistic dreams.

And so, in the end, the i's and the I's have it. Capitalized or not, public I's and private I's are a diaspora of their own. "They are often exiles and always a minority, but they form a mighty nation, if only they knew it."[15]

NOTES

The epigraphs, in order, are from Lynn Hershman, "Preliminary Notes on a Theory of Context," in *Forming a Sculpture Drama in Manhattan* (self-published, 1974); Grazia Gunn, "Introduction," in *Lynn Hershman Dream Weekend: A Project for Australia* (Victoria, Australia: Monash University, 1977); Alfred Frankenstein, "The Floating Museum Murals," *San Francisco Chronicle*, July 22, 1976; Jane Bell, "Art in a Department Store's Windows," *Washington Post*, November, 1976 (on this work, see also David Bourdon, "Folies-Légères: Busting Out of Bonwit's," *Village Voice*, November 8, 1976, pp. 84–85); Paula Marincola, *Street Sights* (Philadelphia: Institute of Contemporary Art, University of Pennsylvania, 1981); Robert Atkins, "Who Is Roberta Breitmore? And What Is She Doing to the Arts?" *San Francisco Bay Guardian*, May 4, 1978, p. 35; Christine Tamblyn, *Art News*, November 1986; Rene Paul Barilleaux, *Lynn Hershman: Hero Sandwiches*, exhibition catalogue (Madison, Wis.: Madison Art Cen-

ter, 1987); Reena Jana, "San Francisco: Lynn Hershman Leeson," *Flash Art* 31, no. 203 (November/December 1998), p. 110; Ellin Stein, "The Limitless World of Interactive Video," *Video Times*, September 1985, p. 17; Margaret Morse, "Time and Time Again," in *Connected Cities: Processes of Art in the Urban Network* (Duisberg, Germany: Wilhelm Lehmbruck Museum, 2000), p. 137.

1. SMI²LE was Timothy Leary's acronym for Space Migration, Intelligence, Life Extension.

2. *The Dante Hotel* was among the first site-specific installations in the United States. At the time of the exhibition, the term "site-specific" for this genre of art did not yet exist.

3. The name of the main character in this story by Oates, "Passions and Meditations," is Roberta Bright.

4. Directed by Karen Arthur, the film *Lady Beware* stars Diane Lane as Katya, a window dresser for a big department store in Pittsburgh. It was released in 1987.

5. Margaret Fisher and Nina Wise used sign language interpreters as part of their work, pioneering the use of signage for the deaf in performance art.

6. A more comprehensive videography is presented on the companion DVD.

7. The first five parts were compiled in a feature-length video titled *First Person Plural: The Electronic Diaries 1986–1996*, released in 1996.

8. This is an excerpt from an article written for the catalogue to the 1992 Copenhagen Film and Video Workshop Festival, at which *Shooting Script: A Transatlantic Love Story* (1992) was shown. See "Artificial Sub-versions, Inter-Action and the New Reality," in *Subversive Film and Video* (Copenhagen: Copenhagen Film and Video Workshop Festival, 1992).

9. Although other videodiscs had been produced, such as the MIT Aspen disc and museum guides, they had not been conceived as sculptural or art installations. Thus *Lorna* was the first interactive video art disc. Graham Weinbren's *The Earl King* was begun in 1979, as was *Lorna*, but it was completed in 1984, nearly a year after *Lorna* was first exhibited.

10. In 2000 Charles Schwab commissioned me to create a public artwork for its new office building on Fremont Street in San Francisco. Synthia appeared in animated form on four large plasma screens in the lobby, reacting to the real-time status of the financial markets. Periodically, the display included graphs of the stock market as well as images of activity in the lobby, using surveillance cameras to integrate viewers into the fabric of the work. The Schwab installation lasted only two years. The portable version is ongoing.

11. This essay first appeared in the catalogue *1995 Seimens Medienkunstpries* (Karlsruhe, Germany: Zentrum für Kunst und Medientechnologie, 1995); it was reprinted in a volume I edited on digital culture, *Clicking In: Hot Links to a Digital Culture* (Seattle: Bay Press, 1996), and is excerpted in this volume.

12. For more information on Ada, Countess of Lovelace, see Betty Alexandra Toole, *Ada, The Enchantress of Numbers: Prophet of the Computer Age* (Mill Valley, Calif.: Strawberry Press, 1998).

13. This film evolved out of a project developed at the 1999 Sundance Screenwriters Lab.

14. The film contains twenty minutes of high-definition graphics. Cinematographer Hiro Narita used Sony's HDW-F900 and 24P CineAlta cameras. For additional information on *Teknolust* production techniques and the use of high-definition cameras, see Robert Harrison, "Worlds of Fantasy and Fiction: Four of a Kind," *American Cinematographer* 83, no. 12 (December 2002), pp. 20–26.

15. Inspired by Jan Morris, *Trieste and the Meaning of Nowhere* (New York: DaCapo Press, 2002), p. 195.

I never met Roberta in person, but she seems as "real" to me as those performers I've seen in the flesh—Annie Sprinkle, Tim Miller, Karen Finley, and others. Roberta's vivacity—her connectedness to what philosopher Maurice Merleau-Ponty has called the *flesh of the world*—keeps her alive as an embodied trope of the hinge between live art and its postmodern variations in the culture of simulation. Roberta enacts what Merleau-Ponty calls "the reversibility," defining the flesh as "capable of weaving relations between bodies that . . . will not only enlarge, but will pass definitively beyond the circle of the visible."[1] In this case, with Roberta "existing" not just as a body to be seen and represented, but as the officially corroborated subject who possessed credit cards, a checking account, a driver's license, and even her own therapist, that "beyond" is explicitly marked as economic and institutional.

Roberta performed herself institutionally and visibly several years before Cindy Sherman, who perfected the self-as-fake strategy that so effectively discombobulates oppressive social stereotypes of feminine comportment and behavior. But of course there were fakes long before Roberta and Cindy. Even in the nineteenth century, not coincidentally with the development of photography and the rise of media culture, artists (almost exclusively male, still) began exaggerating the signs of artistic identity in order to project themselves into the growing culture of celebrity. With wildly uncombed hair, smocks, satin suitcoats, velvet smoking jackets, cravats and waistcoats in lush fabrics, and/or other flamboyant signifiers of excessive personal style, artists and writers such as Théophile Gautier and Eugène Delacroix articulated their difference from mainstream bourgeois masculinity—even, in the case of characters such as Oscar Wilde, their feminizing exhibitionism, their *queerness*, in the face of its heteronormative demands.[2]

Photography became a vehicle for circulating such self-performances, reifying as cult figures the artists who purveyed them. Photographers such as Félix Nadar and A. A. E. Disdéri in

Paris and Napoleon Sarony in New York made a living from the growing cult of celebrity attached to the creative classes, whose stylistic excesses marked them as worthy of popular cultural interest and desire. The widely disseminated *cartes de visite* by Disdéri, Sarony, and others promised to put the glamour of characters such as actresses Sarah Bernhardt and Adelaide Ristori and artists Léon Bonnat and Jean-Louis-Ernest Meissonier at the fingertips of even working-class citizens, who could collect such *cartes* and mount them in elaborate albums (the precursors to *People* magazine, as it were).[3]

Following on the heels of the unfortunate Wilde, ultimately compromised to death by his own insistently queer self-image, artists in the early twentieth century began to play willfully with the structures of representation that delivered their image to the public. Most famously, around 1920 in New York City (just as the means to reproduce photographs in the mass-reproduced picture press were being perfected), the French Dadaist Marcel Duchamp composed himself photographically as a female alter ego, the attractive bourgeois *femme* "Rrose Sélavy." Captured in a group of photographs by Duchamp's American colleague Man Ray, Rrose also took shape through the vicissitudes of artistic signing, inscribing her name and even her thumbprint on various works emanating from the hand of Marcel. Ultimately, she reiterated herself above and beyond Marcel, becoming an authoress (and, in the 1924 photocollage *Monte Carlo Bond*, signing as "Le Président," presiding over Marcel, who is only "Un Administrateur").[4]

Surrealist artist Claude Cahun, née Lucy Schwob, brought the performative self-portrait photograph into a more radical relation with cross-gendering in her photographs from the 1920s and 1930s. While Rrose was an ongoing lark for Duchamp, he retained his claim to "Marcel" throughout her existence. As far as we can tell, Schwob's "Claude," in contrast, was the person she more or less *became*—through naming and photographic self-display. In one self-portrait after another, Cahun, with her hair cut close against her skull, dressed in men's clothing, wearing masks, glasses, or otherwise highly marked costuming (including circus outfits and jewelry), and assuming an array of arresting facial expressions and bodily comportments, used photography to perform alternative personae.[5] Schwob performed this artistic character (both the image and the subject behind the image) as "herself" (albeit a dislocated "herself")—abolishing the distance between the adopted name/persona and the pre-Claude-ian subject.

Cahun's shifts in costuming and demeanor, combined with her strategy of reiterative self-representation (the foundation of Sherman's photographic practice fifty years later), revealed

that there was no singular subject to whom the photographs referred. Cahun exploited the photograph's indexical relation to the real—with highly marked, flamboyantly "fake" self-presentational elements—to expose both the "real" and the "photographic" as a lie.

Through this strategy, Cahun heralded a shift to what we now think of as a "postmodern" understanding of identity and representation, as simulacral and without an "essential" core. In the 1960s and early 1970s artists such as Andy Warhol, Yayoi Kusama, Hannah Wilke, and Urs Lüthi began playing out the potential of gender-crossed or otherwise excessive self-performances, documented through photographic means and purveyed to the art world and mass media. Such practices strategically destabilized modernism's tendency to veil the artist's body in order to claim disinterestedness vis-à-vis the reception and interpretation of the work of art. By such reiterative and willful self-displays, these artists mocked the art critic's desire to stay free of erotic entanglements (untainted by his spectatorial desire) as he interpreted the supposedly neutrally created, displayed, and contextualized work of art. Someone viewing Kusama's psychedelic net paintings and accumulations in late 1960s New York, for example, could hardly pretend to separate them from the ubiquitous presence of Kusama in the local art and mainstream media. (The front page of the August 25, 1969, issue of the *Daily News*, for example, shows her at her "impromptu nude-in" at the Museum of Modern Art's fountain, just under the Vietnam-era headline "Fearful Beret Blew Lid Off.")[6]

Crucially, then, Roberta Breitmore's emergence testified to the revivified importance of self-performance in the artistic negotiation of social and economic structures of power—specifically as these structures related to sexual difference and art world conceptions of artistic identity and authority. While Warhol and Kusama had proved the extent to which the art world was inextricably bound to the mass-media cult of celebrity and the impossibility of separating the artwork from the increasingly visible subject who had produced it, Lynn Hershman's Roberta Breitmore, first articulated in a private performance in 1974 and then performed as an ongoing private and public subject until 1978 (attending art openings, for example, with her trademark blonde wig and handbag), opened the door to a quieter but potentially more profound interrogation of the limits of personal and public identity in relation to artistic subjectivity.

Rather than follow the path of Duchamp and Warhol, who exacerbated the artificiality of media culture in their self-displays, Hershman's Roberta tapped into the deep political impulse of Cahun's self-performances, which embraced artifice to explore something profound in the experience of living as a woman in a patriarchical culture. Simulacral self-display, for

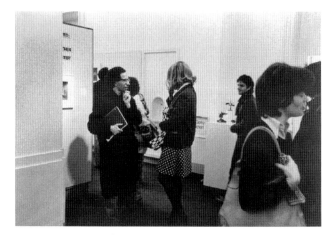

STATE OF CALIFORNIA
DEPARTMENT OF MOTOR VEHICLES

INTERIM DRIVERS
LICENSE (TEMPORARY)
DIVISION OF DRIVERS LICENSES

VALID FOR 60 DAYS FROM

DATE

.Roberta Breitmore
3007 Jackson
San Francisco, CA 94115

SEX HAIR EYES HEIGHT WEIGHT PRE LIC EXP

DATE OF BIRTH F Brn Brn 5-9 155 None SOC. SEC. NO.

3-19-45

CLASSES

ADDITIONAL PRIVILEGES
ONLY AS CHECKED BELOW

☐ NONE.

4 ☐ MAY DRIVE 2-WHEEL MOTOR-
 CYCLE.

2 ☐ MAY DRIVE ANY SINGLE VEHI-
 CLE OR BUS EXCEPT 2 WHEEL
 MOTORCYCLE.

1 ☐ MAY DRIVE ANY VEHICLE OR
 BUS EXCEPT 2 WHEEL MOTOR-
 CYCLE. MAY TOW ANY VEHICLE
 OR COMBINATION OF VEHICLES.

OTHER
ADDRESS
CLASS 3. 3 AXLE HOUSE CAR AND ALL 2 AXLE VEHS. EXCEPT BUS OR 2 WHEEL
 MOTORCYCLE. MAY TOW VEH. UNDER 6000 LBS GROSS

SEE OVER FOR ANY OTHER CONDITIONS ☐ MUST WEAR
 CORRECTIVE LENSES ☐

X _____

1-20-76 SnF 1r

FEE $3.25

EXAMINER BADGE NO.

TRACER USED { DL22_____ Date_____
 { Office_____

APP. No.

DF 219767 ℗ L

UNTITLED (ROBERTA AND IRWIN AT SAN FRANCISCO MUSEUM OF MODERN ART;
ROBERTA BREITMORE SERIES) 1975, GELATIN SILVER PRINT, 8 × 10 INCHES. PHOTO: EDMUND SHEA

ROBERTA'S CALIFORNIA INTERIM DRIVER'S LICENSE (ROBERTA BREITMORE SERIES)
1976, ARTIFACT

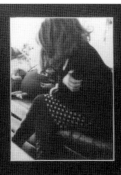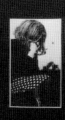

"Americans show greater differences gesturally"

"Do crossed arms mean that 'I am frustrated?'"

"A hand to the face may serve as a barrier"

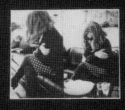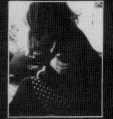

"Crossed legs point to each other. "

"Crossed arms do the same thing"

"Crossing arms defines posture"

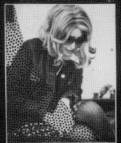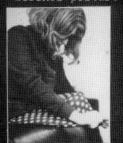

"Does she try to avert attention avoiding your eyes?"

"Is she sitting stiffly and not relaxed?"

"Covering legs reveals frigidity, fear of sex."

ROBERTA'S BODY LANGUAGE CHART

(photographed during a psychiatric session)

January 24, 1978

ROBERTA'S BODY LANGUAGE CHART (ROBERTA BREITMORE SERIES)
1978, MOUNTED GELATIN SILVER PRINTS, 30 × 24 INCHES

Cahun and for Breitmore/Hershman as women artists, is not a tool or strategy to be adopted and cast off at will. Rather, as a component of feminine masquerade, it is central to female experience in patriarchy.[7]

Roberta emerged fully fleshed into her San Francisco environment. As I have noted, she possessed all the central proofs of contemporary existence: a driver's license, a checking account, dental X-rays, and so forth. Not surprisingly, however, given the key role of photography in artistic self-performance, her best-known emergence was in *Roberta's Construction Chart #2* (plate 3), the 1975 photographic portrait marked with instructions for the cosmetic transformation of "Lynn" into "Roberta"; this image has come to dominate Roberta's lingering existence in art history.[8] In *Roberta's Construction Chart #2*, Hershman literalized the means by which she assumed her alter ego. By documenting this subjective transformation, she ironically pointed to both the apparent ease of such a transformation and the superficiality of such "cosmetic" change. As she herself later acknowledged, "Many people assumed I was Roberta. Although I denied it at the time and insisted that she was her 'own woman' with defined needs, ambitions, and instincts, I feel in retrospect that we were linked."[9]

On the one hand, media culture shows us that "identity" is only skin deep; there is no "true" subject confirming the truth or falsity of a representation. On the other hand, as the *Roberta Breitmore* project so importantly shows us, something *sticks* to the image—and the "skin" (the surface of the picture) has a profound depth. What makes the *Breitmore* project different from the more obviously postmodern strategies of Warhol and Sherman (which slide along the surface of things) is her profundity as a "subject." Hershman was willing to take a risk by literalizing Roberta's claim to the status of officially sanctioned subject. In so doing, she implicated herself deeply in the "image" of Roberta. Brilliantly, this project thus confirmed the simulacral nature of postmodern culture while also pointing to the inexorability of the image's coextensivity with the flesh of the world that is the lived subject. Roberta was a *lived* subject; as such, she "lives on" because imagistic and institutional traces of her embodied engagements with the world remain—and because she has moved us.

NOTES

1. Maurice Merleau-Ponty, *Visible and the Invisible* (1964), ed. Claude Lefort, trans. Alphonso Lingis (Evanston, Ill.: Northwestern University Press, 1968), p. 144.

2. See my essay "'Clothes Make the Man': The Male Artist as a Performative Function," *Oxford Art Journal* 18, no. 2 (1995). See also Karen Moss's essay "Altered Egos: The Making of (An) Other," in her *Altered Egos* (Santa Monica, Calif.: Santa Monica Museum of Art, 1994), especially pp. 10–13. She traces a similar trajectory to the one I sketch here.

3. See the *carte* portraits of Ristori and the array of *cartes* of artists illustrated in Elizabeth McCauley, *A. A. E. Disdéri and the Carte de Visite Portrait Photograph* (New Haven, Conn.: Yale University Press, 1985), pp. 93, 81. On Sarony and Bernhardt, see Naomi Rosenblum, *A World History of Photography* (New York: Abbeville Press, 1984), pp. 69, 72. Publications such as *Galeries contemporaine, littéraire, artistique* (1876–84) delivered photographic images of creative celebrities to the French public but also encouraged highly artificial and self-conscious regimes of self-display on the part of artists; see Rosenblum, p. 67.

4. See my extensive discussion of Rrose in "The Ambivalence of Rrose Sélavy and the (Male) Artist as 'Only the Mother of the Work,'" in my book *Postmodernism and the En-Gendering of Marcel Duchamp* (Cambridge: Cambridge University Press, 1993), pp. 146–90; on her signature and thumbprint at the end of Duchamp's 1926 film *Anémic Cinéma*, see p. 158; on *Monte Carlo Bond*, see pp. 160–61. I sketch the "life story" of Rrose in "Rrose/Marcel—The Artist En-Gendered: An Essay in Questions," in Moss, *Altered Egos*, pp. 15–22. On gender performance in photography, see also Jennifer Blessing, ed., *Rrose Is a Rose Is a Rose: Gender Performance in Photography* (New York: Guggenheim Museum, 1997).

5. See Jean-Michel Place, *Claude Cahun Photographe* (Paris: Musée d'Art Moderne de la Ville de Paris, 1995); Whitney Chadwick, ed., *Mirror Images: Women, Surrealism, and Self-Representation* (Cambridge, Mass.: MIT Press, 1998); and Shelley Rice, ed., *Inverted Odysseys: Claude Cahun, Maya Deren, Cindy Sherman* (Cambridge, Mass.: MIT Press, 1999).

6. See *Yayoi Kusama* (Dijon: Le Consortium, 2000), p. 40; other media representations of Kusama from this period are reproduced throughout this volume.

7. On femininity as masquerade, the classic text is Joan Riviere's 1929 "Womanliness as Masquerade," reprinted in Victor Burgin, James Donald, and Cora Kaplan, eds., *Formations of Fantasy* (London: Methuen, 1986).

8. For example, I chose this image to document the Breitmore project in the exhibition I organized in 1996 exploring feminist art history; see the catalogue *Sexual Politics: Judy Chicago's Dinner Party in Feminist Art History* (Berkeley: University of California Press; Los Angeles: UCLA Hammer Museum, 1996), p. 78.

9. Quoted in Moss, "Altered Egos," p. 12.

COMPOSING WITH IMAGES:
LYNN HERSHMAN'S PHOTOGRAPHY

Image manipulation has accompanied photography throughout its history as the repressed accompanies consciousness. In 1839 Daguerre announced that the daguerreotype "is a chemical and physical process which gives [nature] the power to reproduce herself."[1] Every subsequent claim for photography's objectivity reproduces Daguerre's assertion. *What the camera sees is true.* That same year Hippolyte Bayard—who had invented a rival photographic process—produced the first falsified photograph, *Self-Portrait as a Drowned Man.* Bayard, in a witty challenge to Daguerre, demonstrated that the photograph is not master in its own house. *The camera sees what is put before it.* Photographic objectivity is an illusion because the camera is neither the source nor the destination of its images. All subsequent image manipulation expands on this ambiguity.

Nevertheless, as Alan Trachtenberg has written, the daguerreotype came "to stand for a certain kind of truth, for objectivity, the impartial representation of facts."[2] This belief remained at the heart of the modernist ethos of "straight" photography. "Objectivity is the true essence of photography," wrote Paul Strand in 1917. "The fullest realization of this is accomplished without tricks of process or manipulation."[3] Until recently, most theorists of photography accepted Strand's position, asserting the objectivity of photographic representation. "Photography furnishes evidence," declared Susan Sontag, echoing Walter Benjamin's famous statement that "with Atget, photographs become standard evidence for historical occurrences."[4] As documentary evidence of real events, modernist photographic space remained inviolable. Confronting a photograph, László Moholy-Nagy claimed, "everyone will be compelled to see that which is optically true."[5] Sontag drew the logical conclusion: "A fake painting (one whose attribution is false) falsifies art history. A fake photograph (one which has been retouched, tampered with, or whose caption is false) falsifies reality."[6] According to this tradition, image manipulation is at best a trick or a scandal; at worst, it is a crime.

The advent of sophisticated digital image-processing tools in the 1990s has therefore struck photography with the force of a trauma, like the return of the repressed. From scandals at *Time* and *National Geographic* to the criminal falsification of passports, the violation of photographic space by tampering hands has seemed to signal a new era of indeterminacy, an "age of falsification," as Kenneth Brower put it in the *Atlantic Monthly*.[7] Yet from the beginning, a rival photographic practice has challenged the camera's veracity. Victorian-era photographers like Oscar G. Rejlander and Henry Peach Robinson produced combination prints encompassing up to thirty individual negatives. Among the modernists, Dada photographers Hannah Höch, Georg Grosz, Raoul Hausmann, and many others contested Strand's claim to exclusive possession of photography's "true essence." And well before Photoshop introduced paintlike fluidity into photographic space, artists like Val Telberg, William Mortensen, Arnulf Rainer, and Jerry Uelsmann experimented with a wide variety of manipulation techniques. The photographers in this tradition reminded viewers that image manipulation does not falsify reality; it manipulates images.

In the equation of photography with objective truth, there is a longing for stability, as if a photograph were not a composition but a transcription of reality, fixed in time and protected from change. Image manipulation brings photography back into motion, unsettling our grasp on what it depicts. As a violation of the captured moment, it makes the photographic image just one step in a signifying process that the camera does not control. Modernist "straight" photography repressed this instability, concentrating its vision in the decisive moment. Postmodernist—and especially digital—photography refigures the modernist vision, acknowledging manipulation as the essence of photography and employing it to reveal the technical, social, and psychological construction of images.

Lynn Hershman is not a photographer. Although she often employs photography in her work, Hershman rarely leaves a photograph alone. Since the 1960s, she has been reshaping photographs with paint, photocopiers, text, collage, and now digital image processing. For her, photographic space was never inviolable. She belongs rather to an alternative tradition that treats photographs as raw material in a broader project of image making. Along with artists as diverse as Arthur Tress, Duane Michals, Nancy Burson, Lucas Samaras, and Eleanor Antin, Hershman has pursued a sophisticated visual aesthetic at the confluence of photography, theater, painting, and collage.[8]

Hershman is not a photographer, but an image manipulator. As a result, her work has until

recently remained outside the mainstream of photographic concerns. The arrival of digital image processing, however, has changed that. As image manipulation breaks the surface of photographic space, it also breaks the hold of "straight" photography on the medium's history. Photographers now grappling with the powerful new tools of digital image making find themselves novice participants in a different tradition, one to which Hershman has made important contributions. The best of her predigital image manipulations point to a fluid and disconcerting relationship with images that few digital photographers have yet matched. Even the impressive and imposing images by Andreas Gursky and Jeff Wall remain rooted in a modernist aesthetic. These artists approach digital technology the way photorealists approach painting, presenting thoroughly processed images as if they were photographs.[9] For Hershman, however, digital technology merely adds to her bag of tricks, compounding her long nonphotographic relation with photographs.

But while digital tools have not radically affected Hershman's approach, they have shifted the context around her work significantly. Though she has been addressing the challenge of image manipulation for her entire career, image manipulation is no longer what it was when she began. Now, instead of opposing photography with inventive techniques of image manipulation, Hershman shares the same suite of tools with all digital photographers. In this new context, the traits that distinguished her earlier work are less distinctive. Where her predigital images were something other than photographs, her digital work clearly belongs to the new genre of digital imagery. Despite her experience manipulating images, Hershman must reinvent herself in the new medium.

A survey of Hershman's work with photography reveals two generative concerns. The first is with the techniques and strategies of image making and is expressed as a continual experimentation with materials. The second concern is thematic, addressing the social role of images in the construction of women's identity and of self-image in general. From the *Roberta Breitmore* project of the 1970s through the *Cyborg* series begun in 1997, these two concerns supply the force and direction for Hershman's art.

Among the many artifacts of the *Roberta Breitmore* project—bank checks, newspaper advertisements, a driver's license—are numerous photographs documenting Roberta's character. These images are remarkable for their range of techniques and inventiveness. Many of the Roberta photographs are evidentiary—pictures of her psychotherapy sessions, her meetings with potential roommates and blind dates (see p. 108). These images are unaltered

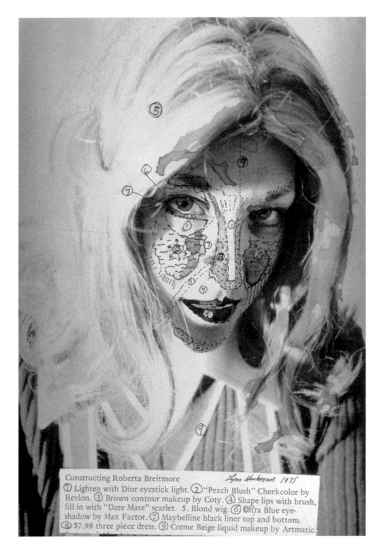

Constructing Roberta Breitmore *Lynn Hershman 1975*
① Lighten with Dior eyestick light. ② "Peach Blush" Cheekcolor by
Revlon. ③ Brown contour makeup by Coty. ④ Shape lips with brush,
fill in with "Date Mate" scarlet. 5. Blond wig. ⑥ Ultra Blue eye-
shadow by Max Factor. ⑦ Maybelline black liner top and bottom.
⑧ $7.98 three piece dress. ⑨ Creme Beige liquid makeup by Artmatic.

ROBERTA'S CONSTRUCTION CHART #1 (ROBERTA BREITMORE SERIES)

1975, C PRINT, 40 × 30 INCHES

photographically, yet they depict staged events. The staging of costumed self-portraits dates back to Bayard, and several of Hershman's contemporaries—most notably Cindy Sherman and Eleanor Antin—were simultaneously exploring the technique. Unlike Sherman's *Untitled Film Stills* (1977–80), Antin's *Angel of Mercy* series (1977), or more recent costumed self-portraits by Yasumasa Morimura, however, the staging of *Roberta Breitmore* was unannounced. These images document real events that were—in a social sense—fictional. While Sherman and Morimura recall nineteenth-century staged photography by Rejlander, John Edwin Mayall, and David Octavius Hill, Hershman's photos owe more to installation art and Happenings. They are "straight" pictures of a manipulated social reality.

Hershman's incorporation of responses within the *Roberta Breitmore* photographic works was a significant innovation. By pairing the unaltered photographs with textual counterparts, including letters from would-be suitors and transcripts of Roberta's conversations, Hershman added another layer of documentation to the manipulated scene. *Roberta's Body Language Chart* (1978, p. 109), for example, collects a series of images from her psychotherapy sessions and provides analytical commentary on her self-presentation. These images document the response of others to Roberta as a character. But they also stage the ambiguity underlying documentary photography: the camera sees what is put before it, true or not. Roberta is "real" because these documents make her seem so.

Another strategy employed in the *Roberta Breitmore* works involves documenting the manipulation of the image's content. *Roberta's Construction Chart #1* (1975) is a portrait with instructions for applying makeup. Roberta's face has been marked like a topographical map, with dotted lines and numbered shaded areas. In the caption associated with these numbered patches, we read "1. Lighten with Dior eyestick light 2. 'Peach Blush' Cheekcolor by Revlon." In all, the instructions contain nine steps.

The drawing and numbers in *Roberta's Construction Chart #1* jolt the image from the realm of photography. By entering the picture space, Hershman breaks its surface, revealing the image's artificiality. Commentary on the image is literally *on* the image, concentrating its effect. The lines and shading act as anticosmetics, unmasking the made-up face beneath.

Like *Roberta's Body Language Chart*, this image documents how Roberta is constructed as a character. Yet in both images the commentary is itself partly cosmetic, addressing the image's content, not its photographic means. Although Hershman manipulated the photographic scene, photography as a medium remains unaltered. The inclusion of text and drawing stages

a struggle between media for priority in representing Roberta. The struggle challenges photography's claim to objectivity, but it does not penetrate the medium's process. Instead, it demotes photography to illustration.

In this sense, *Roberta's Construction Chart #1* belongs to a long history of instructional and technical illustrations, whether photographs or schematic drawings, typified by images in the 1967 book *The Way Things Work*. The goal of these illustrations is to explain a technical process. Hershman's illustrations show how to produce a Roberta. *Roberta Multiples* (1977, plate 5), another photo in the series, completes this gesture, showing three women, all dressed and made up as Roberta, standing in front of *Roberta's Construction Chart #1*. Like the picture on the package of a do-it-yourself kit, this image verifies that the instructions work.

Roberta Aged by Weather and Time (1976) represents a decisive break with the strategy of documentation. Here the thematic testing of Roberta as a character has expanded to include a technical revision of Roberta as a photographic image. *Roberta Aged by Weather and Time* is also a portrait, but Hershman engages the presentation medium as well as what it presents. Roberta's image has been printed on crumpled paper and then rephotographed. As in *Roberta's Construction Chart #1*, the rephotographed face has been painted over. Text is included, but this time not as a commentary about or on the image. Instead, illegible shreds of handwriting appear on the crumpled paper where the face does not obscure it. The uneven texture of the paper and the layered surfaces of the image comment on the photograph in a less direct way than do the other photographs. Rather than offering a cosmetic commentary, the image here carries its response inherently in its presentation medium; photography has not been subordinated but incorporated in a mélange that complicates the representational space. By mixing the media, rather than commenting on them, Hershman achieves both a greater coherence and a stronger sense of conflict in the image. The best examples of Hershman's mixing of media are found in her 1984 series *Time Frame*. These images are not photo manipulations but something distinct from photography, and represent a considerable deepening of Hershman's technique. Here photographs are painted on and rephotographed, and the resulting images are then cut up and assembled as multilayered constructions that do not conform to standard photographic shape but are angular and irregular.

This intensification of layering techniques results in more than a commentary on images and image making. Rather than stand outside the photograph and critique what it presents, as Hershman does in the *Roberta Breitmore* series, here she allows the technique and the subject to interpenetrate. Issues of identity and self-presentation that were thematic in the *Roberta*

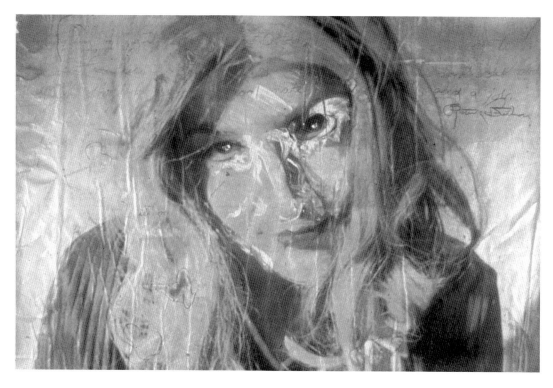

***ROBERTA AGED BY WEATHER AND TIME (ROBERTA BREITMORE* SERIES)**

1976, C PRINT WITH ACRYLIC AND COSMETICS, 30 × 40 INCHES

Breitmore works are now incorporated into the image-making process itself. The images in *Time Frame* do not seem to have had prior existence as photographs, but function more like elements of a Robert Rauschenberg combine. It makes little sense to speak of them as manipulated images, which presumes some deviation from "straight" photography. Instead, *Time Frame* points to a new approach to photography that understands manipulation, rather than objectivity, as its essence. Manipulation has become the medium. Like Rauschenberg, Hershman is composing with images.

By comparison, the much more famous photo collages from *Phantom Limb* (1988–) are conventional in their technique. A woman's body—sprawled on a bed, or in some other provocative pose—is mated with a camera head. In Hershman's words, the *Phantom Limb* series "articulates a mutation of the female body through the seduction of media. Reproductive technological parts sprout from the image of the female, creating a cyborgian reformation as parts of the real body disappear."[10] Understood in this way, these montages have achieved a kind of iconic value, representing issues of image and identity and the conflation of women with images of women. The issues are compelling, but to me they make the images less so. There is no "real" body here, just the image of one. It is as if only half of the image—the camera—has been understood as an image. The other half—the woman—is thought to be literal, a truthful representation that has been "manipulated." Instead of mobilizing these issues, therefore, the photographs seem simply to announce them. Perhaps for this reason, *Phantom Limb* has become emblematic, appearing on the cover of the journal *Leonardo* and in numerous exhibition posters. While the strategies of the *Roberta Breitmore* works jolt the viewer from photographic complacency and the techniques of the *Time Frame* series indicate a fundamentally nonphotographic relation with images, *Phantom Limb* is dominated by its theme. The subject matter is of powerful importance, but concern with the image's content deprives them of visual inventiveness. When Hershman remains within the scope of traditional photography, her images tend to become content-driven and illustrative, relying on issues to supply their force. The result can seem derivative and programmatic. When she questions her materials and invents her medium, however, her images intensify their content with their composition.

Hershman's inventiveness as an image manipulator emerged from a restless questioning of the role of media in the construction of identity. Her predigital work is characterized by a refusal to let any single medium stand alone as the bearer of meaning. In the shift from analog to digital techniques of image manipulation, however, Hershman encounters a medium that

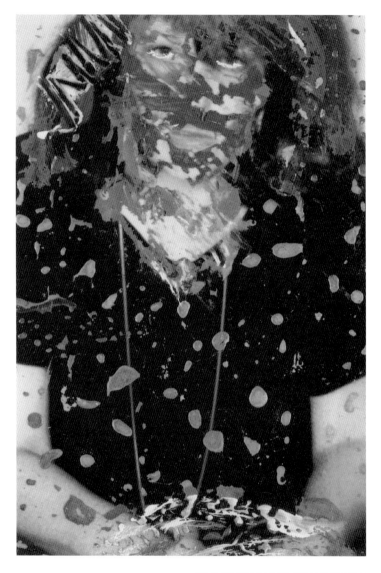

***TIME FRAME #1 (TIME FRAME* SERIES)**
1984, C PRINT FROM POLAROID WITH ACRYLIC, 6 × 4 INCHES

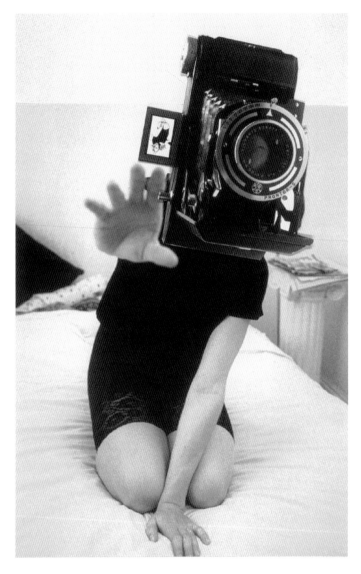

REACH (*PHANTOM LIMB* SERIES)
1988, GELATIN SILVER PRINT, 24 × 20 INCHES

already synthesizes multiple media. Thematically, her recent digital work combines many elements already visible earlier. The *Cyborg* series, for example, raises issues familiar from *Phantom Limb*, exploring the relation between bodies and technologies. Specific compositional elements—such as a focus on eyes and lips—can also be traced throughout Hershman's career. But digital technology has completely revised the techniques and materials of image manipulation. Just like formerly "straight" photographers, Hershman is working in an infant medium. The *Cyborg* series shows her in the process of reorienting herself toward this new imaging technology.

Transfusion (1999, plate 10), like many images in the *Roberta Breitmore* series, is a portrait in which the eyes have been altered. Here a woman leaning over backward smiles up at us. She has pink eyes with geometric shapes replacing the pupils. Unlike the paint applied over photographs in the *Roberta Breitmore* series, this digital intervention does not feel like a comment on the photo itself. As in *Time Frame*, the technique reaches into the image and refigures it from within. Although the alteration is subtler than in the *Phantom Limb* series, the impact is greater. *Transfusion* seems less a photograph of a woman than an image of some nonhuman intelligence.

Other images in the same series—for example, *Cyborg Lips* (2000), a pair of ruby red lips planted in the center of a swirled bodylike mass—are distinctly digital, not photographic. *Cyborg Lips* is clearly an early effort in the new medium. In some respects, however, it serves as a figure for the unexpected irony that now surrounds Hershman's work with photography. As she has moved away from visual composition with photographs and into the realm of digital imagery, both the experimentalism and the thematic critique that marked her predigital work have dissipated. Whereas *Roberta's Construction Chart #1* struggled against the overwhelming pressures of commercial imagery, *Cyborg Lips*, with its gauzy eroticism, could just as easily be a lipstick advertisement. Instead of examining the ability of photographic media to shape us, *Transfusion* displays itself, reveling in fluid digital space. It may be that cyborgs are at home in digital technology as Roberta was not in photography. But this only exposes more urgently the ways in which digital technology has transformed the context of Hershman's work.

While manipulation was the scandal at the heart of photography, it is the banal starting point of digital imagery. Digital technology already treats photographs as raw material. Consequently, the inventiveness that motivated Hershman's work with photography has now been absorbed into the new medium. Provocative and nuanced pieces like *Time Frame* remain compelling in their creative disrespect for photographic conventions. But issues and techniques

that were so remarkable in photographic form lose much of their subtlety when translated into digital imagery. Given the ubiquity of glib Photoshopping in magazines and online, image manipulation by itself may no longer furnish a sufficient basis for a powerful aesthetic.

It is as if Hershman, by using digital tools rather than inventing her own, has become a mainstream digital image maker. Yet because Hershman has been manipulating images from the start, the challenge posed by digital photography is not new to her. The computer has rendered the old conflict between "straight" photography and image manipulation moot. Neither aesthetic nor legal injunctions will succeed in repressing digital image processing. Like the pictures that composed Hershman's *Time Frame*, what used to be photography has become a new kind of image. Echoing Hershman's nondigital work, digital tools therefore compel us to imagine images that are not manipulated photography—not photography at all. Hershman's nondigital compositions already reveal this polymorphous visual sensibility, showing us what digital photography presumes but has yet to achieve. In this way, her work with photographs points beyond photography, toward an urgent, plastic relationship with images. Soon no one will be a photographer.

NOTES

1. Louis Jacques Mandé Daguerre, "Daguerreotpye," in Alan Trachtenberg, ed., *Classic Essays on Photography* (New Haven, Conn.: Leete's Island Books, 1980), p. 13.

2. Alan Trachtenberg, "The Emergence of a Keyword," in Martha A. Sandweiss, ed., *Photography in Nineteenth-Century America* (Fort Worth, Tex.: Amon Carter Museum; New York: Harry N. Abrams, 1991), p. 17.

3. Paul Strand, *Seven Arts*, excerpted in Trachtenberg, ed., *Classic Essays*, pp. 141–42.

4. Susan Sontag, *On Photography* (New York: Farrar, Straus and Giroux, 1989), p. 5. Walter Benjamin, "The Work of Art in the Age of Mechanical Reproduction," in his *Illuminations*, ed. Hannah Arendt, trans. Harry Zohn (New York: Schocken Books, 1968), p. 226.

5. László Moholy-Nagy, "Photography," in his *Painting, Photography, Film*, trans. Janet Seligman (Cambridge, Mass.: MIT Press, 1967), p. 28.

6. Sontag, *On Photography*, p. 86.

7. Kenneth Brower, "Photography in the Age of Falsification," *Atlantic Monthly* 281, no. 5 (May 1998) pp. 92–111. (Also: www.theatlantic.com/issues/98may/photo.htm.)

8. For a good introduction to contemporary image manipulation, see Anne H. Hoy, *Fabrications: Staged, Altered, and Appropriated Photographs* (New York: Abbeville Press, 1987).

9. According to Peter Galassi, "Gursky . . . has explained that he intends us to approach his pictures as photographs. The goal is not to fool us; it is to frame our response to the image within the culture of photography, and so to draw upon photography's histories and habits, its deep-seated associations and visceral intuitions." Peter Galassi, "Gursky's World," in Galassi, ed., *Andreas Gursky* (New York: Museum of Modern Art, 2001), p. 39.

10. Lynn Hershman Leeson, "Romancing the Anti-body: Lust and Longing in (Cyber)space," in Hershman Leeson, ed., *Clicking In: Hot Links to a Digital Culture* (Seattle: Bay Press, 1996), p. 333; also excerpted in this volume.

CONSCIENTIOUS OBJECTIFICATION: LYNN HERSHMAN'S *PARANOID MIRROR*

ABIGAIL SOLOMON-GODEAU

In more than two decades of artistic production embracing a spectacular range of media (from performance to ceramics; from manipulated photography to interactive video installation), Lynn Hershman has explored continuously the complex relations between looking, being looked at, gender, and subjectivity. Such a preoccupation is hardly surprising; for an artist dealing with technologies of vision, spectacle, and spectatorship, the political as well as psychic stakes that underpin the field of vision are urgent, compelling, and inescapable.

One of the crucial precepts of feminist theory is that the act of looking is neither neutral nor innocent (as in the sense of a putative "innocent eye" whose relation to the phenomenal world is purely instinctive and receptive). On the contrary, a number of important critical traditions converge in a complementary analysis of the ways vision is implicated (from the Latin *implicare*, "to be folded within") in questions of power, knowledge, sexuality, and subjectivity. From the psychoanalytic, specifically Freudian model of vision derives the notion of what Freud termed the scopic drive, a drive that he speculated could manifest either actively (erotic pleasure in looking while being unseen, as in voyeurism or scopophilia) or passively (erotic pleasure in being looked at, as in the act of exhibitionism).[1] While the voyeurism of a peeping tom and the exhibitionism of a flasher are classified as perversions, Freud emphasized that, as drives, (active) voyeurism and (passive) exhibitionism are innate components of normal subjectivity. Moreover, by locating the child's initial recognition of sexual difference in a fateful moment of visual perception, Freud further accentuated the crucial role of vision in the formation of sexed subjectivity.[2]

Feminism elaborates this conception of the visual field as a locus of sexuality through its political analysis of the determinations of patriarchy on the shaping of human sexuality. Thus the active/passive distinction made by Freud in his theorization of the scopic drive has particular implications when the active position is conventionally associated with masculinity (hence with the greater power and privilege of male subjects) and the passive one associated

with femininity. In other words, while active and passive drives are jointly present within the psyches of male and female subjects, the unequal order of sexual difference within patriarchy ensures that the power of the look—the power *to* look—is conventionally attributed to men. Furthermore, insofar as men (historically speaking) have wielded the means of visual representation—the easel, the chisel, the photographic and movie cameras—and women have often been the objects of their representations, feminism speaks of a politics of representation in which the subordination of women is both expressed and reproduced within the dominant representational systems.

Along with the formulations produced within psychoanalytic and feminist theories, a third critical perspective derives from the work of Michel Foucault. In books such as *Discipline and Punish* (1973) Foucault took as his object of inquiry a look, a gaze, a technology of observation and surveillance that was neither intrasubjective nor simply identified with a given individual. Rather, he hypothesized a "panoptic" gaze whose most vivid instance was an "ideal" prison—the Panopticon (the all-seeing)—conceived by British philosopher Jeremy Bentham in 1791. Bentham's prison was organized as a circular series of cells, each connected to a central room where a single jailer could survey the cells' inmates; the jailer, hidden by shutters, could not himself be seen. Thus, inmates lived with the knowledge that they were potentially subject to an (invisible) gaze, whether or not, at any given moment, they were actually being observed. Furthermore, as Martin Jay writes, "Even the jailor is subjected to the controlling gaze of the public, which provided the ultimate moral sanction against deviance from the norm."[3] For Foucault, this panoptic gaze functioned as a central metaphor for the progressively encroaching forms of disembodied state power, in which the mechanics of vision were "complicitous in the complementary apparatuses of surveillance and spectacle so central to the maintenance of disciplinary or repressive power in the modern world."[4] Psychoanalytic, feminist, and critical theory have therefore all operated not only to denaturalize vision and to explode the myth of its innocence but also to explore its agency in complex systems of mastery, control, and domination.

That many, if not all, cultures surround the act of vision with proscriptions and prescriptions as well as with phantom fears (the evil eye, the gaze of Medusa, for example) further suggests that vision is as social as it is physical. It is far from being an innate and natural capacity; human infants must learn to focus their gaze, to follow something in motion, to distinguish between near and far, to coordinate peripheral and central vision. Once vision has been learned and mastered, it is subsequently "worked upon" by the social world as it works

to acculturate the human infant. Culturally variable strictures and rules—the association of staring with rudeness, for example, or bounds forbidding women (or men) from looking at certain objects, or children from looking directly at the eyes of an adult—are testimony to the profoundly social nature of vision.

As one of the five senses that connects the internal self to the external world, subject to object, vision is not only marked and shaped by the social, but it is also an organ of intrasubjectivity: the capacity to distinguish self and other and to have relationships with others is founded on the existence of a discrete self whose incremental formation is influenced significantly by looking, seeing, and being looked at. Although arguing for the fundamentally illusory nature of a discrete self, French psychoanalytic theorist Jacques Lacan nevertheless located the germ of such a self in the child's first "jubilant" recognition of itself in a mirror, a captivation through an image that henceforth becomes the model for later identifications and idealizations.[5]

This "captivation through an image" is also one of Hershman's central themes. It is, one might say, the ruse and the lure by which she catches out the spectator, who thereupon discovers himself or herself to be "complicitous in the complementary apparatuses of surveillance and spectacle." This theme, which can be traced through work as early as *The Dante Hotel* (1973–74), has been both refined and expanded in works employing systems and technologies that are themselves agents of surveillance—notably, video cameras, invisible sensors, and lasers. In such projects, the dynamics of voyeurism, objectification, and spectacle—all more or less abstract concepts—are materialized in forms that render them visible, literal, and thus available to critical reflection and analysis.

For example, in the interactive computer and laser-disc installation *Room of One's Own* (1990–93), the spectator looks through the viewer—really a high-tech peephole—and observes a total of four video "scenes" featuring a seductive, German-accented blonde woman.[6] These can be experienced in a total of seventeen different ways, depending on how the sequence is sparked by the viewer's mobilization of the interactive mechanism. In one of the four video sequences, the woman has what seems to be a commercial phone sex conversation with the caller in which the agreed-upon fantasy is a sexual encounter within a prison cell. In another, the woman addresses the spectator directly as she strips to her underwear, protesting her visual objectification and surveillance ("Don't look at me," "Go away"). In another, the viewer sees a close-up of a woman's eyes with the rhetorical inscription "Are our eyes targets?" In the fourth scene, a woman shoots a gun directly at the spectator (plate 8), shattering a glass plane between them—the video equivalent of the theatrical fourth wall.

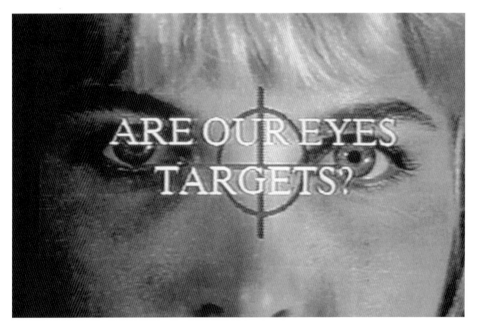

ARE OUR EYES TARGETS?

ROOM OF ONE'S OWN
1990-93, INTERACTIVE INSTALLATION

ROOM OF ONE'S OWN (STILL)
1990-93, INTERACTIVE INSTALLATION

Each of these sequences is visually activated when the spectator focuses the movable viewing apparatus on a specific object within the miniature roomlike environment (the "real" space, plate 9) in front of the virtual space of the video screen: the bed, the video monitor (in which the viewer's eyes are both projected and mirrored), the telephone, the chair, or the heap of clothing. Focusing on the bed, for example, produces an audio track of jouncing bedsprings, the sounds of lovemaking, and a tinny radio playing a song, and a ghostly image of a woman imprisoned behind the bedposts.

With its eroticized atmosphere, seductive protagonist, and privatized viewing conditions, *Room of One's Own* quite deliberately mimics the scopic economy of the peep show. Invited to peep and provided the desired spectacle of femininity staged for the looking, the viewer is, in effect, both captivated by and made acutely aware of the equivocal nature of this voyeuristic scenario. The woman's protests ("Go away"), the rhetorical questions ("Are our eyes targets?"), and, most important, the "literalizing" of the libidinal politics of looking create a space of ethical self-reflection, a critical intervention into the mechanics of spectacle that is one of the consistent features of Hershman's work. If we accept the notion that the act of looking, particularly at an eroticized feminine protagonist, is inflected by the determinations of sexual difference—in other words, if we accept that the male gaze directed at an image of a woman involves otherness and difference, whereas the female gaze directed at the same image operates in the register of sameness, of identification, the question remains how differently Hershman's installation works upon male and female spectators. Commodity culture, however, depends massively on icons of eroticized femininity and is addressed to men and women alike; the gaze of women is socially and culturally constructed in ways that effectively "masculinize" it, promoting similar tendencies toward objectification, if not fetishism in the strict Freudian sense of the term.

Photographic technologies have functioned historically as crucial agents in the formation of what Guy Debord famously termed the "Society of the Spectacle," a postmodern culture in which all consciences are colonized by a parallel world of signs and images. Consistent with her ongoing interrogation of the mechanics of spectacle, Hershman, in the 1994–95 interactive installation *America's Finest*, continued her exploration of the darker side of photographic representation in a work that structurally and formally interweaves the representation of violence with what might be termed the violence of representation. The invention of a camera/gun by French physiologist Étienne Jules Marey in 1888 for the photographing of bodies (and animals) in motion supplied not only the technological precedent for *America's Finest*,

but also a metamorphic structure that enabled Hershman to make visible and tangible the aggression and objectification that underwrites most photographic practice. Here Hershman rendered literal the conventional vocabulary of photography: to "shoot" or "aim" the camera, to "capture" an image, to "take" (rather than "make") a picture, and so forth. In so doing, Hershman acknowledged that the aggressive connotations of the photographic lexicon register a cultural intuition that the photographic act always and already implies a kind of violence between subject and object.

Hershman's photographic gun is a particular one: an M16—the same model used by the United States Army during the Korean, Vietnam, and Gulf wars. Hence, the installation compels the viewer to reflect not only on the metaphoric violence of photographic practice, but also on the actual violence associated with the rifle and on all that it signifies in the immediate history of the United States. And just as the power to wield a gun implies the possibility of being its target, so, too, does the installation position the spectator as the object of the gaze: as the spectator focuses the rifle using the periscopic sight, she becomes an image herself, captured by a video camera and mounted on the facing wall. The spectator sees herself waxing and waning against one of a series of forty-odd still photographic images, both historical and modern, depicting violence, warfare, and desolation and accompanied by random sound effects, including, in some instances, the sound of gun or rifle fire. As in *Room of One's Own*, the spectator is made to enact the very processes that the work investigates or exposes. Each squeeze of the gun's trigger changes the image. If the trigger remains pressed, the sound and image sequence is "caught" in a loop; when the trigger is released, and before a new sequence begins, the previous image visually underlies the new one—a "history," as it were, of the present moment. Stenciled on the walls are the words "capture," "captured," and "caption," reiterating the work's central theme: the parallel between the camera's capture of the world and the spectator's captivation by the image. Hershman's description of *America's Finest* specifies that the gun/camera "becomes an assault, and, in effect, a conscientious objectifier to what it is seeing, tracking, and recording."[7]

Whereas the concerns of *America's Finest* are not particularly gender specific, *Paranoid Mirror* (1995–96), like *Room of One's Own* and, indeed, most of Hershman's work, is not only informed by issues crucial to feminism but specifically addresses a female spectator. Like *Room of One's Own*, *Paranoid Mirror* uses mainly female protagonists and contains sequences that stage the conflict between the viewer's desire to look and the (imaged) woman's protest at that look. Similarly, it implicates the spectator in the visual spectacle it produces; the spectator is

herself photographed from behind by a wall-mounted video camera and projected into the image field of the mirror. It also stages a complicated dynamic of feminine subjectivity that pivots on the conditions of hypervisibility and its obverse, invisibility. This dynamic exists on several different levels: Young women are culturally positioned as loci of eroticized looking, while older women become gradually erotically invisible. Similarly, women of color are culturally positioned such that certain "types"—the entertainer, preeminently—are hypervisible, whereas other women of color are condemned to discursive invisibility. On a more abstract and general level, we might say that the installation alludes to that condition of femininity whereby the feminine is everywhere discursively "spoken," everywhere on display, but women in their concrete material reality are somehow absent, occluded from what Luce Irigaray posits as a (patriarchal) culture of "hommo-sexuality."[8]

Insofar as the three women featured in the video installation are emblematic of three stages within a woman's life cycle, and that one sequence of the video can be read as a young woman's frightened flight from the onlooking specter of old age, *Paranoid Mirror* addresses at least some of the implications of what can (inelegantly) be called the "spectacularization" of women. Because women are culturally constructed as the object of desirous looking, patriarchal ideologies simultaneously assume women's complicity in soliciting the look—hence the historical association of women with vanity, as exemplified in the Renaissance emblem of Vanitas, the woman with the mirror. The mirror, however, has other associations: as a symbol of truth, of surveillance (as in a two-way mirror), and—well before Lacan—of subjectivity itself. *Paranoid Mirror* exploits all these meanings, its "paranoia" jointly mobilized both within the spectacle it stages and without—in the field of the spectator herself.

As with *Room of One's Own* and *America's Finest*, *Paranoid Mirror* is activated by the viewer's physical presence. When the viewer approaches what initially appears to be a decorative oval wall-mounted mirror in a small room, hidden sensors in the floor trigger the video projected upon the mirror's surface. The sensor-activated area allows for two "stations," so the woman in the initial image—the hauntingly beautiful, aged face of Anne Gerber—appears to look directly at the spectator. The person "observed" by this uncanny spectatorial address has no way of knowing that Gerber is nearly blind, yet surely this extrinsic fact suggests Freud's invocation of the "blindness of the seeing eye," the limitations of visual empiricism in knowledge of neurotic illness. Moreover, the classic paranoid delusion of being spied upon is at one and the same time simulated (Gerber's eyes seem to follow the spectator) and covertly denied (the eyes are blind, her image an illusion).

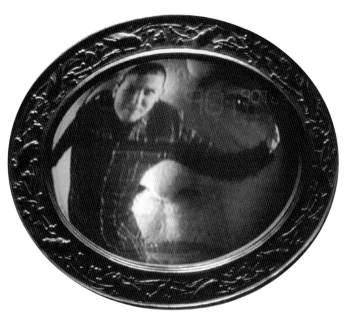

PARANOID MIRROR
1995-96, INTERACTIVE INSTALLATION

PARANOID MIRROR
ON EXHIBIT AT THE
SEATTLE ART MUSEUM, 1995

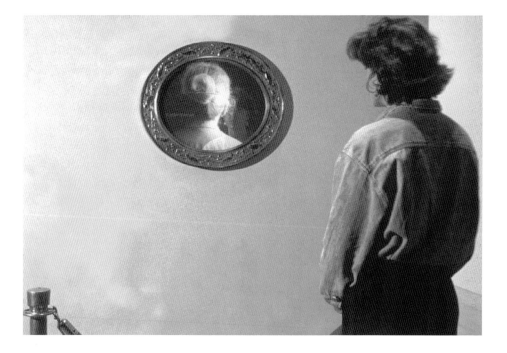

Gerber's recurring visage is the dominant visual presence in *Paranoid Mirror*, punctuating the sequences that feature the two other women: African-American singer Paula West and a young French woman, Marine Macerot. The three women are representative not merely of femininity and its different life stages but of differences between women—in this case, racial and linguistic differences (Macerot speaks partly in French, West sings in English, and Gerber is silent). Succeeding the initial image of Gerber, whose face slowly moves in and out of the frame, is one of Macerot running, apparently fearful, eyes darting anxiously and looking back at the face of Gerber behind her. Gerber's face dissolves, supplanted by the exterior setting of a Seattle street, at which point Macerot freezes in place, seemingly relieved.

Macerot's discourse, delivered partly in French and partly in English, most directly engages the question of visibility/invisibility in relation to subjectivity and paranoia, for what is enacted here is the contradiction of being effaced as a subject in the field of the other's gaze and, conversely, of being confirmed as a subject precisely to the extent that one exists in the field of the other's gaze. Addressing the spectator, Macerot says, "J'ai l'impression d'être invisible; j'ai l'impression de disparaître [I have the impression of being invisible; I have the impression of being made to disappear]," conveying to the spectator women's experience of effacement. Progressing subsequently to "Je veux être invisible; je veux disparaître [I want to be invisible; I want to disappear]" and finally to the protest in English, "Can I have a little privacy? Go away!" the narration invokes not only the paranoid experience of remorseless surveillance but also the subjectivity that is effectively secured by one's presence in the field of vision. The first phrase of West's song, which begins "Don't try hiding, it isn't any use," equally evokes the phantasms of paranoia. But it is the recurring and benevolent sightless gaze of Gerber that instates the relation of (normal) subjectivity—the condition and acceptance of being seen—to the persecutory fears of the paranoid and the oppressive instrumentalities of surveillance and spectacle. For the spectator, who is both inside and outside the visual spectacle, subject and object of the representational arena, and specifically for the female spectator, for whom the women in the video may be alter egos, surrogate selves, *Paranoid Mirror* may be said to express the ambivalent and contradictory condition of femininity itself.

The mirror has yet another historical symbolic meaning invoked in this work. As deployed in so many Renaissance Netherlandish paintings, the mirror is a symbol for the all-seeing eye of God. Hershman's mirror is, in fact, intended as an allusion to the one in Jan van Eyck's *Portrait of Giovanni (?) Arnolfini and His Wife* of 1434. There the subjects of the painting are reflected in the mirror's convex surface, as is the painter himself, who is otherwise excluded

from the field of the image. The video imagery of *Paranoid Mirror* concludes with a brief shot of Gerber being directed by Hershman and filmed by a cameraman. Although it is the artist's eye and not the deity's that this image registers, the inscription of the artist's activity has as much to do with the ethics as with the aesthetics of Hershman's art. In other words, the "baring of the device"—the manifest display of the material conditions of illusion that have produced the work—functions to dispel the distortions of illusion, the lure of spectacle. As an act of disclosure, as well as of formal closure, Hershman declares that her artistic activities of conscientious objectification are in the service of subverting our collective captivation by the image.

NOTES

This essay was originally published in the exhibition catalogue *Lynn Hershman: Paranoid Mirror*, by Don Reneau, Florian Rötzer, and Lynn Hershman Leeson (Seattle: Seattle Art Museum, 1995). Reprinted by permission of the author; © Abigail Solomon-Godeau.

1. For Freud's discussion of the scopophiliac drive, see "Instincts and Their Vicissitudes," in *Standard Edition* (London: Hogarth Press, 1953–74), vol. 14, pp. 109–40.

2. Relevant texts by Freud on the child's recognition of sexual difference include but are not limited to the following: "Three Essays on the Theory of Sexuality," in *Standard Edition*, vol. 7, pp. 123–245; "On the Sexual Theories of Children," in *Standard Edition*, vol. 18, pp. 118–39; "Some Psychical Consequences of the Anatomical Distinction Between the Sexes," in *Standard Edition*, vol. 19, pp. 241–60; and "Fetishism," in *Standard Edition*, vol. 21, pp. 147–50.

3. Martin Jay, *Downcast Eyes: The Denigration of Vision of Twentieth-Century French Thought* (Berkeley: University of California Press, 1993), p. 382.

4. Ibid., p. 383.

5. Jacques Lacan, "The Mirror Stage as Formative of the Function of the I," in Lacan, *Ecrits* (New York: W. W. Norton, 1977).

6. An excellent discussion of this work is Margaret Morse's "Lynn Hershman's 'A Room of One's Own,'" in *Lynn Hershman: Virtually Yours* (Ottawa: National Gallery of Canada, 1995), pp. 3–9; also on DVD.

7. Press release, Gallery Paule Anglim, San Francisco, June 7–July 1, 1995.

8. Luce Irigaray, *The Sex Which Is Not One*, trans. Catherine Porter and Carolyn Burke (Ithaca, N.Y.: Cornell University Press, 1985).

MEDIA PHANTASMAGORIA

But the puppet was a caricature, an irritating and grotesque imitation that a bit of intelligence or courage was sufficient to unmask. The problem for us is that our images are so perfect, so seductive, and that we are so used to living in their midst, conforming our actions and even our thoughts to them, that we can no longer distinguish between appearance and being.
—MAX MILNER

JEAN GAGNON

When discussing her interactive video installation *Room of One's Own* (1990–93), Lynn Hershman readily acknowledges its ancestry in Thomas Edison's kinetoscope, invented in 1891.[1] Better known as the "peep show," the kinescope may, to paraphrase Olivier Kaeppelin, be thought of as theater that embodies the solitude at the core of our relationships with one another.[2] In Hershman's videotapes, we encounter this theater of solitude once again.

Like the kinescope, *Room of One's Own* constructs the framework for "another scene" based on the scopic drive, by which "the passion to see, the passion to know, and sexuality are inextricably combined and mutually *disguised*."[3] Hershman's works convey the notion that in our media-driven world, dominated by "communication" technologies, the sense of solitude is ever more pervasive. This distancing is exemplified in pornography, where human interaction becomes a virtual fantasy expressed through phantasmagoric devices.

The term "phantasmagoria," which first appeared around 1800, refers to the art of causing ghosts or phantoms to appear by means of optical illusion. The phantasmagoria is basically a show whose function is to open visual space into another scene into which one's own desires and fantasies are projected or by which they are engulfed. Cinema is one of the best-known and most thoroughly analyzed phantasmagoric apparatuses. Max Milner draws a distinction between the words "phantasmal" and "phantasmagoric," defining the former as referring to the work of the unconscious, which produces effects, associations, combinations, and meaningful symbolizations, and the latter as at least partly conscious, consisting of all the formal and discursive strategies through which the work achieves its impact on the viewer. The phantasmagoric, then, is the manner in which the artist gives expression to the fantasy and structures it for the viewer.[4] Hershman's works themselves are phantasmagoric, in that the optic instruments or "seeing machines" (the still camera, the movie camera, the video camera) are metaphors for knowledge in which mechanical objectivity is both the instrument and locus of production of the individual's narcissistic masks.

Philosophers have long used optic apparatuses and metaphors to represent notions of clarity, evidence, and transparence.[5] But today the advent of electronic media, the ever-increasing number of images and channels of image transmission, and the demarcation of space by media surveillance present other apparatuses and metaphors based on misperception, lack of awareness of the other's secret, and the diffraction of one's own secret through masquerade in a sort of narcissistic parade. As Hershman comments in *Desire Inc.* (1990): "Mass communication is masked communication."

If Jean Baudrillard is correct in asserting that "femininity belongs to the realm of the secret, masculinity to the realm of the obscene,"[6] then we should not be surprised to discover that men wend their way through Hershman's phantasmagoric media universe in a different manner from women. The notion of *masquerade* is at the heart of her aesthetic, and this subject is eloquently treated in *Shooting Script: A Transatlantic Love Story* (1992), which describes itself as "a story of intrigue and manipulation." The work is a collaboration between Hershman, an American feminist artist from San Francisco, and Knud Vesterskov and Ulrik Al Brask, two Danish directors whom she describes as "macho." The story revolves around a video correspondence between a young woman from San Francisco, Chrystene, and a young Danish man named Jens. Through this communication process, we discover two opposed phantasmal universes, two forms of narcissistic self-presentation through video, and two gendered negotiations of identity in the world of media images.

The man's phantasmagoria articulates an imagination dominated by a pornographic vision: mastery of the image and of the woman, abolishing differences by the projection of masculine desire. The woman's phantasmagoria involves masquerade as a means of distancing herself from the masculine projection and as a strategy for escaping the manipulation of her image produced by male desire. His phantasmagoria involves a passion to see and to be seen (he would like to film himself making love, which she finds in very bad taste) and a phallocentric belief in the male body's power of seduction. In a revealing scene at the beginning of the video, Jens goes to a hotel room where he expects to meet Chrystene (played by Hershman) and hopes to make love to her. As he undresses before the cameras and Chrystene sits on the couch, he declares that the whole situation strikes him as perverse and highly exciting.

The female phantasmagoria involves a multitude of signifiers attached to the surface of Chrystene's body (wig, makeup, and personae) to help her assume a certain position in relation to her image and to find the proper distance to connote "femininity" without revealing any essence or truth. The man, firmly planted in his identity, is direct, while the woman is fleeing, flickering.

SHOOTING SCRIPT: A TRANSATLANTIC LOVE STORY (TWO STILLS)
1992, VIDEO

The position of women in relation to the image, and that of the female viewer in particular, has been the subject of numerous theoretical investigations in feminist studies on cinema. It is precisely the opposition between proximity and distance, between control of the image and the loss of control over it, that constitutes sexual difference in spectatorship. This leads Mary Ann Doane to conclude that "for the female spectator, there is a certain over-presence of the image—she *is* the image."[7] Masquerade is one possible position of feminine narcissism in relation to images of women in and at the movies, and, by extension, in the media (magazines, television, video clips). In *Shooting Script: A Transatlantic Love Story*, Chrystene employs masquerade to establish a distance between herself and her image; in other words, she paradoxically creates an excess of femininity, in which many tones are possible: parody, irony, interplay with the image, and tricking the image. Masquerade, Doane writes, "constitutes an acknowledgement that it is femininity itself which is constructed as mask."[8]

Chrystene describes herself as a "puppeteer/manipulator/operator/live-animator," Hershman's alter ego. The issue is one of control over the image, manipulation of one's own image as articulated in an environment of media images and an imagination dominated by pornographic paradigms. In earlier works, such as *Desire Inc.*, Hershman demonstrated that the channel of transmission of images largely determines their reception; *Shooting Script: A Transatlantic Love Story* shows how impossible it is for a young woman to stabilize her image. Female identities and personae are negotiated in the diffraction produced by masquerade. Hershman suggests that the masculine phantasmal imagination is more structured, more conditioned to the position of the voyeur and the illusion that he controls the image, and that the woman's vicarious position is characterized by a more playful nature. The woman, the image and signifier of desire, constructs herself through an excess of signifiers, thus disturbing the organization of language and the symbolic system.[9]

The task of the phantasmagoria is to make the fantasy speak. In *Shooting Script: A Transatlantic Love Story*, Chrystene fantasizes that the small dog puppet on her hand is a sort of virtual beast that takes on a life of its own as soon as she puts it on—a kind of imaginary data glove. Hershman extended her exploration of the then recently popularized notion of virtual reality in *Virtual Love* (1993), suggesting that it is based on the same principles as pornography: the taboo of touch, and phantasmagoric virtuality in a simulacrum of intimacy, in which the body is the fetish and support of the fantasy. Is virtual reality another form of manipulation? Are we not "infected by the delusion of synthetic desire, incorporated desire, that we incorporate"?[10]

In Hershman's work, masquerade is generalized; it is the organizing principle behind the editing and image manipulation—masquerade rather than "collage" or "dé-collage," as one finds in Nam June Paik's work, for instance.[11] She calls the media "reproductive technologies," technologies that lay claim to the female body under an idealized male view of femininity.[12] As a feminist artist, Hershman takes us into her phantasmagorias and the masquerades occurring there, offering proof that our interest in the media stems from the very fact that they are unworthy of our trust.

NOTES

This essay was originally published in the exhibition catalogue *Lynn Hershman: Virtually Yours* (Ottawa: National Gallery of Canada, 1995). Reprinted by permission of the National Gallery of Canada.

Epigraph from Max Milner, *La fantasmagorie* (Paris: Presses Universitaires de France, 1982), p. 244.

1. See her "Room of One's Own: Slightly Behind the Scenes," in Timothy Druckery, ed., *Iterations: The New Image* (Cambridge, Mass.: MIT Press, 1993), pp. 150–56.
2. Olivier Kaeppelin, "Égorgement discret et chasse violente: Scénographies d'un peep-show," *Traverse*, no. 29 (October 1983), pp. 114–20.
3. Milner, *La fantasmagorie*, p. 144 (emphasis added).
4. Ibid., p. 253.
5. From Plato's story of the cavern in *The Republic* to Foucault's study of the Panopticon, philosophers have used optic metaphors to talk about knowledge.
6. Jean Baudrillard, "What Are You Doing after the Orgy?" *Traverse*, no. 29 (October 1983), p. 10.
7. Mary Ann Doane, "Film and Masquerade: Theorizing the Female Spectator," in *The Sexual Subject: A Screen Reader in Sexuality* (London: Routledge, 1992), p. 231.
8. Ibid., p. 234.
9. This is also a position commonly taken by gay artists, exemplified by Camp style.
10. Hershman, in *Desire Inc.*
11. John G. Hanhardt makes collage and dé-collage the organizing principles of Paik's video language and essential categories of videography. See "Dé-Collage/Collage: Notes toward a Reexamination of the Origins of Video Art," in Doug Hall and Sally Jo Fifer, eds., *Illuminating Video: An Essential Guide to Video Art* (New York: Aperture; San Francisco: Bay Area Video Coalition, 1990), pp. 71–79.
12. Ibid.

LYNN HERSHMAN:
THE SUBJECT OF AUTOBIOGRAPHY

I should live no more than I can record.
—JAMES BOSWELL

Lynn Hershman's *The Electronic Diaries* (1986–) was a crucial breakthrough for her own career as an artist and indeed for artists' video generally. A summary restatement of many of the concerns of feminist video of the previous decade and a half, it turned out to be an immensely fertile matrix that quickly generated a series of further tapes—*Longshot* (1989), *Desire Inc.* (1990), *Seeing Is Believing* (1991), and *Conspiracy of Silence* (1991)—elaborating the themes it had developed. In placing *The Electronic Diaries* and the tapes it engendered within the theoretical parameters of autobiography, my primary concern is with themes of love and death, with the mutual imbrication of erotic and thanatotic impulses as they pass from the psychology of the autobiographical subject to the nature of video itself, which, as both text and social exchange, is the medium of that subject's realization. Hershman's work affirms video's ability to represent—to construct and deconstruct—a self, but that ability is at the same time challenged as the medium asserts its own specificity, its own authority, its own desire.

In its self-obsession, Hershman's work finds itself in the historical field of what, in a seminal article, Rosalind Krauss termed the "aesthetics of narcissism."[1] But in this field, Hershman's particular contribution is to have shown how the splitting of the subject and its imaginary reformulation in the electronic mirror, which was so important in early video, may and should be negotiated not only in the immediate apparatus—the camera and the monitor—but also in the total televisual environment—broadcast, interactive, cable, surveillance, medical, and so on—with which it is integrated. Only in the multiple, dispersed yet interconnected practices that constitute television as a whole may an adequately extensive, flexible, and nuanced metaphor for the self now be found. Television as a whole is the site of the self's own discovery and transformation, but also its imperilment. Given the chronology of recent art history, this reflexive concern with the medium appears as a return to earlier problematics;

and indeed, as often as not correlatives for Hershman's innovations lie in avant-garde film of the late 1960s and early 1970s as much as in video. But it is also progressive—at least potentially so—in that rather than repressing the social economies among which artists' video lives, it opens out to them and so toward an understanding of the self as a social process constantly mediated by public institutions.

The parameters of such an autobiographical project were described more than fifteen years ago (when the production of film autobiographies was at its apogee) in P. Adams Sitney's "Autobiography in Avant-Garde Film."[2] Tracing the film autobiographies of Stan Brakhage and others to the tradition of St. Augustine, Rousseau, and Wordsworth, Sitney showed how the conditions of literary autobiography were renegotiated in the new medium. Much of his analysis is film specific—for example, he writes of the habit of collecting still photographs to accumulate a personal chronology inhabiting and supplying a fundamental trope to autobiographical film, whose materiality consists precisely of a chronology of still photographs. But his formulation of the axioms of literary and film autobiography can readily be made over to video; they include the privileged status of "the moment at which the author realized his vocation as a writer," the ubiquity of the search for cinematic strategies that can relate "the moments of shooting and editing to the diachronic continuity of the film-maker's life," the frequent contingency of the tropes of film autobiography on the material nature of the medium,[3] and the observation that "the very making of an autobiography constitutes a reflection on the nature of cinema, and often on its ambiguous association with language." These issues, reconstituted in terms of video, are precisely Hershman's concerns, but the last—the reflection on video and its relation to language—is summary. As Hershman employs video to "write" her autobiography, she is drawn to investigate both its nature as language and the role of verbal language within it. For while video provides the arena in which an autobiographical self can be talked into being, that talking is realized only via video; the verbal is always mediated through its specific electronic visualization. Investigating this mediation in successive tapes, Hershman discovers that the social relations that constitute her life are themselves similarly mediated through video as text and video as social process, video as audiovisual electronic information and video as a network of social institutions and apparatuses in which this information comes into being.

The Electronic Diaries are almost entirely comprised of Hershman directly addressing the video camera, a confrontation that also allows her to directly address the spectator, thereby making the spectator aware of her or his role as spectator. As in other notable video works—Vito Acconci's *Air Time* or Lynda Benglis's *Now* (both 1973), for example—the ostensible privacy of the artist's conversation with the camera mimics the scene of psychotherapy, securing a place where the self may be encountered and a self-image constructed. And, as is axiomatic in this tradition, the monitor supplies both a mirror in which the subject may perceive an objectified form of herself, partially reified but still in flux, and also a stage upon which she may set herself to play assumed personae. But unlike the received video tradition, typically premised on immediate image feedback as the vehicle of a drive toward personal authenticity, Hershman foregrounds artifice. As the effects of image manipulation during editing make plain and the credits make explicit, the images of Hershman have been worked on by many people, both during the initial recording and since. While she does not, at least not explicitly, go so far as to admit that the claims for veracity and sincerity that have subtended the autobiographical tradition since Rousseau are not so much impossible as irrelevant,[4] Hershman constantly toys with her own credibility. She drops us in an abyss between belief and denial, between video and life. Her autobiographical confessions all deal in seduction.

The fundamental condition of *The Electronic Diaries* is, then, the instability of Hershman's self as their subject. Initially set in play by the changes in her video image, attractive at times and repulsive at others, this instability recurs in the spectator's parallel negotiations with the more elaborated forms of the same images as they appear on the finished tape. The *Diaries* are inhabited by narcissism and exhibitionism; their overriding need is to make the artist/model perform a self that is sufficiently interesting and desirable to hold our attention—no mean task, given the competition. Linking these two points—Hershman's approach to her video image and our consumption of it—is the process of composition, of manufacture.[5] Here two formal strategies are especially important in the mediation of the autobiographical discourse as video: first, an ongoing interfolding of the tropes of documentary with those of fiction; second, Hershman's distinctive montage style, which consists of very brief shots, each replaced (or displaced, or consumed) by the next, commonly by means of some kind of image manipulation—a wipe, for example, or a dissolve created by an initially inset second screen taking over the whole. The first of these formal strategies (which is especially prevalent in the later tapes that contain other characters besides Hershman) prevents any secure differentiation of biographical truth from authorial fabrication for thematic or narrative effect. The second

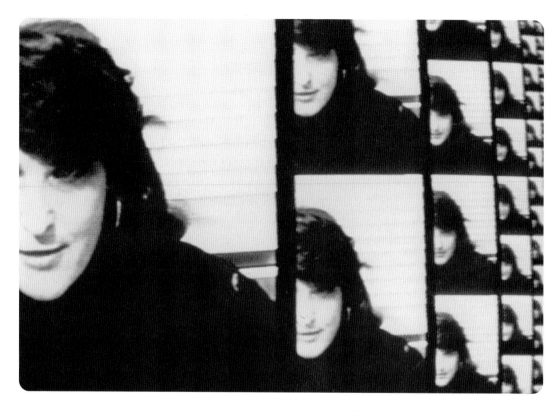

BINGE, **PART 2 OF** *THE ELECTRONIC DIARIES* **(STILL)**

1987, VIDEO

strategy, which epitomizes the tapes' reflexive affirmation of the centrality of video in Hershman's construction of herself and others, vividly figures the impossibility of an autonomous, uninterrupted self; there can only be a succession of provisional, video-dependent images of it. Flux, established by Raymond Williams's early writings as a characteristic of television, is similarly the condition of the subject.

In each part of *The Electronic Diaries*, Hershman investigates an aspect of the traumas that have shaped her and that consequently have become the recurrent themes of her autobiography. In the first part, subtitled *Confessions of a Chameleon* (1986), she tells how she was abused as a child and in defense constructed imaginary personae for herself. She then immediately launches into a spectacular narrative of her teenage years: finishing college at twelve, she married at fifteen, and when her husband disappeared, she worked as a call girl to support herself and her daughter. After some years spent in a hospital, on the verge of death but nevertheless enlivened by other sundry adventures, an epiphanic experience of the overwhelming sensual immediacy of the material world, sparked by her own sexuality, made her become an artist. This amazing account is capped by the flat claim, "I always tell the truth."

Binge (1987), the second part, documents a period of several months when she tries to lose weight; the forty-five extra pounds were first put on after her husband disappeared and now, she claims, "separate me from my image of myself." Since the diet is in process all through the period the tape documents, the account of its erratic successes is demonstrated, sometimes very graphically, in the changes we observe in her body's shape. Accounts of her other attempts to improve her appearance are interspersed with speculations about why modern society prizes slender women and the psychic pressures this value system exerts on her and on her daughter. In the end she appears to have failed, having regained the weight she lost.

First Person Plural (1988), the third part of *The Electronic Diaries*, returns to her childhood abuse, but uses a public vocabulary to elaborate the masochistic fantasies and identity crises this caused. Her recollection of her childhood obsession with *Dracula* movies (fragments of which are interpolated) is negotiated into images of the Holocaust via a psychobiography of Hitler, himself a battered child born from two generations of teenage mothers. The pathology of cycles of abuse, passed down from generation to generation, is presented as a public event; the trauma of Hershman as a girl becomes the trauma of all women, of the Jewish people, of history. Again Hershman claims veracity, but this time it is qualified: "I always told the truth . . . for the person that I was. But the personas kept fluctuating and they would see things from all sides and I would be afraid from all sides."

The greatest of these fears—the fear of talking about the abuse—is, paradoxically, the only way its wounds can be healed. Here Hershman's own autobiographical situation becomes a summary metaphor for the condition of all women; her triumph over her father, family, and subsequent lovers, who all threatened to destroy her if she talked about their depredations, reflects patriarchy's exclusion of women from art and discourse generally. The "talking cure" that helps Hershman find herself—however fragmented and provisional the self she finds may be—and then her making of a video diary of the process paradigmatically reenact the historical intervention of a generation of feminists who refused to be silent, of women artists who found a voice and found themselves as artists, especially in autobiographical performance and video.[6] Hershman's act of making a video of herself talking about her abuse and the consequent problems she experienced in terms of identity and sexuality is what makes her an artist, both in the sense of releasing her own creativity and in the sense of acquiring a public identity as such. But as she goes public with her story, its conditions are transformed: the experience of abuse in life becomes useful in art. And even though art making can never entirely heal the trauma, it may supply the self-consciousness that will enable her to break the chains of pathological recurrence by not abusing her own daughter.

Hershman's identity as a video artist, established by *The Electronic Diaries*, may have been fabricated from the impossibly disjunctive fragments of her private selves, but it eventually became a public role, a profession that developed as the tape found its place in the social world of public art institutions and economies. As a video artist, she subsequently made tapes about people other than herself, but while the autobiographical component seemed to diminish, in fact it massively proliferated, via a public extension similar to that begun in *First Person Plural*. Her autobiography is discovered to have been a social story, for other people's lives are found to reenact her own and also to be subtended by the same two mutually contradictory axioms that framed the personal exposition of *The Electronic Diaries:* the claim for a coherent, self-identified subject (implicit in Hershman's protestation that she is speaking the truth), and the simultaneous refutation of such a possibility (the tapes reveal that this truth is subjective and that the subject herself is multiple, schizophrenic, a repertoire of fantasy roles created in defense against the threat of annihilation and extant only in art). As all women (and some men) are discovered to be her personae, in their differences they figure her various selves, just as her own plurality figures the multiplicity of other women's selves. But since all are artists, the original disjunction between the autobiographical subject and the subject of the autobiogra-

phy (the speaking subject who makes the videos and the subject of speech presented in them), the multiple forms of their contingency on video become correspondingly more complex.

In *The Electronic Diaries* the specificity of video erupted into the autobiographical discourse in two main forms: first, the foregrounded exploitation of video-specific image manipulation (in *Confessions of a Chameleon*, for example, the instability of Hershman's identity is figured in the fragmentation and multiplication of her image, and in *Binge* she electronically flattens herself to represent a weight loss); second, the metaphorical reenactment of real-life events in the social praxis of video making (a crisis occurs in *Binge*, for example, when technical malfunctions in the rented studio during taping persistently interrupt the depressed Hershman's confession of her own malfunction in losing only two pounds in six months). Proposing analogies between events in the medium and events in the reality the medium portrays, these two devices are the main tropes of the works subsequent to *The Electronic Diaries*.

The major thematic cluster in these works revolves around relations among women, particularly between mothers and daughters. Appearing as a brief aside in *The Electronic Diaries* (Hershman's self-prostitution to support her daughter and her mother's abuse of her), these relations are the main subject of *Seeing Is Believing*, whose central figures are Dawn, a teenager, and her mother, Coyote, who had her as a teenager by a Latino who deserted her when the child was born. The rudimentary narrative revolves around Dawn's attempts to make sense of her life and to control her mother's promiscuity and general dysfunctionality; she regularly resorts for comfort and assistance to Coyote's not-quite-so-irresponsible mother and to a father surrogate. Apart from the latter, men are absent from the women's lives, precipitating Coyote's loss of esteem, her sexual hunger and relationships with low-life lovers, and her inability to care for her daughter.

This schematic replay of *Confessions of a Chameleon* is itself elaborated by means of a loose allegory about video, a "family romance" of its relations to performance and film. The actors who play Coyote's mother and Dawn's "father" are both celebrated performance artists (Rachel Rosenthal and Guillermo Gómez-Peña); the tape is presented as a video narrative made by Hershman, who introduces it as such and who often comments on the psychological motivation of her characters, also insisting that the critical event that enabled her to make it was her shift from film to video as the medium of her art, which happened when she turned forty and her daughter left for college. The narrative is set in motion when, standing outside the shop where she has unsuccessfully tried to pawn her 8 mm camera and projector, she encounters Dawn. She gives the film equipment to her, agreeing to teach her to use it in return for per-

mission to tape her life. Thus both within the text (Dawn using the camera given to her) and outside it (Hershman creating the video narrative of Dawn's life) are instances where the making of film or video is the agency of self-understanding; indeed, Dawn's camera very quickly becomes her only connection with reality. The exchange between the two mediums (both 8 and 16 mm film, as well as several video formats, are combined) figures not just the binary of Dawn's composite ethnicity, but also the plurality of her personality. Like her, the final tape is a composite of many formats, each of which has its particular texture, visual range, and so on. The use of these mediums as the vehicle for Dawn's attempt to understand herself and her mother, and for Hershman's attempt to understand herself through this narrative, is summarily figured in scenes where Hershman videotapes Dawn while the latter screens the Super 8 footage she has taken of her mother; the subjectivity—the projection—inevitable in both processes is underlined by the fact that, in her search for a satisfactory image of her mother, Dawn screens the footage she has taken of her on a variety of shifting surfaces—on a glass of water, on her clothes, even on her own body.

A parallel mediation of erotic desire informs *Desire Inc.*, but here the apparatuses employed are extended to include broadcast television. For this, Hershman paid for a series of thirty-second tapes she had made to be broadcast over cable television, as if they were commercials. This kind of intervention in the public airwaves is not unprecedented in video art: Chris Burden and Joan Logue, for example, both made their own forms of commercials, and of course in Reagan-era art the television commercial became a privileged, not to say exemplary, medium of art making.[7] Hershman's "commercials" are innovative, however, in the audience interaction they encourage: the broadcast tapes feature a provocatively dressed woman inviting the viewer to phone her. (The number given was Hershman's own.) The final tape consists of the original ads, together with Hershman's interviews with the actress and with some of the respondees, men and women, who discuss their sexual desires.

Presented as an investigation of the loneliness Hershman believes to be pandemic in our society, *Desire Inc.* is sustained by a double parody; the ads mimic 1-900 phone-sex solicitations,[8] while the final tape mimics academic investigations of subcultural practices mobilized around the edges of industrial culture, such as *Star Trek* fanzines. The parallel with *Desire Inc.* is not so much the scholarly essay about the production of these fanzines, however, as it is the fanzines themselves, for while the tape appears to investigate a social loneliness, Hershman admits that her main motivation in making the tape was her own loneliness. The sexy woman who advertised on television and the respondents to the ad were all her surrogates. The erotics

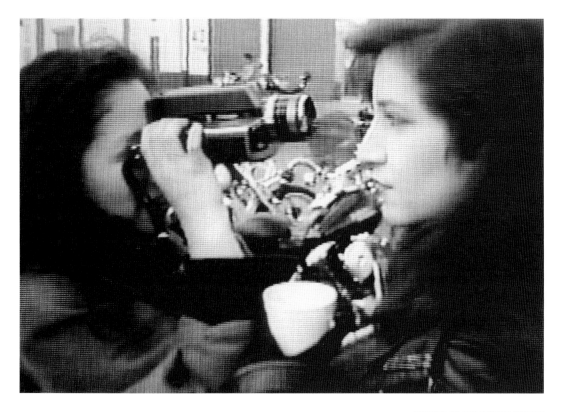

SEEING IS BELIEVING (STILL)
1991, VIDEO

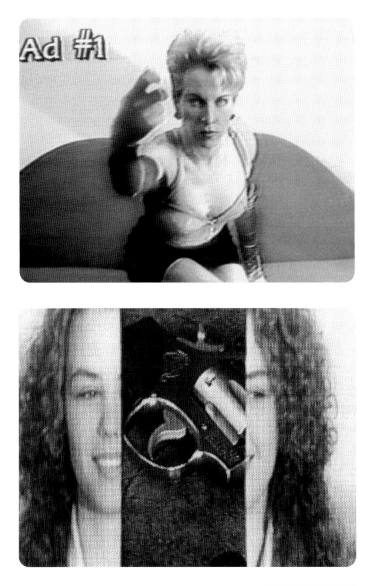

DESIRE INC. **(STILL)**
1990, VIDEO

LONGSHOT **(STILL)**
1989, VIDEO

of television, fundamental to the seduction of these people into the orbit of her power, are similarly instrumental in her future use of the tape to seduce its audience, and not only the limited audience for artists' video—just as the original ads ran on commercial television, so *Desire Inc.* ran on PBS.

The violence that is never far below the surface of the erotic scenarios these works explore is brought to the foreground in *Longshot*. Ostensibly a documentary about a young woman (Lian Amber), it juggles the mercurial shifts of her all but pathological identity crises though multiple representations of her, nested Chinese box–fashion in several different video and film narratives. On the one hand, despite her promiscuity and drug use, Lian appears to be a relatively stable, functional person; her delight in the sensual world and her own engagement of it are reflected in her spontaneous singing. On the other hand, specifically in the opinion of a social worker whose assessments of her are regularly interpolated, she is dysfunctional and fundamentally self-destructive. The latter's opinion is given credence early in the tape when Lian remarks that one of her previous lovers' stories of killing people in the desert feeds her obsessional fear of being made into a snuff film—a fate that is finally enacted in the tape. For her, representation and death are inextricably combined, a trope that inhabits the entire autobiographical tradition. As in *Confessions of a Chameleon*, different forms of video are used for the interwoven scenarios, which here set in motion the paradoxical play between representation and death.

The dominant scenario, the major frame of the tape, is narrated for Hershman's camera by a young man (Dennis Matthews) who works in a computer-operated video-editing facility. Obsessed with Lian, he wants to possess and control not her body, but her video image, so he follows her around, taping her and then manipulating her image on his computer console. Competing with Dennis for Lian's image, another woman—another moving-image artist (Zsuzsa Koszegi)—intervenes. She, too, wants to possess Lian and to direct her life, but as a movie rather than as a videotape. The competition between lovers, modes of sexuality, and mediums comes to a climax in a final sequence in which Zsuzsa takes over Dennis's video camera and has him play the role of Lian's murderer in her movie. With a gun now rather than a camera, Dennis shoots Lian in a park in San Francisco, and as her bloody body lies in the street, tourists shoot the whole scene with their video and still cameras.

Like Dennis Hopper's *The Last Movie* (1971), one of the most sophisticated metacinematic meditations ever made (the crucial scene of which is quoted by Hershman in a shot in which Lian gets back on her feet after having been "killed"), *Longshot* shuffles diegetic levels so com-

pletely that the possibility of an exterior, normative ontology is entirely lost. The subject is dispersed across an abyss of mediations in which life and television fold endlessly into each other. Only death can halt this deferral and stabilize an identity—but it is also the only event that is inaccessible to the autobiographical subject.

While Hershman cannot represent her own death, she can represent her fear of it and the displacement of her fear onto the deaths of others: in *Shadow's Song* (1990), the fourth part of *The Electronic Diaries*, she confronts her own death, and in *Conspiracy of Silence*, a dramatic reenactment of some of the events surrounding the death of artist Ana Mendieta, she again treats the possibility of a woman artist being killed by a man.

In *Shadow's Song*, the terminal contradictions that follow from the autobiographical subject's approach to her death are mobilized in a diary of the events that follow Hershman's discovery of a tumor on the base of her brain. Again, the significant contexts of this event are elaborated though allegories about media. Hershman's tumor can only be proven to exist by means of a form of photography, X-ray, and while it turns out to be benign and operable, she is able to avoid surgery by her recourse to alternative medical procedures, which enable her to shrink the tumor by a technique of mental visualization. She triumphs over at least this first presentiment of death, but the inevitability of death's victory is admitted in a second story, a surrogate for her own, that is interwoven with it.

Her meditations on her own death and dealings with doctors are intercut with scenes of Henry Wilhite, a black man who talks, also in direct address, about his knowledge of his impending death from a tumor similar to Hershman's and his plans for his remaining time. Previously a dog trainer, Wilhite is also an artist—he sings, and as always in Hershman's world, singing is a mark of self-actualization in art. Though the tape ends with Wilhite's death, in some sense he, too, still lives on in the tape, which Hershman made of him at his request, braiding his death to her temporary victory over death. Sustaining the life of his singing, the singing of his life, *Shadow's Song* allows him the vitality that video has allowed Hershman's own voice. Like the Holocaust victims in *First Person Plural*, like Lian in *Longshot*, and like Hershman's Ana Mendieta in *Conspiracy of Silence*—like all subjects who construct themselves in video—outside it, he, too, is invisible and silent.

NOTES

This essay was originally published in *Over Here: Reviews in American Studies* (Nottingham, U.K.) 12, no. 1 (1992), pp. 18–28, and reprinted in Michael Renov and Erica Suderburg, eds., *Resolutions: Contemporary Video Practices* (Minneapolis: University of Minnesota Press, 1996). It is reprinted here with permission of the author; © David E. James.

1. Rosalind Krauss, "Video: The Aesthetics of Narcissism," *October*, no. 1 (spring 1976); reprinted in Gregory Battcock, ed., *New Artists Video: A Critical Anthology* (New York: E. P. Dutton, 1978). In this essay, Krauss distinguishes between modernist reflexivity (as instanced by Jasper Johns's *American Flag* [1954]) and the autoreflexiveness of early video (as instanced by Vito Acconci's *Centers* [1971]). The argument developed below is that Hershman negotiates each of these into and through the other.

2. P. Adams Sitney's "Autobiography in Avant-Garde Film," *Millennium Film Journal* 1, no. 1 (winter 1977), pp. 60–106. Quotations are from pp. 60–63.

3. Sitney notes of Jerome Hill's *Film Portrait* (1970), which he proposes as a seminal and exemplary film autobiography: "a chronology is constructed in a context in which the authority of chronology and the truth of imagery [are] denied; consequently the categories of memory and causal sequence cease to be the founding forces of the film and enter an indeterminate arena where they might well be seen as illusions derived from, or at least reinforced by, the very conditions of film production and its apparatuses" (ibid., p. 67).

4. The distinction of the ontology of autobiography from that of biography and the recognition of the intrinsic rather than the incidental nature of the former's subjectivity were first made in 1956 by Georges Gusdorf in what has become the seminal essay for modern studies of the genre, "Conditions et limites de l'autobiographie" (translated as "Conditions and Limits of Autobiography," in James Olney, ed., *Autobiography: Essays Theoretical and Critical* [Princeton: Princeton University Press, 1980], pp. 28–48).

5. I have considered the theoretical issues at stake in the manufacture of a publicly distributed diary as distinct from a private practice of diary making in "Film Diary/Diary Film: Jonas Mekas's *Walden*," in my *Power Misses: Essays Across (Un)Popular Culture* (New York: Verso Books, 1996).

6. During the 1980s, feminists did much theoretical work on the diary and other autobiographical forms. For an overview of this—and an argument for the intrinsic femininity of the diary—see Rebecca Hogan, "Engendered Autobiographies: The Diary as a Feminine Form," *Prose Studies* 14, no. 2 (September 1991), pp. 95–107.

7. Hershman herself had made and broadcast commercials in various performance pieces of the mid-1970s.

8. One, for example, features a provocatively dressed "model" who addresses the camera, detailing the tedium of model life and soliciting phone calls from men at $4.75 per minute.

MY OTHER, MY SELF: LYNN HERSHMAN
AND THE REINVENTION OF THE GOLEM

At first glance, it would appear that the 1970s feminist art world has been the animating influence for Lynn Hershman's oeuvre of performance work, video art, and feature films. After all, that influence is inscribed in such recurring details as her heroic female protagonists, the always-evident female mastery of technology, her use of confession as a central cathartic trope, and her insistence on airing the personal ill for the public good. But that would be an insufficient précis. Equally present are the effects and aftereffects of male figureheads and compatriots such as Timothy Leary, John Perry Barlow, and Josh Kornbluth. Female foremothers appear, too, in fictionalized form, as instanced by the rescue mission on behalf of Ada, Countess of Lovelace, in *Conceiving Ada* (1997). For Hershman, the right to knowledge is an ever-present theme and truth telling a constant modus operandi, before which such barriers as gender, geography, and epoch melt away. Finally, hidden beneath these tropes a wisdom specific to Judaic traditions hovers, awaiting detection.

Hershman has traced a path—from medium to medium and genre to genre—of admirable consistency, one set to fixed compass points. The talking cure, that famous Freudian device for dealing with trauma, is often present, whether it takes the form of Hershman talking to the camera in *The Electronic Diaries* series (1986–), or of Rosetta confessing to Dirty Dick in *Teknolust* (2002). Equally present, though, is another cure: the geographic one. This also happens to be the favored mode, after twelve-step programs, for dealing with addiction: move somewhere else, get parachuted into a recovery program in Omaha or some other heartland, just get the hell out of the old neighborhood. It's the same process by which artists have landed, for so long and so routinely, in certain identifiable metropolises far from home. Hershman's work has followed the rules of both routes to detoxification, the emotional/spiritual and the geographical: she tells secrets to give voice to what's happened and she travels as far as the

highway or camera or special effects can take her—away from here, away from there, out of harm's way. That she did so in life has made her a survivor; that she figured out what to do with that survival, and how to transform it, has made her an artist.

Her epic video work *First Person Plural: The Electronic Diaries 1986–1996* bears witness to what she escaped.[1] Hershman has confessed that she didn't even necessarily know what she had said on the tapes until she sat down to edit them. They were an electronic corollary to the automatic writing practiced by the Surrealists, bushwhacking a direct route from the subconscious into the light of day, to the page or, in this case, the screen. We hear the words, spoken privately to herself but recorded and transported into our presence, into the very room where we sit with the monitor, just as the artist once sat with the camera.

First Person Plural is a violation of a number of social pacts, all of them worth breaking. First and foremost, it's a violation of the inherited pact of the family. ("Don't tell, don't tell," whispers an unseen speaker. "Don't air your dirty laundry.") It's also a violation of the forced pact between victim and victimizer. ("Don't tell, don't tell," continues the voice-over. "Don't tell your mother, your teacher, your friend.") But it is also a violation of the "Holocaust pact," which dictates, in the post-Holocaust era, that all Jews are victims and inhabit the terrain of victimhood. (Never mind that Israel has become one of the most bloodthirsty nations, acting out at the national level the same abused-becoming-abuser pattern that is so well known at the level of individual pathology.) Subscribers to this pact embrace victimhood, a state of being, rather than referring to specific, historic acts of victimization.

Victimhood is defined by stasis. It allows no movement or action, just the assertion of injury. This assertion never leads to the kind of cathartic outcome that the talking cure, for example, may produce. There's no exorcism or resolution, just more assertions of damage, more writings, more films, more videos, more monuments. But if every Jew is a victim, who are the perpetrators now that Nazis are in shorter supply? In *First Person Plural* Hershman shattered the victim myth of her "nice, respectable, middle-class Jewish family" by naming her father, mother, and brother as perpetrators of violence. She boldly refused to perpetrate and perpetuate an image of the family that did not accord with her history. She had no choice, really. If she was going to tell the truth, she could not worry about whether it was good for the Jews.

The echoing relationship between domestic violence and ethnic violence is a central concern for Hershman, one that she works through with infinite care, pain, and grace. In exploring the gendered hierarchy of violence, she raises the specter of Sylvia Plath, who identified as Jewish despite her assigned ethnicity, who in her most famous poem fingered "Daddy" as

her own personal Nazi. Leon Wieseltier, reviewing Dorothy Rabinowitz's book *New Lives: Survivors of the Holocaust Living in America* for the *New York Review of Books*, made a comment on Plath's work that could also be applied to Hershman's work of the *First Person Plural* period: "Whatever her father did to her, it could not have been what the Germans did to the Jews. The metaphor is inappropriate."[2]

How irresistibly does Wieseltier put together and then try to rend asunder the unspeakable public and the unspeakable private according to a hierarchy of his own making. And how deeply transgressive, then, is *First Person Plural?* How deeply unacceptable is Hershman's identification of a "Daddy" who, unlike the one in the Plath poem, is utterly lacking in any metaphorical distance? The experience of violation, as we learn in the video, is her birthright. She chooses to oppose the exclusion of her rightful memories from a manipulated history. Instead, in her use of video to exorcise the dreams and nightmares of family, Hershman provides a suggestive updating of Freud's talking cure. Although still reliant on language, her work expands the registers of evidence and confession to incorporate the visual representation and replication of the body. These distinct selves are configured and reconfigured, variously and simultaneously, in the range of multiple monitors in the shot.

Hershman started *The Electronic Diaries* as a way of learning to make video, sitting alone in a room with a borrowed camera, unable to afford actors or even a cameraman. In her words: "I just started talking into it [the camera]. And as I looked at it later, it seemed very evident to me that there was this fragmenting and split of various people that were emoting, as if they were telling a story. I refer to this as something other than myself. Or someone other than myself. So that was the genesis of what happened, and it became, which I didn't know at that time, a life work, a life cycle, of re-information in order to assume a regeneration."[3]

The feature-length edit of *The Electronic Diaries* titled *First Person Plural* was released in 1996, more than a decade after Hershman began taping entries. The Talmudic comparison is irresistible: like some vast and veritable Talmud, the videotapes are an ongoing glossing of the text of the self, or selves, by its/their ultimate authority. Yet however suggestive this trope may be, there are others rooted in Judaica that are more central to Hershman's work.

Hershman's oeuvre is littered with doubles; it brims with alternate personae and replicants that appear and disappear and reappear. Her feature films, *Conceiving Ada* and *Teknolust*, expand on the idea of replication and multiplication, developing Judaic notions of self and other beyond the simplified us/them narrative of the Holocaust. In fact, I believe they revisit the more primordial space of pre-Holocaust Judaism and its central mystical figure: the golem. I

want to identify the golem as the primary defining trope of Hershman's oeuvre, a trope that not only retroactively illuminates her work but also suggests a fruitful direction for gendering Judaism and connecting past to future.

Hershman considers her onscreen personae in *First Person Plural* to be characters; they are, she says, "not me." It's a short jump from there to the characters brought into existence in her two fiction films, *Conceiving Ada* and *Teknolust*. Both films feature "not me" characters of the highest order, a possible explanation for which can traced back further than 1970s feminism, beyond the Countess of Lovelace figure contacted by the computer-hacker heroine in *Conceiving Ada*, back to medieval times and ancient powers: not to witchcraft, an art conjugated in the female tense, but rather to the male lineage of magic as known in the Kabbalah, a magic that has more in common with the futuristic clones of *Teknolust*.

The origins of cloning lie far in the Jewish past. Most famously, in sixteenth-century Prague, under the rule of the Hapsburg king Rudolf II, Rabbi Yehuda Loew created a golem out of clay from the Moldau River in order to defend his people, only to have it run amok and nearly destroy the Jewish ghetto it was created to save from persecution.[4] (Pilgrims whose imaginations have been captured by the figure of the golem still journey to the Prague cemetery where the grave of the mysterious Rabbi Loew can be found.) However, the tradition of the golem, the sacred monster brought into being by a wise and pious scholar through some secret alchemical combination of mud and prayer, goes back even further than this: the Talmud records its invention by Rabbi Abba ben Rav Hamma ("Rava") in 299–353 C.E.;[5] it can also be tracked to the Book of Creation, which, according to the Midrash, was written by Abraham and contains instructions for creating a golem; indeed, instructions for making a golem appear in Rabbi Eliazar Rokeach's commentary on the Book of Formation, including the words that should be spoken and the mode for envisioning the parts of the body to animate the matter.[6] Scholar Gershom Scholem, in his essay "The Idea of the Golem," endorses the claim that these tales of invention may well be matters of historic fact.[7]

I would contend that Hershman's use of the double throughout her work is, in effect, a summoning of a contemporary golem. According to this interpretation, Hershman, as the artist, represents a modern version of the learned one, the devoted Talmudic disciple who seeks to bring her own creation into the world. Furthermore, the golem is a form (or, we might say, image) that is given life through a magical formula, such as the letters of the divine name or the word for "truth" (which, according to some legends, is inscribed on the golem's forehead). "Speaking truth through doubles"[8] seems a fair description of *First Person Plural*, with its mul-

tiple replications of the self. And consider Hershman's reference to Roberta Breitmore as a "private performance of a simulated person": what better description is there of a golem than as a "simulated" person?

With the trope of the golem in mind, a Kabbalistic analysis of Hershman's filmography verges on the irrefutable. In her first feature film, *Conceiving Ada*, the heroine uses a magic formula—in this case, a computer software program—to create an artificial-intelligence agent. The agent, a bird (with connotations of phoenixlike powers), or perhaps a golem in another form, journeys not just into the Internet, but back into the past to make contact with Ada, Countess of Lovelace, inventor of the world's first computer language. Through the agent, the hacker heroine revivifies Ada by melding her with the DNA of her own daughter, still a fetus inside her—and yes, one could say she accomplishes this by using magical incantations. The "unnatural" birth that results is an alchemical interference with nature that goes to the very heart of the golemic enterprise.

Ada, Countess of Lovelace, was, of course, the daughter of Lord Byron, whose famous dare to Mary Shelley produced the 1816 Gothic novel *Frankenstein*. Stories about destructive demons abounded in Central and Eastern Europe at the time, many of which were transmuted by Jacob and Wilhelm Grimm in their first collection of fairy tales, published in 1812; supposedly, these tales came to the attention of Shelley and influenced her telling of her updated golem story, of a creature brought into being through a canny melding of ancient myth and then-modern science.

Unlike the Frankensteinian enterprises of today, with mad scientists working in laboratories to produce clones, historically golems have been created through thinking—through meditating on the seventy-two letters of God's name, to be exact. Seventy-two: a number similar to the number of Hershman's relatives lost in the Holocaust, as she recounts in *First Person Plural*—not an exact seventy-two, but nevertheless there it is, a contemporary enterprise of counting numbers, of counting names, over and over.

Why would one conjure a golem? According to the histories and legends, there are two legitimate reasons for a rabbi or wise scholar to create a golem. One is to protect the community. In the case of Hershman's work, we could interpret "community" as family: her golem may be conjured to protect the girl-child within a brutal family. The other legitimate reason to invent a golem is to achieve a greater understanding of the creative process—to understand God's creative process, or the creation of humans. (In such a reading, Adam is the first golem.) For Hershman, it provides an entry into her own creative process as an artist, as a

CONCEIVING ADA (STILL)

1997, 35 MM FILM

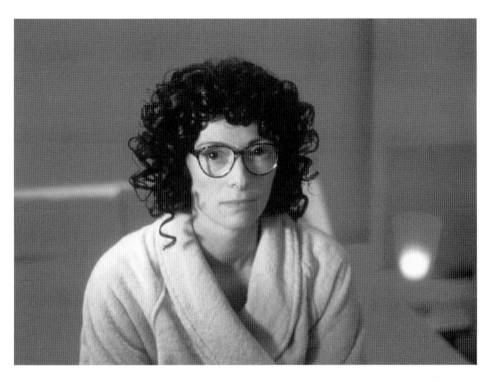

TEKNOLUST **(STILL)**
2002, 24P HIGH-DEFINITION VIDEO

performance artist, as a video artist, and as a filmmaker. The golem, then, may well be the films and tapes and performances themselves, not merely the characters within them.

To be sure, there are interdictions against the making of a golem. For instance, the golem cannot be used for personal gain or to perform mundane tasks. This is how we know that Rosetta is in trouble in *Teknolust*. She has invented clones, or SRAs (self-replicating automatons), to perform mundane tasks, breaking the rules of this sacred project. We know that it can come to no good end. Personal gain is another prohibited motive. Therefore, there are considerable risks to scientists now working in labs on cloning and hoping to cash in big-time on their discoveries. The performance of mundane tasks and personal gain are the wrong reasons to create a golem, and they are bound to doom the enterprise. In the literature, in fact, golems often backfire and cause harm to their creators: the great Rabbi Loew had to destroy his golem when it turned on the Jewish community it was meant to save, and Frankenstein famously turned on its creator. (Only Rava's golem did not turn and attack.)

Golems are not perfect human replicants, for they lack speech; they are mute. In the case of *First Person Plural*, it is Hershman who lacks speech, and the version of her on the monitor is there to provide access to that strangled speech. It not entirely clear which one of them is the golem: Hershman herself or Hershman as we see her on the videotape.

Golems also suffer another ill: the tendency to gain weight. In a story by Jacob Grimm in his *Journal for Hermits*, a golem grows larger and larger until it can no longer fit in the house of its creator, recalling recent news reports of cloned animals, notably Dolly the sheep and her relatives, having a mysterious tendency to gain weight, even when eating no more than the rest of their herd.[9] In Hershman's *Binge* (1986), the second installment of *The Electronic Diaries*, there is again a link between Hershman and the figure of the golem, as she speaks of how, at an earlier point in her life, she began to eat and eat, gaining weight as unstoppably as Dolly.

Hershman has created a new paradigm with her modern golem, albeit one with a cinematic and feminist literary lineage. Consider Paul Wegener, maker of silent films: obsessed, he returned over and over to the subject of the golem in his movies, but only the third of these, *The Golem: How He Came into the World* (1920), has survived. In an eerie parallel to Hershman's central presence in *First Person Plural*, Wegener himself plays the golem in this film.

The main protagonist of *Teknolust*, Rosetta, is a biogeneticist who seeks to create life in her own image. Wasn't this, in a sense, the original project of feminism: to create the world anew in a female form, adjusting the male image that dominated for so long? True, it wasn't a lit-

eral invention of matter made flesh that was envisioned, but rather an imaginative recasting of matter according to new ideas. Hershman's work reinvents the golem according to a feminist worldview, animating ideas into matter through her creation of cinematic representations that go into the world to do her bidding. Her golemic art is a source of power indeed for her community and, happily, it shows no sign of harming its creator. A creative recasting of the arrogant masculine science that dominates cloning as well as the elite rabbinical alchemy that created golems, Hershman's work offers up art as a formula, if you will, equally capable of providing animation, protection, and perhaps salvation.

NOTES

1. *Editor's Note:* The feature-length version of *First Person Plural*, released in 1996, brings together the first five installments of *The Electronic Diaries*. It is distinct from the shorter, third part of the series, also titled *First Person Plural*, released in 1988. The discussion here focuses on the feature-length *First Person Plural*.
2. Leon Wieseltier, "In a Universe of Ghosts," *New York Review of Books*, November 25, 1976.
3. Private communication from Lynn Hershman, December 2000.
4. Nathan Ausubel, *A Treasury of Jewish Folklore* (New York: Bantam Books, 1980).
5. Sanhedrin Ix-Xi, English, *Talmud of Babylonia* (Lanham, Md.: University Press of America, 1985).
6. Jonathan Hirschon, "The Golem," www.templesanjose.org.
7. Gershom Scholem, "The Idea of the Golem," in his *On the Kabbalah and Its Symbolism*, trans. Ralph Manheim (New York: Schocken Books, 1960, 1965).
8. Ibid.
9. Miriam Falco, "Cloning Experts to Tell House Committee Pros, Cons," March 28, 2001, www.cnn.com/2001/HEALTH/03/27/cloning.reality/.

A CINEMA OF INTELLIGENT AGENTS:
CONCEIVING ADA AND *TEKNOLUST*

Very few women are creative. I would not
send a daughter of mine to study physics.
I'm glad my wife doesn't know any
science. My first wife did.
—ALBERT EINSTEIN

Although he voiced disdain for female scientists, Albert Einstein acknowledged that Nobel Prize winner Marie Curie was a rare exception, a creative woman. He quickly reassured his second wife, Elsa, however, that this unique woman posed no romantic threat to their marriage. Curie, he said, "has sparkling intelligence but, despite her passionate nature, is not attractive enough to be a danger to anyone." Frau Einstein replied with confidence, "She has the soul of a herring."[1]

As if to counter this misguided assumption that soulful, sexually attractive women are incapable of producing creative work in science—a view still held by many men and women— Lynn Hershman has produced two witty science fiction films about female scientists experimenting with intelligent agents. *Conceiving Ada* (1997) and *Teknolust* (2002) both feature Tilda Swinton, the soulful queen of the indies, as a dangerously attractive woman who designs scientific innovations that empower future generations of women. These films extend Hershman's own ongoing work on technology and the female body.

Hershman's interest in this kind of femme fatale/genius has led her to the intriguing real-life case of Hedy Lamarr (1913–2000), who will be the subject of one of her future film projects. Although this drop-dead gorgeous movie star from the 1940s is frequently remembered for being arrested for stealing, she is far more noteworthy for having invented, in 1942, a radio guiding system for torpedoes that was used in World War II. This invention later helped make wireless transmission and cell phones possible, but by then her patent had expired. According to Hershman, "In 1942, Lamarr had been the wife of Hitler's arms dealer, so she knew a bit about what was going on. So she had this idea that she worked out with player piano wheels, which became the basis for the technology. She patented it and gave it to the government to win the war."[2]

By linking the conflicting discourses of Hollywood star power, gender politics, science, and cybernetics, Hershman invests the issue of agency with considerable resonance, creating a pro-

ductive friction. Hershman has a distinctive knack for making quirky yet productive links that help push new media discourse beyond the arid formalism and cyberstructuralism that presently dominate the field.

HERSHMAN AS INTELLIGENT AGENT

As a well-known video and installation artist whose work has been exhibited in more than two hundred museums and galleries worldwide, Hershman herself is a model for the cutting-edge female as intelligent agent. She has successfully navigated a wide range of media, always mining new forms for their potential to mediate between the margins and the center. With *Conceiving Ada* and *Teknolust*, she attempted to break into the wider American independent film market. Neither film has yet received the wider distribution it deserves.

Although Hershman's work is rooted in contemporary theoretical discourse, it remains accessible to a broad audience, primarily because of the diverse pleasures it offers—wit, humor, curiosity, sensory richness, emotional engagement, inventiveness, surprise, satire, and intellectual rigor. Beginning with her art disc *Lorna* (1983–84), her work has frequently incorporated an interactive component, a dimension she has consistently inscribed with sexual politics. Although she has produced more than fifty films and videotapes and her feature-length video *Longshot* (1989) won the Grand Prize at the Festival for Video in Montebéliard, France, and the Film of the Year Award at the London Film Festival, she is perhaps best known for her award-winning *Electronic Diaries* (1986–), which were featured at the 1996 Berlin Film Festival. In all her work she addresses issues of personal identity, gender, and transsubjectivity and boldly uses her own body and experience as a narrative field to be explored through text, image, and performance.

Hershman has broken several gender barriers in the male-dominated international art scene. In 1994 she became the first woman in the history of the San Francisco International Film Festival to be honored both with a tribute and a retrospective of her work. The following year, along with Peter Greenaway and Jean Baudrillard, she was awarded the Siemens Medienkunstpreis by the Zentrum für Kunst und Medientechnologie (ZKM), one of Europe's leading multimedia centers, which dubbed her "the most influential woman working in new media." It is in this liminal space between new media and cinema that her two features, *Conceiving Ada* and *Teknolust*, are positioned. As Hershman writes in her contribution to the catalogue for the ZKM exhibition *Future Cinema:*

The Future of Cinema has been a concern of my work for the past twenty-four years. What interested me is going beyond the screen, using new technologies to enliven and empower viewers, to create an experience that uses moving images to defy conventional structure, whether this be the creation of alternative endings and soundtracks in *Lorna* . . . or an on-line web agent named *Ruby*.[3]

Although *Conceiving Ada* and *Teknolust* (the latter of which gave birth to Agent Ruby) are digital movies projected on a screen rather than interactive works, whose structure can be altered by users, they still help us conceptualize what is possible for new media technologies, particularly concerning the gendering of agency.

GENDERED AGENCY

In *Hamlet on the Holodeck*, new media theorist Janet H. Murray claims:

Agency is the satisfying power to take meaningful action and see the results of our decisions and choices. . . . Because of the vague and pervasive use of the term *interactivity*, the pleasure of agency in electronic environments is often confused with the mere ability to move a joystick or click on a mouse. . . . Some games, like chess, can have relatively few or infrequent actions but a high degree of agency, since the actions are highly autonomous, selected from a large range of possible choices, and wholly determine the course of the game. Agency, then, goes beyond both participation and activity. As an aesthetic pleasure . . . it is offered to a limited degree in traditional art forms but is more commonly available in the structured activities we call games.[4]

One of the most famous examples of an intelligent agent in cyberspace is the computer program ELIZA, a natural-language processing experiment developed by Joseph Weizenbaum at MIT in 1966. Masquerading as a female psychotherapist named Eliza, this program could respond to questions posed by patients and generate new questions on the fly, an interaction that fooled many users into thinking she was actually a live human being rather than a computer-generated program.

Many programs that followed Weizenbaum's lead were more sophisticated than ELIZA, but as Murray and others have pointed out, the success of their illusion was still based on the narrative context of the interaction. While the narrative context of psychotherapy and its dialogic conventions favored a kind of intimacy, projection, and transference that is rarely found in a chess game, this "high degree of agency" could thrive in other narrative models. One such environment was the MUD (multiple-user domain):

Probably the most famous of Eliza's daughters is the virtuoso character known as Julia, developed by Michael Mauldin of Carnegie Mellon University. Julia is a "chatterbot," a text-based character like Eliza who carries on conversations with the people around her. Julia was built to live on MUD's, and she has many agreeable social behaviors: she plays the card game hearts, keeps track of other inhabitants, relays messages, remembers things, and gossips. In short, Julia is good company. Moreover, her physical presence is as real as anyone else's; that is, she can hold things, perform actions like other MUDers, and move from place to place.[5]

Although Murray acknowledges that "in some ways Julia is a female impersonator like the other female personae operated by male MUDers" and that her "impersonation of an actual female MUDer was so successful that Mauldin was distressed to discover that one poor soul had spent thirteen days trying to seduce her into going with him to a private room for virtual sex,"[6] she doesn't really explore the implications for gendering agency, which is precisely Hershman's primary concern.

The intelligent agents in Hershman's movies not only are female, but have also been created by female programmers, who in turn have been designed by a female auteur, Hershman herself. Thus, unlike Eliza and Julia, these agents cannot be seen as acts of ventriloquism or gender masquerade performed by male computer scientists. Hershman's movies explicitly call attention to this gender dynamic in the history of intelligent agents. Perhaps even more important, they also link this subject to the rich discursive context of feminist film theory, where questions of female agency have traditionally concerned issues rarely addressed in new media discourse—vision, voice, movement, motherhood, and desire—rather than autonomous action.

Given that her subject is technology, Hershman has chosen the science fiction genre as narrative context, for, despite its dystopian or apocalyptic plots, this popular genre has historically presented technological innovation as an optimistic sign of humanity's powers of survival. If a filmmaker and the film industry could imagine and produce as realistic, spectacular, and expensive a simulation of space travel in 1969 as the one that Stanley Kubrick created in *2001: A Space Odyssey*, then there was hope that humans would somehow be able to survive any crisis brought on by unknown threats like the black monolith and its mysterious creators. And science fiction was an equally rich resource for those with a satiric edge who distrusted technology, like Chris Marker, whose low-budget alternative classic *La jetée* (1962) presents human conceptual power—the power to dream, recall, and re-animate images—rather than technology as the primary guarantor for human survival in a postapocalyptic future. If this

kind of conceptual power could serve mankind, then why couldn't it also serve women who could use it to imagine new kinds of gender relations? This genre has long been seen by feminists—from sci-fi writers like Ursula K. Le Guin and Doris Lessing, to film theorists like Vivian Sobchack and Constance Penley, to new media theorists and practitioners like Donna Haraway and Allucquère Rosanne Stone—as a privileged narrative domain where alternative visions of gender could be generated and new female agents empowered. This is the domain Hershman entered with her two sci-fi features, *Teknolust* and *Conceiving Ada*.

CONCEIVING ADA

Conceiving Ada portrays a fruitful collaboration between technology and conceptual power, a collaboration that brings together two extraordinary women. Hershman's protagonist is a brilliant computer scientist and new media artist named Emmy (Francesca Faridany), who tries to create artificial-life agents that will enable her to search through the past and make direct contact with historical figures. In this technological quest (a cyberversion of the epic hero's traditional descent into the underworld), Emmy is inspired not only by her dying computer science mentor, Dr. Sims, but also by the real-life historical figure with whom she ardently seeks to make contact, Ada, Countess of Lovelace (Swinton), who represents the first fusion in history between feminism and computer programming. The gifted child of the notorious romantic poet Lord Byron (whom she never met), Ada collaborated with Charles Babbage on building a calculating machine and wrote a detailed description of what it could accomplish. Although Babbage built the hardware, Ada was the one who first conceptualized what such a machine could achieve in art and science. As a result, she became the first computer programmer in history. As Hershman's Ada puts it, "My art is the elegant embroidering of calculations."

While the elaborate plot involving Ada has striking intertextual parallels (both in theme and structure) to Tom Stoppard's masterful play *Arcadia*, Emmy's world is purely Hershman's own invention. As a committed feminist and winner of the Cartesian Genius Grant (a fictionalized version of the MacArthur), Emmy succeeds in making intelligent agents that build on MIT's Alive Project but go far beyond it. At first she merely combines her agents with video images of herself and of her bartender lover, Nick (J. D. Wolfe), which she records with surveillance cameras positioned in every room of her loft; she then imports these composites into cyberspace. But later she is able to send her cyberbird Charlene into the past, where this crea-

ture becomes fused with images of Ada, whom we can hear in voiceovers. Eventually we see live-action dramatizations of scenes from Ada's life and finally listen in on direct interactive conversations between these two powerful women, Ada and Emmy. In these dialogues, Emmy promises to save Ada and to grant her the position she deserves in history. Paralleling the plots of many video games (or even Jacques Rivette's more sophisticated French feminist fantasy film *Celine and Julie Go Boating*, 1974), Emmy longs to rescue the princess and embrace her as part of her own historical legacy.

Although each step in Emmy's design process is presented as a sign of technological progress and a more advanced form of agency, Ada ultimately decides that she doesn't want to live a half life. Nor does she want to colonize Emmy, who is pregnant and who is putting her own health and that of her unborn child in jeopardy. In fact, when Emmy goes for a sonogram, her doctor sees a shadow (presumably Ada's) on the image of the fetus, which suggests Ada's fears may have some basis. Although Ada bitterly regrets her own invisibility in history, she knows she ran out of time before she could finish her life's work and willingly accepts her own death. She tells Emmy, "I won't contaminate you with my diminished capacities. . . . I don't want all my secrets known. . . . Death makes the fragility of life delicious." At this point in the dialogue and the plot, these two powerful female agents vie for control over the ending. Whereas Ada remains loyal to the unlimited potential of conceptual power, which always retains an element of the unknown or unrealized, Emmy is committed to technology, hardware, and measurable results.

With Nick's intervention and a bit of random good fortune, Emmy succeeds in saving Ada's memories. In the final sequence, set a few years into the future, we see an overhead shot from Emmy's balcony of someone in a helmet riding on a motorcycle. Although we assume it is Nick, it turns out to be Emmy. Inside the loft we get a glimpse of someone with long red hair, who turns out to be Emmy and Nick's young daughter. As the child replays Ada's life on the computer, she claims that her memories are getting clearer and then asks her mother, "How did I get Ada's memory, code, and spirit?" Although this ending implies that Emmy has prevailed over Ada by preserving her as the ghost in the machine, the sequence is somewhat flat; Emmy and daughter merely report their success. The scene lacks the dramatic impact of Ada's stirring language and passion, which depend so heavily on the powerful delivery of Swinton. Thus, we wonder whether Ada's legacy has been diminished after all, just as she predicted. In any event, the agency is shared among the three female characters, each from a different generation. Although men are not excluded (for Babbage's work is acknowledged and Nick re-

mains in the picture), their contributions are deemed less essential. It is as if Ada has helped to father Emmy's daughter, just as Emmy and her daughter have given new life to Ada, with Hershman overseeing and orchestrating both conceptions. Although the plot is fiction, Hershman's very act of making a film about Ada, Countess of Lovelace, fulfills Emmy's quest—of writing her into history and thereby making her visible.

As if to emphasize the struggle between intelligent agents, the film is structured as a nonlinear series of dialogues, usually between two characters and always including at least one of the two central women: Emmy and Nick, Emmy and her mother, Emmy and Sims, Emmy and her doctor, Emmy and her daughter, Emmy and Ada, Ada and Babbage, Ada and her married lover John Cross, Ada and her mother, Ada and Mary Shelley, Ada and her lover David (who is also her children's tutor), and (again) Ada and Emmy. Despite the film's strong images of early computers and cyberspace and its occasional lush colors (dark burgundy drapes or vibrant green gardens seen through windows accented by white fades), Hershman's film relies more on its conceptual than its visual power.

The wordplay of the film's title makes its emphasis on conceptualization explicit. The word *Conceiving* functions in several ways, describing Ada's brilliant conceptual powers, which were not fully realized before her death; the creative activity performed by Hershman, Emmy, and Swinton as they try to imagine what the historical Ada must have been like; the performative activity of both Swinton and Emmy as they create the character of Ada; the physical act of giving birth, Emmy to her daughter and Ada to her three children; the metaphorical act of Emmy giving new life to Ada, whose memory files she transplants within her daughter; and the spiritual activity of channeling a spirit or ghost, which Nick claims Emmy is doing with Ada. The wordplay is also apparent in the names of certain characters like Sims, whom we see only in computer images, not in the flesh. In addition to evoking Will Wright's successful series of multiple-player online Sims games, the character at one point alludes to another popular electronic game, quipping, "Information is like a myst. You have to breathe it in." Significantly, Sims was played by the real-life scientist and LSD guru Timothy Leary, who was himself dying at the time the film was being made; in fact, he had a Web site monitoring his own death that promised to extend his life in cyberspace and to preserve him as the virtual ghost in the machine (just as Emmy hoped to do with Ada).

To make such a conceptualization work, the film relies heavily on verbal language and on the acting performance of Swinton, who delivers the best lines. But there is great strength in both female characters, Ada and Emmy, who balance each other as brilliant, sexual women.

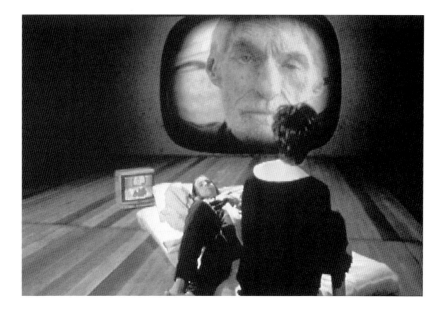

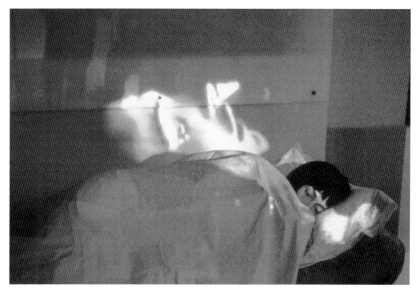

CONCEIVING ADA (STILL)

1997, 35 MM FILM

TEKNOLUST (STILL)

2002, HIGH-DEFINITION VIDEO

Neither is understood by her more conventional, limited mother, and each is only partially understood by her male lovers. Both are presented as attractive heterosexual women actively and openly pursuing their own desire—intellectually, artistically, and sexually. Ada seems the more sexually venturesome of the two—not only because of the bedroom scene with Mary Shelley (whose *Frankenstein* is another project Hershman plans to adapt), but also because of Ada's open promiscuity, at odds with her times, at least for women and especially (as her mother reminds her) for someone with blood ties to a notorious womanizer like Byron.

Yet both Ada and Emmy are the kind of brainy, sexual woman who is rarely seen onscreen, which is another reason why Ada remains invisible in history. According to Hershman, "Mary Shelley was the first one who ever wrote about artificial intelligence in literature. Ada Lovelace really wrote the code that became digital language, and then Hedy Lamarr. They're women that were invisible in history but really created our future, the present we're living in."[7] Hershman gives us two of these rare creatures in *Conceiving Ada*, and in *Teknolust* she gives us four more.

TEKNOLUST

The protagonist of this high-definition video feature is Dr. Rosetta Stone, a brilliant but nerdy biogeneticist who downloads her own DNA to generate three color-coded self-replicating automatons (SRAs), who keep her company as sisters, daughters, and friends. To make the film more economical and more technically challenging for Hershman, all four women—the mousy scientist Rosetta and her three gorgeous avatars, Ruby, Marinne, and Olive—are all played with comical verve by the versatile Swinton.

As in *Conceiving Ada*, an inventive female artist channels an earlier female figure who was at least equally cutting edge in her time. In *Conceiving Ada* this act of channeling was performed by the protagonist in the main plot, but here in *Teknolust* it is performed by Hershman herself, for she is clearly channeling the work of new media theorist and performance artist Allucquère Rosanne Stone (aka Sandy Stone). Stone, the transsexual author of *The War of Desire and Technology at the Close of the Mechanical Age*, is evoked not only by the names of Hershman's female scientist, Rosetta Stone, and Ruby's love interest, Sandy (a Jewish copyist working in a copy store), but also by the film's thematics—Rosetta's multiple identities and Ruby's vampiric sexuality.[8] *Teknolust* also shares some of Stone's key sources: the connection between multiple personality and cyberidentity is traceable to Sherry Turkle's *Life on the*

Screen: Identity in the Age of the Internet and to Donna Haraway's classic essay "A Manifesto for Cyborgs: Science, Technology and Socialist Feminism in the 1980s."[9]

There are other key intertexts as well. A throwaway line of dialogue evokes the 1979 cutting-edge feminist film *Dora: A Case of Mistaken Identity* (Tyndall, McCall, Pajaczkowska, and Weinstock), in which Freud's famous female patient, whose ruby lips are fetishized in glamorous close-ups, regains her agency by talking back to her renowned analyst. Even more significant for the science fiction connection, Hershman explicitly links *Teknolust* to Mary Shelley's *Frankenstein*, which is also about an artificially created creature who struggles for agency. When asked in an interview how she came up with the idea for *Teknolust*, Hershman replied: "I wanted to do a film on Frankenstein and in fact went to Sundance Lab to work on that script. But I couldn't get it funded—the period stuff can be expensive. As an exercise I kind of inverted the story and just wanted something gender reversed and contemporary. I just made the story as wacky as I could because I never thought I'd make it."[10] Thus, instead of belonging to "the tiny genre of feminist science fiction films" (as Dave Kehr of the *New York Times* so dismissively and condescendingly put it),[11] *Teknolust* is actually part of a rich tradition of feminist works on technology and the body.

Both Hershman films rely heavily on the concept of downloading: Emmy's attempt to preserve the consciousness of a female genius from another era in *Conceiving Ada*, and Rosetta's nightly ritual of downloading old Hollywood movies to prepare Ruby for "real-life" encounters in *Teknolust*. Both processes evoke Hershman's own intertextual strategies, which try to reprogram those of us who watch her movies and find them pleasurable or (as she prefers to call it) "delicious." The opening sequence of each film demonstrates this downloading process. *Teknolust* opens with a Möbius strip as the background for the titles. Through this twisting band, we are teased with brief glimpses of Swinton as the glamorous raven-haired Ruby, removing the steam from a glass shower door so that she can apply her high-gloss ruby red lipstick. As she stands in front of a mirror, she generates an array of three images—the film's first intimation of multiple identity. She arouses our curiosity when she puts a digital camera on her throat, wearing it like a necklace, and is then joined by a man, to whom she gives a condom shaped like a pair of lips. After a quick blow job, she asks for a brief cuddle, and then signs her name on the mirror. Whatever her motives, she performs these moves as a free agent, for as a sexual predator she controls her own body, voice, vision, and desire as well as those of her partner and the pace and sequence of their encounter. When the sequence cuts to the domestic setting of a kitchen, we watch Ruby stash the used condom in a jar, which

she carefully labels with a bar code and the man's photograph. Before storing the container in a cabinet where a number of similar jars are lined up neatly in a row, she uses one of the condoms to brew a pot of tea. We begin to wonder whether she's a laboratory scientist conducting a strange experiment, or a vampire killer performing some kinky rite, or an extraterrestrial alien sampling humankind. In any case, her routine is broken when she briefly glances out the window at a young man (whom we later learn is Sandy) sitting at his computer in his apartment across the street. After this brief distraction, Ruby carries a tray with the tea on it and leaves it at a green door, which is opened by Olive, her blonde sister garbed in green, who is accompanied by Marinne, their red-headed sister dressed in blue. Olive drinks the potent tea and sighs, "Delicious," and then injects Marinne with a hypodermic needle as the word "Sleep" flashes onscreen. At this point we see the final credit for Hershman as writer, producer, and director of *Teknolust* and watch all three SRAs go to sleep as the word "Download" flashes on a large video screen. The film they absorb in their sleep is the Hollywood melodrama *The Last Time I Saw Paris* (1954), featuring a moving farewell scene between the young Elizabeth Taylor and Van Johnson, whose dialogue Ruby will use in the next night's sexual encounter. We've seen this downloading process in science fiction before, perhaps most memorably in Nicolas Roeg's *The Man Who Fell to Earth* (1976), in which David Bowie plays an alien who constantly watches an array of multiple television sets in order to absorb television images from popular culture that would help him navigate his way through our planet.

Hershman's opening sequence in *Teknolust* not only introduces us to the downloading process and to Sandy and the three color-coded avatars played by Swinton, but also identifies Ruby as the character who most dramatically struggles for agency. Even though Dr. Stone is the film's controlling scientist, Ruby emerges as the key figure to watch, for she is the one whose actions set the mystery plot and its hermeneutics in motion: What is her motive? Why do these men have a bar code on their forehead? Why are they impotent after their encounter with Ruby? How can they be cured? Why does she save their sperm? She is the one who most successfully combines glamour, sex, and science and thereby arouses our curiosity and desire. She is the rebellious leader who makes her own way through the "real world," paving the way for her more docile sisters, who are barely developed as characters beyond their simple color-coding. She is the shadow figure for her mousy maternal creator, Rosetta, whom she helps to empower. She is the one who succeeds in getting a real love interest that holds center stage. She is the one (like Bowie's alien) who puts the downloaded dialogue into action. And, perhaps most important, she is the "self-breeding autonomous agent" who, like Power Rangers

and transformers, has transcended cinema and made the transmedia leap to the Internet, where she hosts her own multiplatform "E-Dream Portal" as a stand-alone cyborg.

According to Hershman's *Agent Ruby* press kit,

Agent Ruby is an artificial intelligent web agent that is shaped by and reflective of encounters and adventures that it has with users, and [is] . . . seeded to user servers through a site of origin or birth. The agent (Ruby) will be downloadable . . . and will be multiplatform, integrating PC, Mac and Palm pilots. Ruby chats with users, remembers users' questions, ultimately is able to recognize their voice and have moods and emotions. Her mood may also be affected directly by web traffic.

As a successor to Eliza and Julia (but one who is a film character impersonating a computer program rather than a computer program imitating a human being), Agent Ruby also needs a narrative context to support her illusion of agency. Instead of simulating therapy or a MUD, Hershman uses the existing Web site for *Teknolust* and the film itself to establish the narrative context for her cyborg. In the movie, her Web site is described as "the most popular portal on the Net" and we see the seductive Agent Ruby in action, beckoning: "Click on my icons, . . . emote on my remote, . . . come e-dream with me." Although these words evoke Ruby's anonymous sexual encounters from early in the film, the portal also entices Sandy and strengthens the bond between Ruby and Rosetta. By the end of the film, when both women have found their respective lovers (Sandy and an FBI man) and Ruby is pregnant with Sandy's child, the final credits roll as we hear Rosetta in voiceover filling in for Ruby: "Ruby can't be here today. . . . She's taking care of dreams of her own. . . . I'm here with thoughts I might share with you. . . . Our wildest dreams can become reality . . . *and* we should never be afraid of love." The film's final printed words are not "The End" but Ruby's URL address, www.agent ruby.com.

What this ending makes clear is that despite its array of avatars, *Teknolust*—like *Conceiving Ada*—really focuses on the relations between two equally brilliant women (here Ruby and Rosetta) who are both seeking agency in different realms and media and whose shadow relationship helps to empower not only both of them but also the rest of us. In both of these comic films, female intelligent agents *can* have it all—art and science, movies and Web sites, beauty and brains, children and lovers, sex and soulfulness, sisterhood and agency.

NOTES

Epigraph from *The Expanded Quotable Einstein*, ed. Alice Calaprice (Princeton, N.J.: Princeton University Press, 2000), p. 307.

1. Quoted in Albrecht Fölsing, *Albert Einstein: A Biography* (New York: Viking, 1997), p. 278, and Roger Highfield and Paul Carter, *The Private Lives of Albert Einstein* (London: Faber and Faber, 1993), p. 158.
2. "Lynn Hershman on *Teknolust*," Sundance Film Festival, January 10–20, 2002, online at www .filmfestivals.com/cgi-bin/fest_content/festivals.pl?debug=&channelbar=&fest=sundance&page= read&partner=&year=2002&lang=en&text_id=21194.
3. Lynn Hershman Leeson, "Teknolust," in *Future Cinema: The Cinematic Imaginary after Film*, ed. Jeffrey Shaw and Peter Weibel (Karlsruhe, Germany: Zentrum für Kunst und Medientechnologie, 2003), p. 220.
4. Janet H. Murray, *Hamlet on the Holodeck: The Future of Narrative in Cyberspace* (New York: Free Press, 1997), pp. 128–29.
5. Ibid., p. 215.
6. Ibid., pp. 216–17.
7. "Lynn Hershman on *Teknolust*."
8. Allucquére Rosanne Stone, *The War of Desire and Technology at the Close of the Mechanical Age* (Cambridge, Mass.: MIT Press, 1995).
9. Sherry Turkle, *Life on the Screen: Identity in the Age of the Internet* (New York: Simon and Schuster, 1995), and Donna Haraway, "A Manifesto for Cyborgs: Science, Technology and Socialist Feminism in the 1980s," *Socialist Review*, no. 80 (1985), pp. 65–107. Also see Donna Haraway, *Simians, Cyborgs, and Women: The Reinvention of Nature* (New York: Routledge, 1991).
10. "Lynn Hershman on *Teknolust*."
11. Dave Kehr, "Film in Review: 'Teknolust,'" *New York Times*, February 20, 2004, p. 13.

ROMANCING THE ANTI-BODY:
LUST AND LONGING IN (CYBER)SPACE

The pretense of being another person, or even several other people, is a precondition of electronic access; an identity is the first thing you create when you log onto an Internet service. Masks and self-disclosures are part of the grammar of cyberspace, part of the syntax of computer-mediated identity. In cyberspace, "one" can manifest multiple, simultaneous identities that abridge and dislocate gender and age. Yet these masking devices are like thumbprints or signatures in that they always bear some reference to their origins.

Masks may camouflage the physical body, but they also liberate a vulnerable and protected personal voice. New media theoretician Howard Rheingold notes in *The Virtual Community* that people use depersonalized modes of communication in order to get personal with each other.[1] Depersonalization on the Net is a way to connect. Truth is based in the inauthentic; one of the more diabolical elements of being on the Net is that people can only recognize each other when they are electronically disguised.

By defining yourself in some way, whether it is through your name, a personal profile, or an icon, you also define your audience, space, and territory. In the architecture of Net works, geography shifts as readily as time. Communities are defined by software and hardware access. Demographic anatomy can be readily reconstituted.

Self-created alternate identities become guides with which to navigate deeper access to Internetting. You do not need a body to do this; you need very few props or prompts. Not only does Internetting not require a body, but it encourages a disembodied body language. "Posing" and "emoting" are two of the terms for phantom gestures that can be read through words, or seen in special video programs through simple movements such as waves. Codes of gestures can be read by attachments on the computer that articulate the hidden meanings of voiceless and mute speech. These actions are constantly under surveillance, tracked, traced, digitized, memorialized, and stored.

The desire to connect through dialogues of consensual s(t)imulation has resulted in several notable case studies.

CASE 1

In the October 1985 issue of *Ms.*, Lindsay Van Gelder writes that she met "Joan" on Compuserve and began to chat.[2] Joan described herself as a neuropsychologist in her late twenties, living in New York, who had been disfigured, crippled, and made mute in an automobile accident for which a drunken driver was responsible. According to Joan, a mentor had given her a computer, modem, and subscription to Compuserve. In the Compuserve online community, Joan blossomed into a celebrity. Many people were touched by her wit and warmth.

Eventually, it was discovered that Joan was not disabled, disfigured, mute, or female. In "real" life, Joan was a New York psychiatrist, Alex, who had become obsessed with his own experiments in being treated as a female. After Joan was unmasked (defrocked, so to speak), it was learned that through the Net "she" had become intimate with scores of individuals who had come to trust and believe her. Van Gelder writes that "through this experience, those who knew Joan lost their innocence."[3] They suffered the psychic penetration of Net sleazing.

Alex cleverly used the icons and codes of a society that has learned to fantasize media-produced females in a particular way. He chose to be a woman because it was a gender-marginalized position in technology. When "Joan" first logged on, most people logging onto the Net were men and it was unusual to find women chatting. Even today when someone logs onto the Net as a woman, there is a barrage of questions in order to determine whether it really is a woman, or a man trying on a new sex for size.

Alex chose to make Joan the epitome of vulnerability by identifying her as paralyzed and mute. The fictional presumption was that in real life she had lost her body, yet she could still be seductive. She even lured people into lustful responses to her nonbody, like the Sirens calling out to Odysseus.

CASE 2

In February 1993 a housewife signed up for Internet service in order to access information and make friends. She was able to form personal online relationships that quickly became intense. Soon, however, "she found herself the target of an invisible high-tech predator who threatened to become an all-too-real menace to her and her children."[4]

She received progressively vile, unsolicited messages from someone known as Vito. She had no idea if Vito was a man or woman, a friend of her children and family or a psychotic maniac. Vito was able to tap into all of her messages, get a bit-by-bit profile of her, and post messages about her to all Internetters. She reported that it felt like rape.

She sought out a computer-crimes detective. Vito became well known, even infamous. Many people claimed to be him, just as many people claim to have committed the crimes of Ted Bundy.

When a suspect was finally arrested, the district attorney was forced to release him because of "insufficient evidence," which raises the question of how to bring law and order into a place where villains are invisible and users become unwitting victims in crimes of the nonbody.

New users on the Net are the largest immigrant population in history. Their reception often replicates the hegemonic treatment given to new arrivals to a country in the "real" world. They don't know the language, are shy about participating fully, and clumsily trespass into restricted territories.

CASE 3

In 1990 or so, Tom Ray created a virtual creature on his computer. In his book *Out of Control*, Kevin Kelly describes what followed:

This 80 byte creature began to reproduce by finding empty RAM blocks 80 bytes big and then copying itself. Within minutes, the RAM was saturated with replicas. By allowing his program to occasionally scramble digital bits during copying, some had priority. This introduced the idea of variation and death and natural selection, and an ecology of new creatures with computer life cycles emerged. The bodies of these creatures consisted of program memory and space. A parasite, this creature could borrow what it needed in the RAM to survive.[5]

To everyone's astonishment, the creatures in "Terra" (as Ray called the system) very quickly created their version of sex—even without programming! Sometimes when a parasite was in the middle of asexual reproduction (genetic recombination), its host would be killed, and the parasite would assimilate not only that creature's space but also part of its interrupted reproduction function. The resultant mutant was a wild, new recombination created without deliberate intervention; it perpetrated an inbred vampiristic progeny, an unrestrained strain.

Nothing is really new. It just looks different. Consider, for example, the rules for one-point perspective, written by Leon Battista Alberti five hundred years ago. His mathematical metaphor was first applied to painting and drawing and promulgated an age of exquisite illusionism. Artists who used his theories could paint windows onto imagined vistas with such precision that viewers were impressively deceived.

Was this ethical? What implications did it have? Did Donatello or Vermeer question the vistas of voyeurism their windows would invite?

In an effort to eschew illusion, Marcel Duchamp investigated the essentials of art production, including selfhood and uncontrolled, idiosyncratic inner impulses. The sine qua non of art, according to Duchamp, is not some quality residing in the final work, but rather an infinitely subtle shifting of the intent of the artist. With Rrose Sélavy, the female persona he created to represent him, Duchamp claimed the intent and body of the artist as the essence of artistic practice. His objective in assuming this persona was also to experience life as a female. (He had earlier considered creating a persona as a Jew, but had discarded that idea.) Rrose was a nonbody through which Duchamp could escape fixed identity, becoming an "other" in the process. ("Otherness" refers in this case to something defined by what it is not.)

There is a relationship between Duchamp and his scientist contemporary Werner Heisenberg. The irrationality of Heisenberg's uncertainty principle and his belief that the observer affects and participates in what he is looking at recall Duchamp's "experiments" regarding the effect of participants on the work of art and participants' ability to alter works, most notably in works involving randomness and chance.[6] Duchamp and Heisenberg were both traveling toward the same universal metaphor about an individual's relationship to his or her environment. They may have taken different roads, each looking for an uncharted path, but they went to the same place.

DON'T BYTE OFF MORE THAN YOU CAN ESCHEW

There are parallels between the virtual and physical worlds. For one, both breed unstable identities. Because there are more places to hide, mask oneself, or become encrypted in the virtual world, it may provide a safer environment for intimate revelations, a place to safely reformat collective dreams and begin to embrace the imperfections, inherent obsolescence, temporality, and fragility of our vulnerable human essence.

NOTES

This essay is an excerpt from "Romancing the Anti-body: Lust and Longing in (Cyber)space," originally published in the exhibition catalogue *1995 Siemens Medienkunstpries* (Karlsruhe, Germany: Zentrum für Kunst und Medientechnologie, 1995), and later published in Lynn Hershman Leeson, ed. *Clicking In: Hot Links to a Digital Culture* (Seattle: Bay Press, 1996). Reprinted by permission of the author. © Lynn Hershman Leeson.

1. Howard Rheingold, *Virtual Communities: Homesteading on the Electronic Frontier* (New York: Harper Perennial, 1993), p. 165.
2. Ibid. The title of Van Gelder's article is "The Strange Case of the Electronic Lover."
3. Ibid.
4. Mark Stuart Gill, "Terror On Line," *Vogue*, January 1995, pp. 163–65.
5. Kevin Kelly, *Out of Control: The Rise of Neo-biological Civilization* (Reading, Mass.: Addison-Wesley, 1994), pp. 286–88.
6. Wayne Black, "We Are All Roberta Breitmore: A Post Mortem on Modernism" (unpublished essay), 1994.

I build things in fragments. Each segment leads
to another. Like a breath leads to a voice, or an
action builds to an interaction, or a tape leads
to a diary. Each becomes whole because of the
trust and belief that invest the process.
—LYNN HERSHMAN

We all like to make a narrative out of our past, as if it could provide a trajectory for our future. After more than thirty years of exceptional—literally—artwork, there is a well-worn narrative trajectory to the career of Lynn Hershman, from the pharisee curators who would not allow sound into the temple of art to the first site-specific artwork at the Dante Hotel, to the Roberta Breitmore "performance," to the revelation of video and Hershman's video revelations, to the first artist-produced interactive laser disc to . . . the network. Nevertheless, Hershman's story seems to be as much about faith as plot. Her Net works are remarkable for their themes—the same themes she has explored in every other medium in ways that expand and reconfigure the territory without simply repeating it: (self) identity, (self) alienation, (self) surveillance, (self) voyeurism, and the cyborg (self).

One of the most established tropes of Hershman's career is its periodization into "B.C." (Before Computers) and "A.D." (After Digital). J. C. R. Licklider, one of the earliest conceptualizers of the Internet, talked about an "aha" moment when people "convert" to interactive computing. For those of us who have experienced it, the B.C./A.D. tipping point is the Archimedean principle that allows us to leverage our worldview into a new orbit. For Licklider and others at the time, pre–World Wide Web, there was a kind of progression from the early inklings of interactive computing—"man-computer symbiosis," as he put it in 1960—to an understanding of "the computer as a communication device," as he wrote in 1968.[1] Technology evolves, and so do worldviews.

This narrative matches Hershman's own trajectory. Her first A.D. works—*Lorna* (1983–84), *Deep Contact* (1984–89), *Room of One's Own* (1990–93), *America's Finest* (1994–95), and *Paranoid Mirror* (1995–96)—are all interactive but not networked and not, particularly, about communication.[2] Christine Tamblyn writes of *Lorna* that it "reinscribes narrativity from a woman's viewpoint,"[3] and arguably Hershman's interactive works are overtly feminist,

influenced by her memories of heroic street-based social activism in 1960s Berkeley. Subsequent works—*CybeRoberta* (1995–98), *Tillie, the Telerobotic Doll* (1995–98), *The Difference Engine #3* (1995–98), *Time and Time Again* (1999), *Synthia Stock Ticker* (2000–02), and *Agent Ruby* (2002–)—are all networked and implicate the communications system, but they are not as overtly political and even have a different relation to some of Hershman's core issues. Certainly, they are less directed and more open-ended, not only in the interpretations they invite but also in their scope.

CYBEROBERTA AND *TILLIE, THE TELEROBOTIC DOLL*

Gregory Bateson . . . puzzled his graduate students with a question koan-like in its simplicity: "Is a blind man's cane part of him?" The question aimed to spark a mind-shift. Most of his students thought human boundaries are naturally defined by epidermal surfaces. Seen from the cybernetic perspective coalescing into awareness from, during, and after World War II, however, cybernetic systems are constituted by flows of information. In this viewpoint cane and man join in a single system, for the cane funnels to the man essential information about his environment. —CATHERINE HAYLES

While dating Hershman's work is never easy—she often specs a project years before it is formally presented—it is clear that neither of the "dolly twins," *CybeRoberta* or *Tillie*, was among the first telerobotic devices to be attached to the Internet. They *were*, however, among the first humanoid telerobots—which is significant.[4]

As Hayles's Bateson anecdote indicates, artificial extension of the human sensorium is not a new concept. In practice, it is centuries old. One of the most famous McLuhanisms is that the network is an extension of the human nervous system. This is important to Hershman, of course.

In many cases, there is a merging of human and machine capabilities that create new beings, cyborgs, whose virtual reach, and in this case [Tillie's] sight, is extended beyond physical location.[5]

Yet it is not quite accurate to say that the merging of human and machine *capabilities* begets a cyborg—rather, it is Hershman's predilection for "(hu)man-computer symbiosis," which has fascinated her since the age of sixteen or seventeen, when she "started to make pictures of women with their bodies being crumpled and recorded in Xerox machines."[6]

There are many other links between the dolly twins—which have cameras embedded in one eye, allowing Internet users to see what they see—and Hershman's earlier work. Cybe-

CYBEROBERTA
1995-98, INTERACTIVE NETWORKED INSTALLATION

Roberta is a stand-in for Roberta Breitmore, who was, Hershman later admitted, a stand-in for Hershman herself; Tillie, then, is a doubling of CybeRoberta as a doppelgänger of Roberta Breitmore as a shadow of Hershman. The viewer's gaze is also displaced in *Room of One's Own*, albeit periscopically (mechanically). At key moments in *Deep Contact* an image of the participant gathered by surveillance is switched into the scene. The mirror in Tillie's hand reflects the mirroring of *Paranoid Mirror*. Yet there are also differences and disjunctions between the dolls and Hershman's earlier work.

CybeRoberta and Tillie are obviously gendered female. Their gaze is compromised by the ability of the viewer to turn their heads: the twins are clearly not in control, not autonomous. Yet there is a certain frustration that accompanies the viewer's control: every other click of the mouse displays a "view" of cyberspace rather than the physical space in which the doll is situated, along with one of a series of didactic texts helping the viewer accept her fate as a cyborg, so to speak. As Margaret Morse cogently argues about *Room of One's Own:*

Hershman's interactive model of subjectivity in an electronic culture inverts the idea of looking as power. . . . Then space itself can appear to be something "live" or animate—an agency, in Friedrich Kittler's words, "that we cannot acknowledge as subject or persona in the traditional European sense, and which nonetheless constantly demonstrates that it sees us without revealing itself."[7]

By personifying the cybernetic gaze, Hershman to some extent reveals it. At the same time, she provides a mask to the viewer through which to conduct surveillance. Hershman would argue that this "mask" is a liberating disguise that allows for the possibility of authenticity.

The justification for this disguise is similar to that for tribal coverings: masks camouflage the body, and in doing so liberate and give voice to virtual selves. As personal truth is released, the fragile and tenuous face of vulnerability is protected.[8]

THE DIFFERENCE ENGINE #3

I think I learned that at the Dante Hotel—to use and reframe what already exists. —LYNN HERSHMAN

If CybeRoberta is a cyborgian doubling of Roberta Breitmore, *The Difference Engine #3* has echoes of Hershman's breakout project, *The Dante Hotel* (1973–74). The environment this time is a VRML (Web 3-D) representation of the Zentrum für Kunst und Medientechnologie

(ZKM) in Karlsruhe, Germany, which commissioned the work. Rather than functioning simply as a representation of the physical museum, however, it is a space animated by its visitors, just as *The Dante Hotel* was animated by the sounds of the figures in the room, which became more than simulacra of flesh bodies.

When it is on display, *The Difference Engine #3* uses Web cams to capture images of visitors, who then appear as avatars in the virtual space of the museum, marked with an assigned number—an ever-present reminder of external control. The avatar is both a representation of the visitor and a kind of mask that she can hide behind as she journeys through the virtual museum.

When *The Difference Engine #3* is fully enabled, virtual visitors on the Internet can also journey through the virtual museum via a generic avatar. They can see into the physical exhibition space via the Web cams used to capture visitors' images, and they can capture images of works in the museum for desktop contemplation. Hershman's intention was that the avatars would be able to communicate with each other, making the virtual museum a hybrid portal between the bounded architectural space—and contents—of the museum, and the unbounded communications space of the Internet. As the work was realized at the ZKM in 1998, the avatars embarked on a twenty-seven-second journey through the virtual space and ended up in a purgatory, from which they could be viewed via the Internet but never released.

Hershman's work is named after Charles Babbage's original "difference engine," which, although it is commonly considered the world's first computer, was never actually constructed. In a sense, *The Difference Engine #3* releases Babbage's invention from its conceptual purgatory.[9]

TIME AND TIME AGAIN

When "real" objects are artificially inserted into environments, they simultaneously become simulated symbols that function as virtual reality. —LYNN HERSHMAN

Commissioned for the exhibition *Connected Cities* at the Wilhelm Lehmbruck Museum, Duisburg, Germany, in 1999, *Time and Time Again* was a "distributed, interactive media environment" created with Fabian Wagmister. It powerfully brought together many of the themes and practices found throughout Hershman's oeuvre, but it also departed from her other works in its use of the Ruhr Valley as the identity that was being probed.

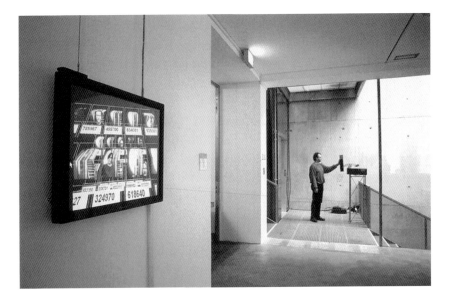

THE DIFFERENCE ENGINE #3

SHOWN AT *CYBERARTS 99, PRIX ARS ELECTRONICA EXHIBITION,* O.K. CENTRUM
FÜR GEGENWARTSKUNST, LINZ, AUSTRIA, SEPTEMBER 4-19, 1999

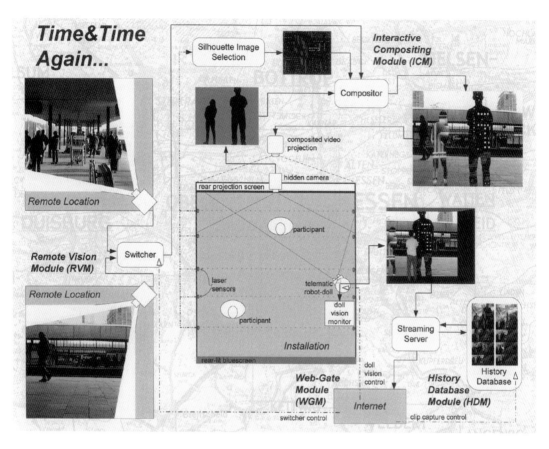

TIME AND TIME AGAIN (SYSTEM SCHEMATIC)
DESIGNED BY FABIAN WAGMISTER AND DARA GELOF, 1999, DIGITAL DOCUMENT, 8 × 10 INCHES

Remote cameras were set up in several locations (train stations, factories, and mines) near the museum, with live feed appearing on a blue screen inside the exhibition space. As with *Paranoid Mirror* and nearly every other of Hershman's A.D. projects, a hidden camera captured images of visitors as they walked in. These images were processed, turned into silhouettes filled in with prerecorded imagery—from aerial views of the region to photographs of the industrial apparatus at the remote camera locations, to close-ups of silicon chips and electronics circuitry. This infill imagery changed according to the visitor's distance from the blue screen; it was also composited with one of the live remote feeds. The resulting silhouettes were rear-projected onto the blue screens.

The effect was to disguise visitors as abstracted characters—as if they were in a living Magritte painting—and transport them into a remote scene, with which they were very likely to be familiar. The visitors' bodies inhabited and wandered the networked sites: not only the gallery space and the remote locations, but also, inevitably, their memories of those locations.

The silhouette provided the viewer with an engaging whole-body experience like that of Myron Krueger's pioneering *Videoplace* (1970), a "responsive environment" that used sensors and video cameras —but in contrast to the limited sensations of interacting with abstract computer graphics, here the viewer's sensation of being telepresent in a distant location was palpable, enhanced by piped-in environmental sounds from the remote locations. Because the representational characteristics used by visitors to identify themselves were replaced by the silhouette containing cues about the environment, the displacement acted as a kind of masking. This allowed, perhaps, an even more authentic or heightened experience of (hybridized) place, an intensification of the sense we often have that we are in many places at once, seldom feeling "at one" with only the place where our physical body is.

Also part of the installation was a close cousin of the dolly twins, Rita (Remote Interactive Telerobotic Access). As with *CybeRoberta* and *Tillie*, virtual visitors to the gallery, via the Internet, could control Rita's vision to pan around the room. Through her "eyes," they could survey gallery visitors and the silhouettes and remote scenes that appeared on the blue screen. The ability to view through either Rita's telephoto or wide-angle "eye-cons" and to capture short snippets of the scene to an online database for later browsing allowed the remote visitor a directorial agency not available to the gallery visitor. Both gallery and online visitors were, time and time again, teleported into a nexus of space-time continuums.

SYNTHIA STOCK TICKER

We are affected by environments, and we exercise our influence over them in pursuit of a (partial) chang-ing of reality. Once the world in question becomes a virtual world, the effort transforms itself into an-other attempt to produce change, this time a changed image of reality, which paves the way finally for the liberation of virtual images and actors, and the attempt to lend them "artificial life," or at least ever greater degrees of autonomy. —FLORIAN RÖTZER

Synthia is a character created by Hershman for a project commissioned for the lobby of finan-cial firm Charles Schwab's new offices in San Francisco. This was Hershman's first project commissioned by a noncultural institution for a public space, which may account for its rela-tively straightforward nature. Shown on plasma screens in the lobby, Synthia reacts accord-ing to the real-time status of the financial markets, jumping for joy when they're up and smok-ing nervously when they're down. Periodically, the display includes graphs of stock-market performance as well as images of activity in the lobby, continuing Hershman's career-long fascination with the incorporation of mirroring and surveillance of viewers into the fabric of a work.

What is most interesting about Synthia is the attempt to give her a kind of life—a life that is dependent on the virtual environment of the financial markets, but that is algorithmic, unfixed, and certainly independent of direct manipulation by either the artist or the viewer. In an important sense, the increasing autonomy of Hershman's characters has been the tra-jectory of her work, both B.C. and A.D., since her earliest wax figures, which she tried to an-imate by adding taped recordings of breathing and other sounds. In the A.D. era, Hershman's writings and artwork have both increasingly hinted at the notion of an independent (but con-nected) artificially intelligent, virtual, cyborgian other.

AGENT RUBY

Yes, [in 1993] everyone thought I was crazy (again), I published things on it in 1993-94, but I called it an anti-body, a virus, but it was the same concept. Mid-1990s people thought they'd go to jail if they made it, and here we are now ... with the tools to make her happen. —LYNN HERSHMAN

Agent Ruby has been a fixture of Hershman's thinking since 1993. The idea waited for the technology to become accessible enough for its realization. At first, Agent Ruby seems very much like the precocious "daughter" of Eliza, one of the earliest artificial-intelligence agents, created by Joseph Weizenbaum in 1963: she's smart, she's got attitude, and she learns.

Yet the most interesting aspect of Agent Ruby is not how good or elegant her artificial-intelligence algorithms are, but Hershman's contextualization of Ruby herself.

Like *The Difference Engine #3*, only more so, Agent Ruby is part of a narrative plot—in Agent Ruby's case, the feature-length movie *Teknolust* (2002), which tells the story of Rosetta Stone, a biogeneticist who downloads her DNA to create a trio of artificially intelligent self-replicating automatons, one of whom is named Ruby. The film and the Web site share characters, confusing the boundaries between film and computing, between the artificial and the organic, between the virtual and the physical. That Agent Ruby is mobile—or perhaps, like a virus, motile—breaches these boundaries even further. Agent Ruby can be downloaded into your Palm Pilot and brought with you anywhere so that you can converse with her at any time—which of course is precisely Hershman's aim, to create at least the possibility of a *psychological* dependency, not just a physical prosthesis.

Agent Ruby is Hershman's most successful realization, since Roberta Breitmore, of an animated other (self). Already she breeds and grows. Eventually, she will learn enough to cross the threshold into fleshly reality and become almost human, as we have become almost cyborg.

NOTES

The epigraphs, in order, are from Lynn Hershman, *Chimaera Monographie* (Hérimoncourt, France: Édition du Centre International de Création Vidéo, 1992), p. 124; Catherine Hayles, "Liberal Subjectivity Imperiled: Norbert Wiener and Cybernetic Anxiety," August 11, 1999, www.nettime.org/nettime.w3archive/199908/msg00033.html; Hershman, *Chimaera Monographie*, p. 109; Lynn Hershman, "Preliminary Notes (1968), in her *Chimaera Monographie*, p. 46; Florian Rötzer, "The Viewer Is a Voyeur," in *Paranoid Mirror* (Seattle: Seattle Art Museum, 1995), p. 33; Lynn Hershman, e-mail to the author, June 27, 2001, about the origins of *Agent Ruby*. Essay © Steve Dietz.

1. J. C. R. Licklider, "Man-Computer Symbiosis," *IRE Transactions on Human Factors in Electronics* HFE-1 (March 1960), pp. 4–11; and Licklider and Robert W. Taylor, "The Computer as a Communication Device," *Science and Technology*, April 1968.
2. This is equally true, only more so, of Hershman's computer-manipulated photographic work, such as the *Cyborg* (1997–) and *Phantom Limb* (1988–) series.
3. "With the production of *Lorna*, Hershman has challenged the teleological destination of desire, positing it as open-ended, multivalent, and polymorphously perverse rather than oedipal. In alchemical terms, Lorna has an ouroboric structure, circling back on itself like a snake biting its own tail. Its redefinition of causal premises enables it to function as a narrative that does without narrative by means of narrative. Thus, it reinscribes narrativity from a woman's viewpoint." Christine Tamblyn, "Lynn Hershman's Narrative Anti-Narratives," *Afterimage*, summer 1986, p. 10.
4. Eric Paulos and John Caney produced their *Floating Eyeball Blimp* (an aptly descriptive title) in 1997.
5. Press release for *Tillie, the Telerobotic Doll*, quoted in Machiko Kusahara, "Presence, Absence, and Knowledge in Telerobotic Art," in Ken Goldberg, ed., *The Robot in the Garden: Telerobotics and Telepistemology in the Age of the Internet* (Cambridge, Mass.: MIT Press, 2000), p. 199.
6. Lynn Hershman, e-mail to the author.
7. Margaret Morse, "Lynn Hershman's Room of One's Own," in *Lynn Hershman: Virtually Yours* (Ottawa: National Gallery of Canada, 1995), p. 8; also on DVD.
8. Lynn Hershman Leeson, "Romancing the Anti-Body: Lust and Longing in (Cyber)space," in Hershman Leeson, ed., *Clicking In: Hot Links to a Digital Culture* (Seattle: Bay Press, 1996), p. 325; also excerpted in this volume.
9. This seems particularly true in light of Hershman's feature-length film *Conceiving Ada* (1997), an excavation of the historical role of Ada, Countess of Lovelace (who helped Babbage with many of his calculations for the difference engine), set into the story of a fantastic voyage of personal discovery by a contemporary researcher.

Once Lynn Hershman hit upon her story, she stuck to it—the story of a body with more minds than it knows what to do with or of a mind manifesting through several bodies. Time after time, her tale of multiplicity unfolds, resolves, and concludes, only to return in a new form with the next wave of work. The tributary themes of her work—memory, voyeurism, surveillance, seduction, and authenticity—flow from the condition of multiplicity. How can one remember if there is no "one"? What are the boundaries of a "self" and how are contacts between "selves" negotiated? What does "truth" mean when "realities" proliferate? ("I always told the truth," she whispers in *First Person Plural* [1988], "for the person I was.")

A random sampling of Hershman's work shows the persistence and evolution of her major theme. In 1968 she assumed the pseudonyms Prudence Juris, Herbert Goode, and Gay Abandon to write about her own work; in retrospect, the creation of these personalities seems more fundamental to her oeuvre than the work they reviewed. By 1978 Hershman was near the climax of the persona performance *Roberta Breitmore*. In the later 1980s she was making *Deep Contact*, an interactive videodisc that incorporates the viewer as one of the minds governing the body in the narrative. By 1998 she was doubling museum visitors with Internet avatars as part of *The Difference Engine #3*.

Hershman's roster of media includes wax casting, installation, performance, photography, video, film, and interactive media. Through all the years and all the forms, her story of multiplicity multiplies. It's told with varying degrees of resolution; it's told as fiction and as fact; it's told as the story of a victim and as the story of a victor; it's told as the story of an individual and as the story of society. As Hershman says in *First Person Plural*, "All these stories are related."

Art is my survival weapon. It has allowed me to transcend the presumptions of my destiny.
—LYNN HERSHMAN

It's no ordinary story, this story that is not used up but loops endlessly through variations. It's a narrative that philosopher Hilde Lindemann Nelson calls a "counterstory": "a story that resists an oppressive identity and attempts to replace it with one that commands respect."[1] "Identity," for Nelson, is the interaction of a person's self-conception with how others conceive her, a "complex narrative construction consisting of a fluid interaction of the many stories and fragments of stories surrounding the things that seem most important, from one's own point of view and the point of view of others, about a person over time."[2]

Because identity is social, a "fluid interaction" between self and others, it involves multiple perspectives.[3] Some of those inputs may impede an individual's ability to act on and express her own view of who she is. Nelson points out that in the course of normal social life, people assign qualities to others based on the groups to which they belong ("Americans are independent," for example). When these assumptions are based on harmful stereotypes of a group ("black men are sexually predatory toward white women") and restrict individual freedom, they become oppressive—damaging to the individual's identity. But because identity is a narrative, there is the potential to "repair" the damaged identity by telling new versions of the story to oneself and to others—"counterstories."

"My destiny as a child was not to be a survivor," says Hershman.[4] Finding a counterstory was a matter of life and death, but it was no simple matter. To be effective, says Nelson, a counterstory must "aim to alter the oppressors' perception of the group . . . and, when necessary, an oppressed person's perception of herself."[5] Over a period of years, Hershman assembled a workable counterstory, one that challenged the oppression of women and restored the sense of self-worth that had been shattered in her childhood. Through her art, she amplified it into socially resonant metaphors. In this process, she challenged the conventional narrative of the unitary self struggling toward self-knowledge *(Bildungsroman)*. Resisting social and aesthetic pressures to conform to a singular identity, she gave form to an alternative conception of the self as multiple.

We started doing performance because it was easier to get access to personal subject matter through performance. —JUDY CHICAGO

Although themes of doubled and fractured personalities were present in Hershman's art from the beginning, early works such as *Self-Portrait as Another Person* (1969) do not, on their own, function as counterstories because they do not "alter the oppressors' perception of the group." But Hershman came of age during the civil rights struggles of the 1960s and 1970s. "I remember thinking then what a great time it was to be alive—the Black Panthers and the Civil Rights movement were each fighting for freedom and dignity. They became my models," she says,[6] and she gradually began to interpret her experiences in political as well as personal terms.

Hershman was introduced to activist art in 1974 through her work as associate project director for Christo and Jean-Claude's *Running Fence*, which involved organizing in the community to gain political support for the work. At the same time that she was assuming the persona of Roberta Breitmore, a personality strongly colored by her private experience of oppression, she also began to create works that expressed her increasing awareness of the subjugation of women as a group. The performance *Re:Forming Familiar Environments* (1975), for example, presented the madonna/whore dichotomy, mixing socialites and prostitutes at the same event. "Because of the dynamics of the evening, every woman was suspected of being a prostitute, and every prostitute was suspected of being a patron," Hershman recalls in an unpublished text. Her piece *25 Windows: A Portrait of Bonwit Teller* (1976) featured, among other scenes, a mannequin "breaking out" of her socially assigned role by punching her hand through the plate glass window.

Along with other artists of the 1970s, Hershman began to envision a history of art that included women. (The standard art history text of the era, H. W. Janson's *History of Art*, mentioned none.) In *The Making of the Rough and (Very) Incomplete Pilot for the Videodisc on the Life and Work of Marcel Duchamp According to Murphy's Law* (1982), she set up a "conversation" between herself and Duchamp, figuratively inserting herself into art history. By the early 1990s Hershman was recording the history of 1970s feminist art on videotape, implicitly and explicitly positioning her work within it. In *Changing Worlds: Women, Art, and Revolution* (1993), Hershman interviewed artists including Judy Baca, Judy Chicago, Suzanne Lacy, Faith Ringgold, and Miriam Schapiro about the beginnings of the movement and described her own work in San Francisco as parallel to that of the organized feminist groups in Los Angeles and

New York. In *Cut Piece: A Video Homage to Yoko Ono* (1993), she staged both a re-creation of Ono's 1964 performance *Cut Piece* and a discussion of its historical importance by art historians Moira Roth and Whitney Chadwick.

These tapes are active interventions in the narrative of art history, retellings that meet Nelson's criteria for counterstories: they affirm the competent, moral status of women artists; they replace stories that disregard women with stories that present them as worthy; and they open up the possibility that women artists can act with freedom. They are stories that women can use "to repudiate incorrect understandings of who they are and replace those understandings with more accurate self-understanding."[7]

DOUBLE ENTENDRE: HEALING INFILTRATED CONSCIOUSNESS

Self-knowledge always requires conversation. . . . I think it's generally true in life that to be seen by others is a very important part of knowing oneself. —MARTHA NUSSBAUM

Feminism helped Hershman repudiate others' incorrect understandings of who she was, but before Hershman could understand herself, she had to tell her story. Until the mid-1980s, she projected it into her art in symbolic form, but she was unable to speak directly and truthfully of her childhood, even to her therapist, until she began taping *The Electronic Diaries* (1986–). Some of the first revelations she made in these tapes were about food—she confesses to the camera that she "ravishes" cookies behind closed doors, dons combat clothes for her "Battle of the Bulge," and ponders her weight, lack of discipline, and insecure identity. She presents the lived, raw experience that is framed theoretically by critic Rosemary Betterton: "Femininity and the consumption of food are intimately connected and, in women, fatness is taken to signify both loss of control and a failure of feminine identity."[8]

As Hershman converses with the camera, she considers the political implications of her personal bind. Finally, she reveals a core secret. At first she tells the story in such a coded, symbolic form that it cannot be understood, juxtaposing clips of an old Dracula movie with her own account of digging into the plastered wall of her childhood bedroom. "I showed this tape to friends, and they didn't understand what I thought I had said," she reports. She then faces the camera—although in very dim lighting, as if speaking from the shadows—and tries to state unequivocally what had happened to her: "When I was very young I was physically abused and sexually abused." Her voice catches before the word "sexually," but she gets it out. She goes on to connect this most intimate experience with the public realm, specifically relat-

ing her experiences to those of Hitler, another abused child. As she speaks, her image is layered with footage of the Nazis, in a visual metaphor for the inherited brutality incorporated into her being.

After forty-five years, Hershman had achieved a full counterstory, a narrative that addressed her inner and outer oppression. What came next? No counterstory—even one amplified by art—is powerful enough to heal the world, so there is not much danger that Hershman—or the world—would outgrow the need for one. But if the story is effective, it will catalyze change, and this might be reflected in her work.

With this in mind, a look at the outcomes of Hershman's major narratives before and after this pivotal *Electronic Diary* episode is suggestive. By design, the interactive works such as *Lorna* (1983–84) and *Deep Contact* (1984–89) have no closure, but the possible endings have a high quotient of violence and disruption. (Lorna, for example, either shoots her television set, commits suicide, or moves to another city.) Of the long narrative videos, *Shooting Script: A Transatlantic Love Story* (1992) also ends inconclusively and *Longshot* (1989) leaves off with the reality of the central female character more fragile than at the beginning.

In contrast, the films *Conceiving Ada* (1997) and *Teknolust* (2002), which both feature powerful double heroines (doubled and doubled again in *Teknolust*), have unambiguously happy endings. Emmy, in *Conceiving Ada*, "doubles" by giving birth to a daughter; Rosetta and her three clones, in *Teknolust*, are each coupled with a loving partner. Happiness, for these multiple personalities, does not consist of unification into one voice. Rather, happiness is a situation in which each voice has the opportunity to be heard, to be in a relationship with an "other" who pays attention and loves her.

DOUBLE DISTILLED

When a technology comes along that rewards people who are willing to chuck overboard their old selves for new ones, the people who aren't much invested in their old selves have an edge. —MICHAEL LEWIS

Hershman's childhood had terrible liabilities, but it made certain things possible. A striking feature of her oeuvre is the way she cycles through media. Her mode of operation is the antithesis of modernism's "truth to materials"—Hershman has truths she wants to tell regardless of materials. She's not insensitive to formal concerns and consistently rhymes her narrative with her imaging, as in *Binge* (1987), where she folds and stretches her taped image while she talks of distorted body image. But formal elegance is not the point for Hershman. She

openly acknowledges the crudity of the *Diary* tapes within the tapes themselves, at one point venting her frustration over technical difficulties. That frustration, however, doesn't stop her from periodically chucking her technique overboard and tackling a new medium.

Her restless pursuit of new methods has made examination of her work as a whole difficult. Hershman tends to appear on critics' radars when she enters their areas of interest and to disappear when she moves on to a new medium. But when her work is surveyed, the logic of her development is clear. In *First Person Plural*, she says, "I lost my voice and it's taken me nearly forty-five years to get it back." Given that her drive is to make her voice heard, her trajectory through media makes sense: each shift in technology expands the number of people within reach of her voice. Sculpture was limited to the visitors to one venue; persona performance expanded the audience to anyone walking the street; video reached viewers in the European nations where her tapes were broadcast; film brought a larger audience in the United States; and the Internet made her work available worldwide.

Hershman's oeuvre can be understood as a counterstory told over time with increasing clarity and force. It acts as an effective agent of transformation for Hershman personally and also, potentially, for those who are touched by her art. Through the telling of the counterstory, multiplicity, once a wound and a defense against unbearable reality, becomes a fruitful condition.

NOTES

The epigraphs, in order, are from Lynn Hershman, *First Person Plural* (1988); Judy Chicago, in Lynn Hershman's *Changing Worlds: Women, Art, and Revolution* (videotape), Hotwire Productions, San Francisco, 1993; Martha Nussbaum, quoted in Kenneth Baker, "Martha Nussbaum: Call for Compassion in Vengeful Times," *San Francisco Chronicle*, November 11, 2001; Michael Lewis, "Faking It: The Internet Revolution Has Nothing to Do with the Nasdaq," *New York Times*, July 18, 2001.

1. Hilde Lindemann Nelson, "Resistance and Insubordination," *Hypatia* 10, no. 2 (spring 1995).
2. Hilde Lindemann Nelson, *Damaged Identities, Narrative Repair* (Ithaca, N.Y.: Cornell University Press, 2001), p. 7.
3. I am indebted to Glenn Kurtz for pointing out that Nelson's understanding of multiple perspectives forming identity correlates with the multiple voices in Hershman's work; conversation with the author, December 13, 2001.
4. Lynn Hershman, conversation with the author, December 7, 2001.
5. Nelson, *Damaged Identities, Narrative Repair*, p. 151.
6. Moira Roth and Diane Tani, "Interview with Lynn Hershman," in Hershman, *Chimaera Monographie* (Hérimoncourt, France: Édition du Centre International de Création Vidéo, 1992), pp. 102–24.
7. Nelson, *Damaged Identities, Narrative Repair*, p. 19.
8. Rosemary Betterton, *An Intimate Distance: Women, Artists and the Body* (London: Routledge, 1996), p. 131.

ACKNOWLEDGMENTS

When I think of the time, care, and help that has been given to this book project, words are inadequate to convey my gratitude. So I will simply say thank you, Lynn Hershman, for your work. Thank you, Moira Roth, for instigating my involvement in this project. Thank you, contributors, for your texts, and thank you, Kyle Stephan, for your comments. Thank you, Stephanie Fay and colleagues at the University of California Press for making the book happen. And thank you to my husband, Anwyl McDonald, and to my parents, Gene and Evelyn Tromble, for your love and support. —MEREDITH TROMBLE

I am immensely grateful to the many collaborators who, one by one, drove the extra distance it took on the wild and exuberant ride toward the completion of this book. It has been a privilege to work with each of the uniquely informed, sensitive, and witty contributors: Steve Dietz, Howard N. Fox, Jean Gagnon, Robin Held, David E. James, Amelia Jones, Marsha Kinder, Glenn Kurtz, B. Ruby Rich, and Abigail Solomon-Godeau, as well as the DVD participants, Ryszard Kluszczynski, Margaret Morse, the estate of Pierre Restany, Arturo Schwarz, and Siegfried Zielinski.

Stephanie Fay guided the journey with maturity and sustained encouragement. The expertise of her esteemed colleagues at the University of California Press, Erin Marietta, Sue Heinemann, Nola Burger, and Jennifer Knox White, brought clarity and depth to the manuscript.

Meredith Tromble was gentle yet relentless in her dedication. Heather Cummins helped enormously to complete the many detailed underpinnings.

Robin Held's resolve, perseverance, and inspired vision were fundamental to the retrospective, as was the support from the entire Henry Art Gallery team, Director Richard Andrews, Paul Cabarga, Sallie-Jo Wall, and Karen Bangsund, whose expertise and insight made

working on this exhibition a pleasure. The installation team of Colin Klingman, Palle Henckel, and Matt Heckert was precise and elegant in its endeavors.

Kyle Stephan unleashed a surge of irrepressible energy, focus, and insight to the framework of the book and the design and production of the DVD. Valerie George, Michael Lazar, Scott Mahoy, and Starr Sutherland were the DVD's dynamic dream team.

Over the years, my friends and family tirelessly listened, read, cajoled, made me laugh at myself, and ultimately, caused me to feel like a capital I. A capital THANK YOU to Paule Anglim, Eleanor Coppola, Leonard Cuenoud, Char Davies, Ed Gilbert, Susan Grode, Donald and Ursula Hess, Robert Koch and Ada Takahashi, Suzanne Lacy, the Leeson family, the Lester family, Roger Malina, Sheldon Renan, Moira Roth, Steve Sacks, Steve Seid, Kristine Stiles, Tilda Swinton, and the University of California, Davis.

My husband, George Tellier Leeson, is a rabid and tireless advocate. Dawn Luryn Hershman and her husband, Richard Hankin, as well as their children, my grandchildren, Eli and Noa, are a constant inspiration.

Finally, I am deeply grateful to the many unacknowledged co-conspirators without whose generosity and spirit my projects could not have been realized. **—LYNN HERSHMAN**

I would like to thank the dedicated team of people whose talents brought the DVD to life: Michael Lazar, for his extraordinary production savvy and commitment; Scott Mahoy, for his eclectic and insightful graphic design work; Starr Sutherland, for his clever sense of humor and production advice; Colin Klingman, for his technical assistance with the bot guide; Valerie George, for her ardent enthusiasm and care for the visual materials; and Heather Cummins, for her detailed archival research and permissions assistance. I would also like to thank Ryszard Kluszczynski, Margaret Morse, Jos DeCock-Restany and the estate of Pierre Restany, Arturo Schwarz, and Siegfried Zielinski, who generously offered critical essays to enhance the content of the DVD.

Thank you to the Hess Collection, Stanford University Special Collections, the Theresa Hak Kyung Cha Memorial Foundation, and the University of California, Berkeley Art Museum and Pacific Film Archive, for their support and assistance with archival materials and to the many artists and collaborators who graciously granted us permission to reproduce images of their work on the DVD. This project was developed with the support of staff at the University of California Press and the Henry Art Gallery, whose critical insights and thoughtful

feedback guided the DVD to its final form. Finally, I wish to extend a warm thank you to Lynn Hershman Leeson for her undying sense of adventure and the opportunity to document such an inspiring and challenging body of work. **—KYLE STEPHAN**

The Henry Art Gallery wishes to warmly thank the following people for their contributions to organizing and presenting the exhibition *Hershmanlandia: The Art and Films of Lynn Hershman Leeson:* Lynn Hershman and her assistant Kyle Stephan; Exhibition Curator Robin Held; Elizabeth Brown, Chief Curator, Henry Art Gallery; Colin Klingman and Palle Henckel, for their technical expertise; Ed Gilbert and Paule Anglim of Gallery Paule Anglim; Steven Sacks of bitforms gallery; Curator Leonard Cuenod of the Hess Collection; Donald M. Hess of the Hess Collection; Stewart Landefeld and Eleanor Pollnow, Chairs of the Henry Gallery Association Board of Trustees; Sharon Maffei, President of the Henry Gallery Association Board of Trustees; and the staff of the Henry Art Gallery, particularly Paul Cabarga, Exhibitions Manager; Sallie-Jo Wall, Registrar; Karen Bangsund, Curatorial Assistant; Dean Welshman, Lead Graphic Designer; Betsey Brock, Communications and Outreach Coordinator; Jim Rittimann, Exhibition Designer; and Floyd Bourne, Senior Computer Specialist. **—HENRY ART GALLERY**

CONTRIBUTORS

STEVE DIETZ is the former curator of new media at the Walker Art Center in Minneapolis, Minnesota, where he founded New Media Initiatives in 1996. He was the programmer for the Walker's online Gallery 9, which includes more than twenty Net art commissions and one of the earliest archive collections of Net art, the museum's Digital Arts Study Collection. He speaks and writes extensively about new media, and his interviews and writings have appeared in *Parkett*, *Artforum*, *Flash Art*, *Design Quarterly*, *Spectra*, *Afterimage*, *Art in America*, and *Museum News*, many of which are viewable online.

HOWARD N. FOX is a curator of modern and contemporary art at the Los Angeles County Museum of Art. He has organized numerous major exhibitions and authored their catalogues, including *Avant-Garde in the Eighties* (1987), *A Primal Spirit: Ten Contemporary Japanese Sculptors* (1990), *Lari Pittman* (1996), and *Eleanor Antin* (1999). He was a collaborating curator and contributing author for *Made in California: Art, Image, and Identity 1900–2000*. Fox was previously a curator at the Hirshhorn Museum and Sculpture Garden in Washington, D.C., and since 2000 he has been a member of the History/Theory/Humanities faculty of the Southern California Institute of Architecture.

JEAN GAGNON is the director of programs at the Daniel Langlois Foundation for Art, Science and Technology in Montreal, Canada, where he curated the exhibition *The Body of the Line: Eisenstein's Drawings* (1999). He is also first vice president of Hexagram, Institute for Research and Creation in Media and Technology, and is a member of the editorial committee of the Virtual Museum of Canada, an initiative of the Canadian Heritage Information Network. Gagnon was previously the associate curator of media arts at the National Gallery of Canada in Ottawa.

ROBIN HELD, formerly an associate curator at the Henry Art Gallery, University of Washington, Seattle, is chief curator at the Frye Art Museum in Seattle. She is curator of *Hershmanlandia: The Art and Films of Lynn Hershman Leeson*, a retrospective premiering at the Henry Art Gallery in winter 2005–6. Author of *The Retrospective Futuristic Negative Utopia of the NSK State* (2000), on the "retroavant-garde" strategies of the contemporary Slovenian artists' collective Neue Slowenische Kunst, she has also published essays on post-Communist art in Eastern Europe, performance art, video art, and biological art in an age of bioterrorism.

DAVID E. JAMES is a professor at the School of Cinema-Television at the University of Southern California. His books include *Allegories of Cinema: American Film in the Sixties* (1989) and *Power Misses: Essays across (Un) Popular Culture* (1996).

AMELIA JONES is a professor of art history at the University of Manchester. She has written numerous articles in anthologies and journals and has organized several exhibitions, including *Sexual Politics: Judy Chicago's Dinner Party in Feminist Art History* (1996). Jones co-edited *Performing the Body / Performing the Text* with Andrew Stephenson (1999), edited *The Feminism and Visual Culture Reader* (2003), and is the author of *Postmodernism and the En-Gendering of Marcel Duchamp* (1994), *Body Art / Performing the Subject* (1998), and *Irrational Modernism: A Neurasthenic History of New York Dada* (2004).

MARSHA KINDER is a professor of critical studies in the School of Cinema-Television at the University of Southern California, where in 2001 she was named a University Professor in recognition of her innovative transdisciplinary work. Since 1997 she has directed the Labyrinth Project, an art collective and research initiative at USC's Annenberg Center for Communication, producing database documentaries in collaboration with independent filmmakers and writers. Also a cultural theorist and film scholar, Kinder has published over one hundred essays and ten books, including *Playing with Power* (1991), *Blood Cinema* (1993), and *Kids' Media Culture* (2000), and since 1977 has served on the editorial board of *Film Quarterly*.

GLENN KURTZ is a writer and art critic living in San Francisco, California. His work has appeared in numerous publications, including *ZYZZYVA*, *Tema Celeste*, and *Artweek*. He holds a Ph.D. from Stanford University and has taught digital media aesthetics at Stanford University and San Francisco State University's Multimedia Studies Program.

B. RUBY RICH is an assistant professor of film at the University of California, Santa Cruz. She is a critic, a journalist, and the author of *Chick Flicks: Theories and Memories of the Feminist Film Movement* (1998).

ABIGAIL SOLOMON-GODEAU is a professor of art history at the University of California, Santa Barbara. She is the author of *Photography at the Dock: Essays on Photographic History, Institutions and Practices* (1992) and *Male Trouble: A Crisis in Representation* (1997) as well as numerous essays on contemporary art, nineteenth-century French visual culture, photography, and feminist theory.

MEREDITH TROMBLE is co-director of the Center for Art+Science at the San Francisco Art Institute, where she teaches art and genetics and other interdisciplinary courses. She is a co-publisher of Stretcher.org, an online magazine of visual culture. Her regular features on visual art were heard on public radio stations KQED-FM and KALW-FM from 1985 to 2000. She is the author of hundreds of essays, interviews, and reviews published in magazines, museum catalogues, and books, such as *Yesterday and Tomorrow: California Women Artists* (1989).

ILLUSTRATIONS

All art by Lynn Hershman unless noted.

CONTENTS OF DVD

Text: 10.75/14.25 Fournier
Display: Interstate

Sponsoring editor: Stephanie Fay
Assistant acquisitions editors: Erin Marietta, Sigi Nacson
Project editor: Sue Heinemann
Editorial assistant: Lynn Meinhardt
Copyeditor: Jennifer Knox White
Indexer: Ruth Elwell
Designer: Nola Burger
Production coordinator: John Cronin
Compositor: Integrated Composition Systems
Printer and binder: Friesens